ATLAS OF
FORESHORTENING
THE HUMAN FIGURE IN DEEP PERSPECTIVE

ATLAS OF
FORESHORTENING

THE HUMAN FIGURE IN DEEP PERSPECTIVE

JOHN CODY

PHOTOGRAPHS BY
Leon Staab and Greg Matlock

VNR VAN NOSTRAND REINHOLD
I(T)P™ A Division of International Thomson Publishing Inc.

New York • Albany • Bonn • Boston • Detroit • London • Madrid • Melbourne
Mexico City • Paris • San Francisco • Singapore • Tokyo • Toronto

To:
Rupert's swell family—Lupe, Phloop-phloop, Anja,
Grimsley and Ambrosiabomb—with love.

For more information, contact:

Van Nostrand Reinhold
115 Fifth Avenue
New York, NY 10003
Germany

Chapman & Hall
2-6 Boundary Row
London
SE1 8HN
United Kingdom

Thomas Nelson Australia
102 Dodds Street
South Melbourne, 3205
Victoria, Australia

Nelson Canada
1120 Birchmount Road
Scarborough, Ontario
Canada M1K 5G4

Chapman & Hall GmbH
Pappelallee 3
69469 Weinheim

International Thomson Publishing Asia
221 Henderson Road #05-10
Henderson Building
Singapore 0315

International Thomson Publishing Japan
Hirakawacho Kyowa Building, 3F
2-2-1 Hirakawacho
Chiyoda-ku, 102 Tokyo
Japan

International Thomson Editores
Campos Eliseos 385, Piso 7
Col. Polanco
11560 México D.F. Mexico

97 98 99 00 01 QEBKP 16 15 14 13 12 11

Library of Congress Cataloging-in-Publication Data

Cody, John, 1925-
 Atlas of foreshortening.

 1. Models, Artists'. 2. Nude in art. 3. Perspective.
I. Staab, Leon, 1947- . II. Matlock, Greg, 1951-
III. Title.
N7574.C62 1984 702'.8 84-3644
ISBN 0-442-21594-0
ISBN 0-442-21595-9 (pbk.)

CONTENTS

PREFACE

Ask a well-trained artist or illustrator to draw a human body from
memory and you will probably get the following results. He or she
will draw a figure whose long axis (head to foot) is presented at right
angles to the viewer's line of vision; that is, there will be no *foreshort-
ening* of the form. If the artist is one with considerable experience in
drawing the nude, the sketch will undoubtedly look correct and well
proportioned.

But ask the same able draftsperson to draw from memory a figure
in deep perspective—for example, a person reclining so that the head
is considerably closer to the viewer than are the feet—and the artist
will probably be perturbed. He or she will offer apologies in advance
and tell you that it is extremely difficult to draw from imagination a
convincing figure whose parts overlap and interlock in the unpredict-
able ways that occur when the body is perceived as foreshortened.

Even the great masters of the Renaissance had trouble with such
views. They had already developed certain rules of thumb, such as the
body is seven and a half heads high; the distance between the level of
the nipples and that of the navel is one head length; the distance be-
tween the crotch and the knee joint is one and a half head lengths;
and so on. But these guidelines, so helpful in enabling them to pro-
duce credible likenesses of the upright human body, failed them when
they wished to draw figures in perspective. Such guidelines are clearly
useless when all distances and relations are truncated and distorted,
as they are when the body is seen head on or feet first.

Even when the old masters drew from living models, they encoun-
tered difficulties. One such difficulty is inherent in our binocular vi-
sion, although in standard poses this presents no problem. When a
model is standing or lying with his long axis at a 90-degree angle to
the artist's line of vision, the images of him on the artist's two retinas
are roughly congruent—that is, they have almost the same shape, the
same outline. The artist's brain has no trouble overlapping them, and
he does not have to choose between the form as seen by his one eye
and the form as seen by his other. But if the model is posed so that
the long axis of the body diverges very much from a 90-degree angle
with the artist's line of vision, then the two retinal images are no
longer congruent. And if the model is close to the viewer, so that the

foreshortening is very drastic, the images presented to the two eyes may be incongruent indeed. In this case the artist may decide to ignore one image and follow the other, forcing him to draw with one eye squinted shut—an uncomfortable procedure.

Because of this discomfort and these difficulties some masters dealt with foreshortened poses by viewing the model through a pane of glass on which a grid had been drawn. On this they traced the outline of the model as seen through the glass, the observed distortions maintained in accurate relation to each other as a result of the powerful frame of reference provided by the squares of the grid. The most drastic foreshortenings in the history of painting were probably done that way. One thinks especially of some of the figures of Mantegna, Signorelli, Tintoretto, and Tiepolo, the last's generally seen from below. Few of Michelangelo's entire figures are seen in deep perspective, but a marvelous example of drastic foreshortening of the arms alone can be found in his painting of the crucified Haman on the ceiling of the Sistine Chapel. Just try drawing a pose like that from memory or imagination!

This brings me to the rationale for this book. Any aid or technique that is helpful to the artist is legitimate if it enables him to realize the vision in his head. What counts in art is only the final result, not the scaffolding of devices, methods, and expedients the artist employs to reach that result. No special virtue lies in doing something the hard way unless it is the only means of producing the artist's vision. If he can achieve his aim more directly and successfully through some contrivance or other, then he would be foolish to spurn that aid.

This holds true for the use of photographs in the production of drawings, paintings, and the like; hence these foreshortened views of the nude. They are simply the modern equivalent of the squared-off windowpane of the Renaissance. The impressionists, and even Gauguin, often painted from photographs, and it seems likely that, had they been available in their day, even Michelangelo and Tintoretto would have found them useful.

It is remarkable that an atlas of photographs of the foreshortened human body has never before been available. As a practicing medical and biological illustrator a quarter-century ago, I was always waiting for such a work to appear. I had acquired early a detailed knowledge of human anatomy, inside and out, as a result of having painstakingly dissected, studied, and drawn two cadavers, one at the Johns Hopkins Medical School and the other at the University of Arkansas Medical Center. I knew the origins and insertions of every muscle in the body, as well as all the bony structures to which they are attached. I could, moreover, identify these parts from the surface contours of a living person. This scientific knowledge, combined with much practice in drawing the nude in innumerable life classes, enabled me to produce, from memory and with some facility, plausible graphic representations of the human body.

That is, I could produce them provided I was not called upon to show the body in a foreshortened view. Like most artists, I found it impossible to create a really convincing perspective drawing of the body from imagination alone. Upright in front of me, or reclining

with head and feet roughly equidistant from my eyes, the body falls into a series of more or less simple geometrical shapes. But foreshortened, these structures take on the most unexpected, most surprising contours. Limbs and torsos often assume a thick, stubby bluntness that is quite unlike their form under ordinary viewing conditions. For these drawings I *had* to have a model. But models were more often than not inconvenient to come by. At such times I most ardently wished I could find an atlas like this one.

Recently I decided to limit my medical practice to pursue additional activities. Only then did this *Atlas*, which I had been mulling over in my head for years, first become a possibility. As soon as I presented the idea to my photographers, they became enthusiastic at the prospect, and Leon Staab offered the use of his professional studio for taking the photographs. But how to begin?

We could not simply start snapping pictures of models willy-nilly and hope to produce a comprehensive collection of foreshortened views. We needed some way of keeping track of where we were at every moment, so as not to repeat poses and perspectives, and so as to exploit exhaustively every possibility the body offered for foreshortening, without overlooking interesting and unforeseen variations. Obviously, what was essential was a scheme for approaching the project systematically so that we could orient ourselves at the beginning of every posing session and, finally, know precisely when we had accomplished our task.

In imposing order on our efforts, the first principle we developed was that all foreshortened views of the body necessarily fall into one of two primary categories. These we called "head close" and "head distant"—"close" and "distant," that is, in relation to the camera lens or to the eye of the observer. How, we then asked ourselves, could we further subdivide these categories? The answer was obvious: the model could lie (1) supine (face up), (2) prone (face down), (3) on his side, or (4) supported by one or both arms and one or both legs. In addition, the pose could be a twisted one in which the model's shoulders are turned in the opposite direction from the pelvis. These we termed (5) tortion poses. Moreover, the side-lying poses (3) could be further subdivided into those in which the front of the model is turned toward the camera and those in which the back is toward the camera. Similarly, subcategory (4) could be further broken down depending on whether the model's back or front was toward the floor.

This line of thought provided us with fourteen distinct categories of poses, seven under "head close" and seven under "head distant." This number was then doubled by taking into consideration the degree of obliqueness of the pose in relation to the camera. Accordingly, we came up with "straight on" poses, in which the long axis of the body was a continuation of the imaginary line that extended from the lens to the model's head or feet, and "oblique" poses, in which the long axis of the body lay at an angle, more or less than 90 degrees, to that line. Now we had twenty-eight different categories of foreshortened positions. Finally, we further subdivided each of these "straight ons" and "obliques" into threes according to the degree of foreshortening: "slight," "moderate," or "marked" (a matter decided by either the

height of the camera above the model or the degree of obliqueness of the body in relation to the camera). In sum, then, we ended up with a scheme that provided for eighty-four different groups of poses. We then arbitrarily decided that we would try to conjure up eight different individual poses for each of these eighty-four pigeonholes. Thus, our shooting schedule called for 672 photographs of each model. These encompassed six different views, in varying degrees of foreshortening, of 112 distinct poses.

A selection, not the complete results, is presented in the *Atlas*. The photographs in this book are organized along different lines from those dictated by our shooting schedule for several reasons. First, for some categories, notably those subsumed under tortion poses, we simply could not devise eight different positions different enough to justify including them all. Though we cudgeled our brains—photographers, models, and myself—and invented in our imaginations some marvelous and unprecedented designs (in this we fairly rivaled the painter William Blake), the models could not possibly conform to them, for there are absolute limits, anatomical and mechanical, beyond which the human body cannot go. For example, if the model lies on his back and keeps his shoulders flat against the floor, his pelvis can only be twisted so far to the right or left and no further; conversely, with pelvis flat the shoulders can be turned only so far to either side. Indeed, at times during our photo sessions, we thought with alarm that we heard something snap!

Furthermore, it became evident to us early on that it would not be advisable to present every pose in its complete sequence of six viewpoints. A certain number of poses looked clear, natural, and aesthetically appealing from every angle, but not all of them did. Some, drastically foreshortened, caused the model to look like a heap of obscure debris. Neither an interesting abstract shape nor anatomic instructiveness was present in sufficient degree to justify their inclusion in the book. Then there were other pictures that conformed to what Greg Matlock dubbed "your basic dead-person pose"—dull, rhythmless, uninspiring stretches of inert, featureless flesh. These we also quickly decided to leave out.

Then we encountered another phenomenon: poses that appear to be very different when viewed from some angles become virtually identical when viewed from others. So we eliminated the peculiar redundancy and included only the unique aspects of each pose.

And finally, when one is committed to capturing foreshortened poses from every conceivable angle, there are bound to arise views of otherwise good poses that might be considered inimical to the model's dignity—resulting, for example, in awkward or "medical" positions. These, too, we deleted for the most part. I must say, however, that we wished not to limit too much the usefulness of the *Atlas* for all kinds of illustrators and preferred to lean toward comprehensiveness rather than toward prudishness. Relevant to this, I emphatically agree with Johns Hopkins Hospital's great early twentieth-century medical illustrator, Max Brödel, who said that there is no part of the human body, inside or out, that is not beautiful and a wonder to the eye of an artist.

As I have indicated, all our poses are basically reclining ones as these constitute the most practicable way of portraying the human body in perspective. They have the limitation, however, of not showing the model in vigorous action, a limitation that can be overcome by photographing standing, running, leaping subjects from above or from underneath—the objective, perhaps, of a companion volume to this one. Not that the *Atlas* suffers from monotony—It was clear to us from the beginning that, given our fourteen basic parameters, the number of distinct combinations would be very large and result in an abundance, if not an overabundance, of material. Beyond that, further richness would be introduced by the use of male and female models.

During the course of making the photographs, one of the models asked, "What are you after, anyway, definition?" I thought about that. No, we were not aiming to capture definition of the body (in the sense that weight lifters use the term, meaning the clearest possible delineation of separate muscle groups). Rather, what we were after was *proportion*, the relation of parts of the body under special viewing conditions. We also wanted to capture the sense of design that the various masses of the body create when they are deployed in space under a wide variety of arrangements. We chose as our models, therefore, those with the most harmoniously developed, well-proportioned, and normal bodies we could find. They are athletic, but they are not bunnies or iron pumpers.

A brief word should be said about the book's actual organization in view of our not having followed herein the shooting schedule described earlier. It is divided into two parts, the one devoted to the female figure, the other to the male. Each part has five sections. The second in each consists of sequences of photographs showing roughly the same pose from various viewpoints and in various degrees of perspective. These are the exceptional poses that seemed to us to be unmuddled and graceful from every angle. The following three sections in each part present what we think are the best views in the different categories of marked, moderate, and slight foreshortening. These photographs were extracted from those sequences containing other views rejected because of awkwardness, lack of clarity, or other reasons, and are presented here because we believe they exhibit in themselves qualities of design, rhythm, and overall aesthetic appeal. The first section in each part shows our models in conventional, non-foreshortened views. We include these for the sake of comparison and to show what the models' figures look like when they are not telescoped by the interesting vagaries of foreshortening that characterize the bulk of the photographs.

Before our project was finished, the photographers and I had grown overwhelmingly aware of the still-existing artistic potential in the human figure. And this observation, we came to believe, is even more applicable when that superb structure is viewed in a foreshortened form as contrasted with upright conventional poses at right angles. In the latter mode, the figure is seen as just that—a bodily shape, unmistakably a bodily shape—and although a thing of beauty, it is in a sense limited in its aesthetic usefulness as an *abstract* shape, as an

interlocking part of a flat design on paper or canvas. But when fore-shortened, the figure in its abstract shape—in its silhouette—often be-comes something wholly new. It grows compact, it becomes more square or triangular or elliptical, it may even take on a flowerlike form. I believe that anyone who studies these photographs carefully cannot fail to gather an impression of much untapped artistic vitality in that oldest and most worked-over subject, the human anatomy.

It is our hope that all kinds of draftspeople use the material in this book. You should feel free to make adaptations and reproductions of its images in paint, ink, or any other medium, except photography. The book is an *atlas*, after all, designed to make its particular con-tents accessible and easily usable. It is meant to be a source book, a trove of visual ideas and images not available elsewhere. We hope that artists and illustrators in their own creative practice will find it enlightening, stimulating, and helpful.

ACKNOWLEDGMENTS

The creation of this book would doubtless have been possible without the encouragement, good will, and active cooperation of the following people—but it certainly would have been much less fun and a lot more strain. Therefore, I want to thank Dr. Bill Jellison and Dr. Don Fuertges of Fort Hays State University for paving the way in my search for models from among their students. I also want warmly to acknowledge the leadership of Dr. Gary Arbogast and Tony Perez in sparking the interest of the physical education majors in my project—certainly a first and a puzzlement, especially for a conservative, midwestern town like Hays, Kansas. Most particularly I want to express my deep appreciation and admiration for the enthusiasm and verve of our models, Carla Steward and Michael Miller, who never failed to show up and take off their clothes for our scheduled camera sessions, even though some of these happened to coincide with our worst midwinter blizzards. My gratitude also goes to my super secretary, Susan Wagner, and to Ann Staab, Leon's wife, for record keeping and "chaperoning." I would also like to thank Dorothy Leidig. Our high-angle telephoto pictures had to be photographed in a space with an eighteen-foot ceiling. Mrs. Leidig generously lent us the seemingly sole chamber in Hays suitable for the purpose: her living room. To her, therefore, we owe a special debt of gratitude. And finally, to all those students who tried out as models but who, for whatever reasons, could not be included in the book: a most sincere *thank you*.

PART I
THE FEMALE FIGURE

Nonforeshortened Views: A Point of Reference

Foreshortened Views
Poses from Multiple Angles
Poses with Marked Foreshortening
Poses with Moderate Foreshortening
Poses with Slight Foreshortening

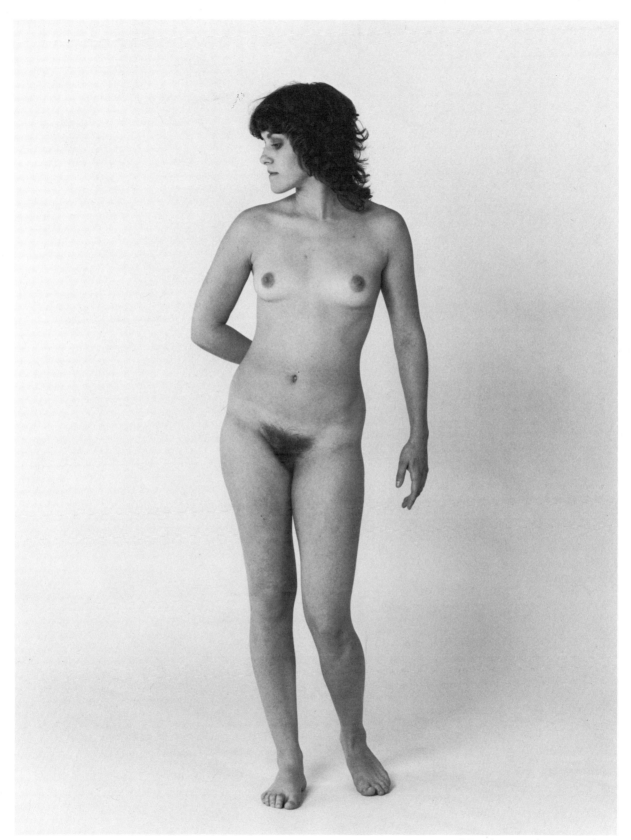

Nonforeshortened Views

3

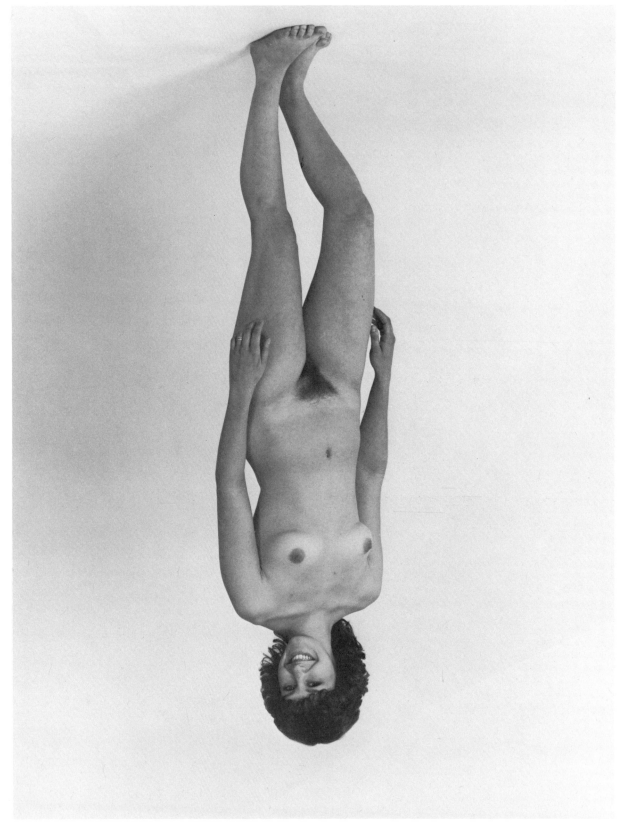

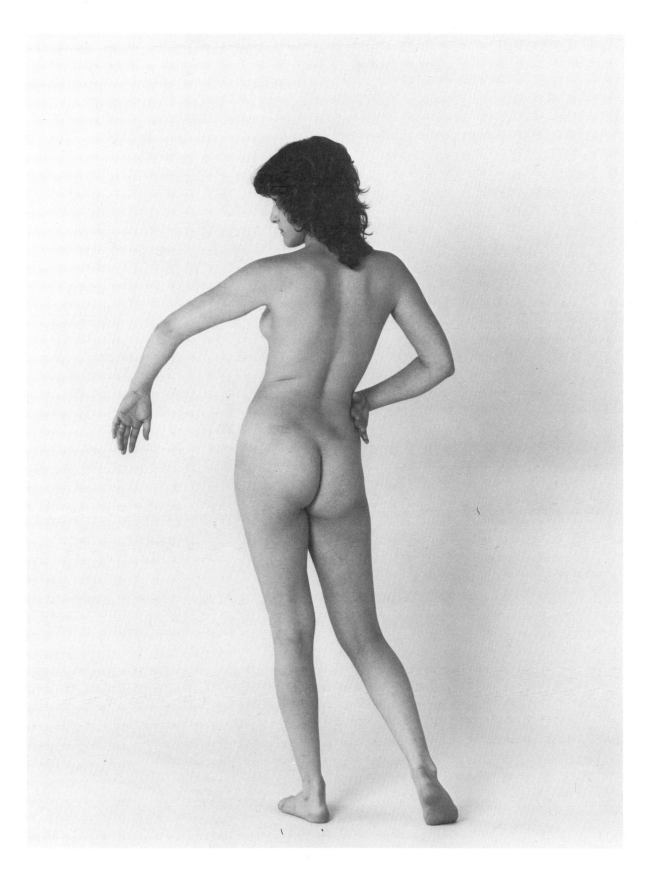

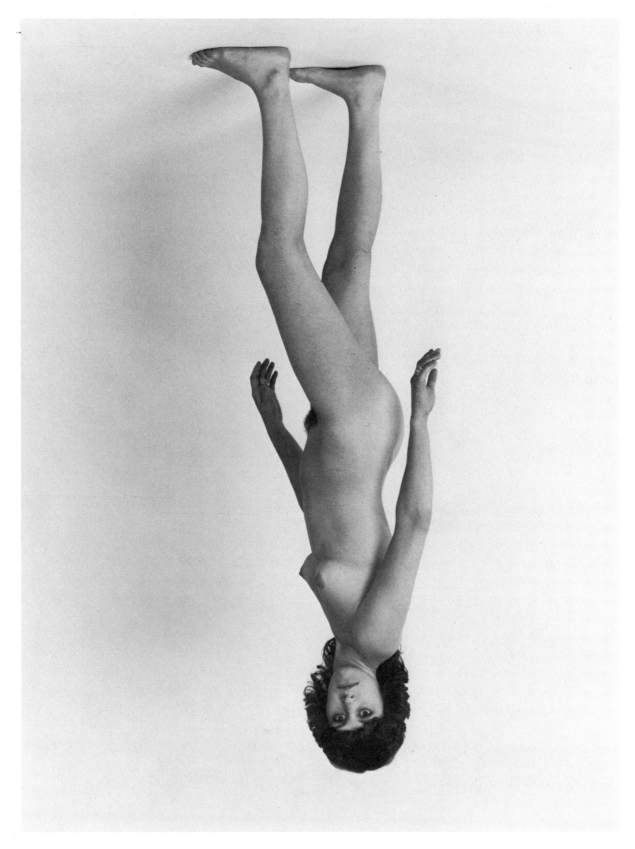

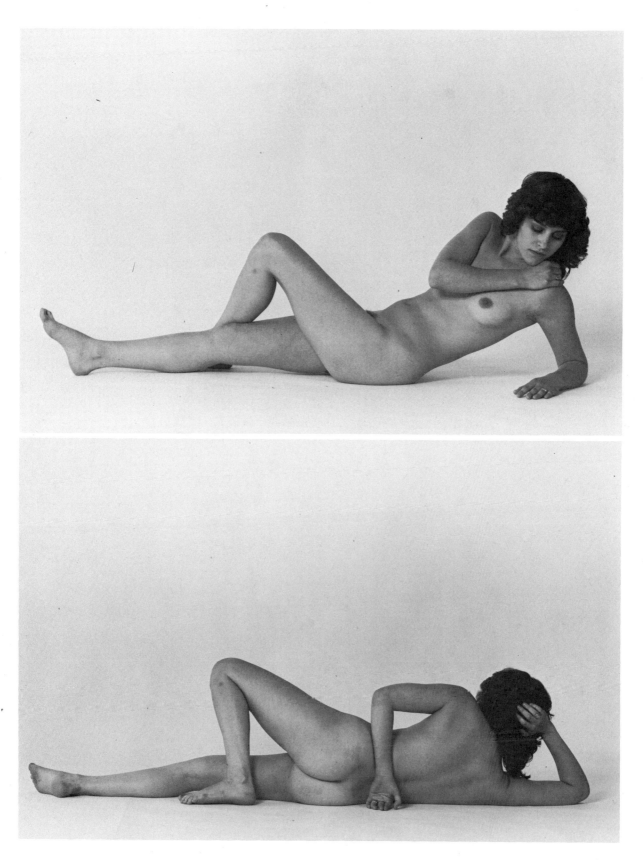

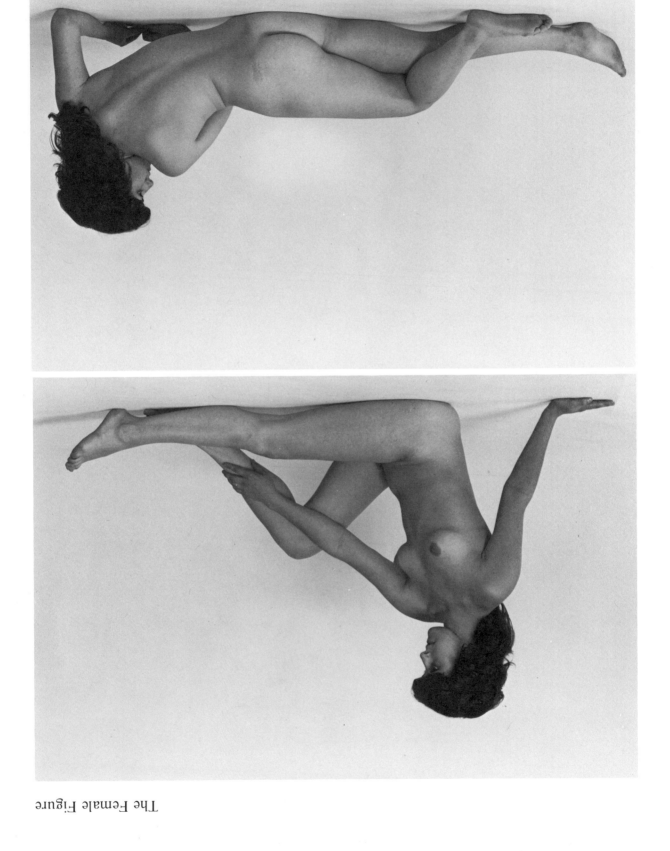

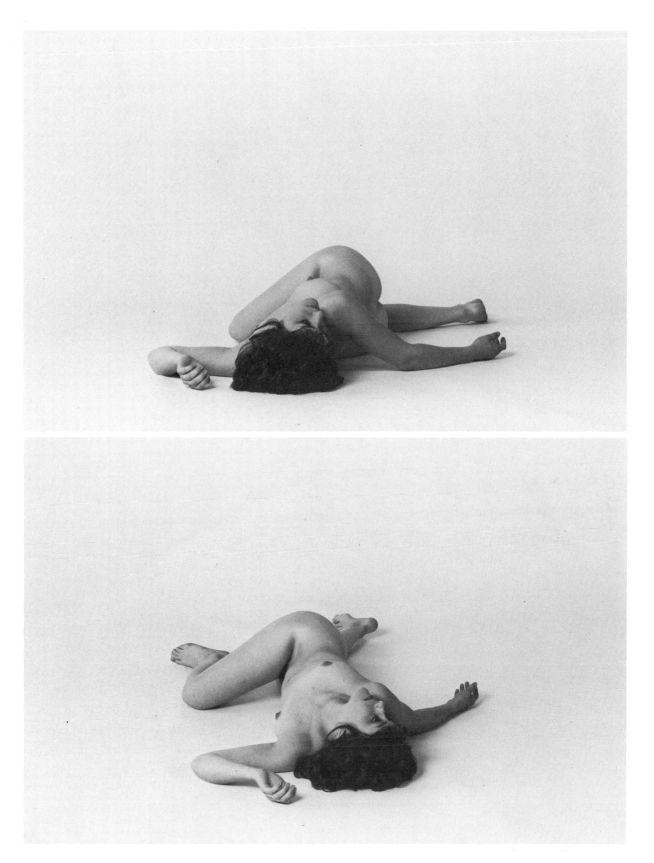

Foreshortened Views: Poses from Multiple Angles

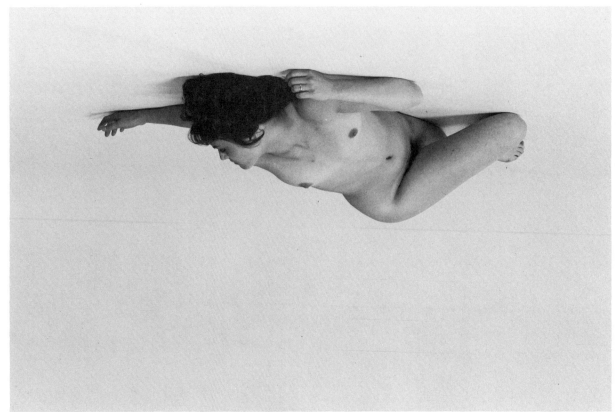

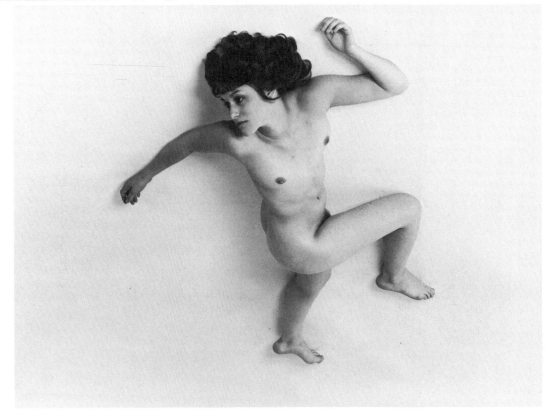

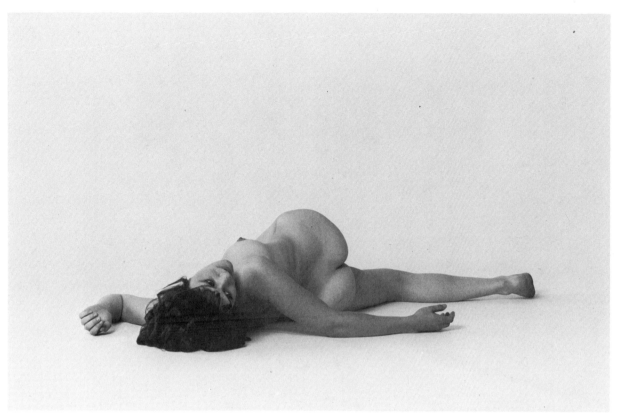

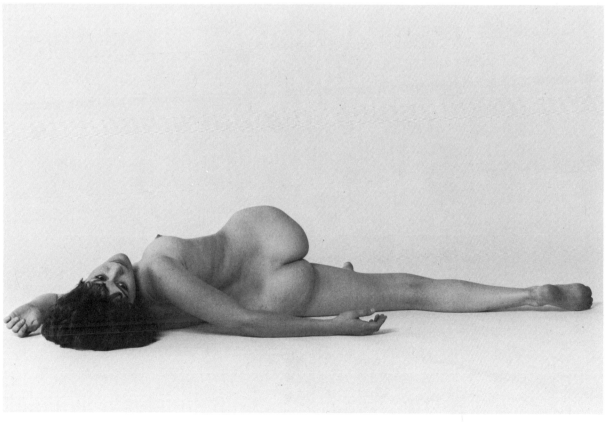

Foreshortened Views: Poses from Multiple Angles 11

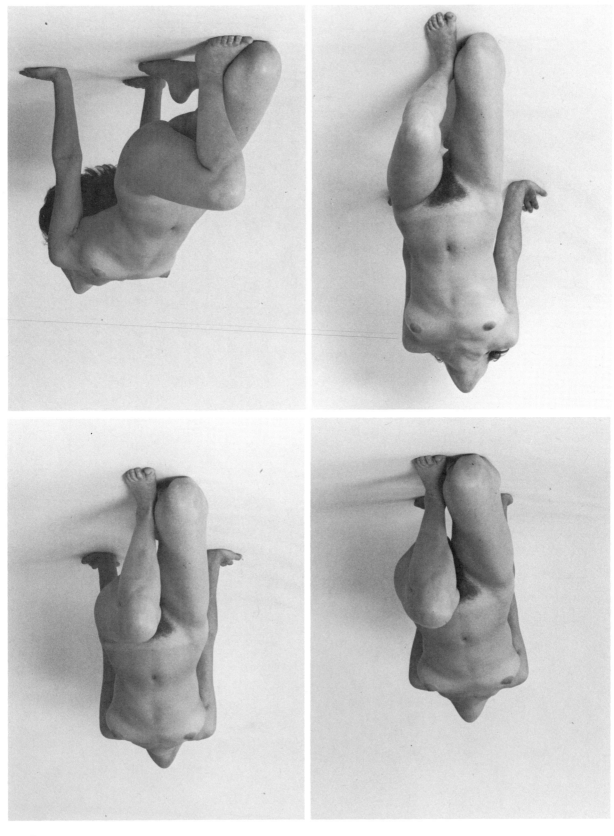

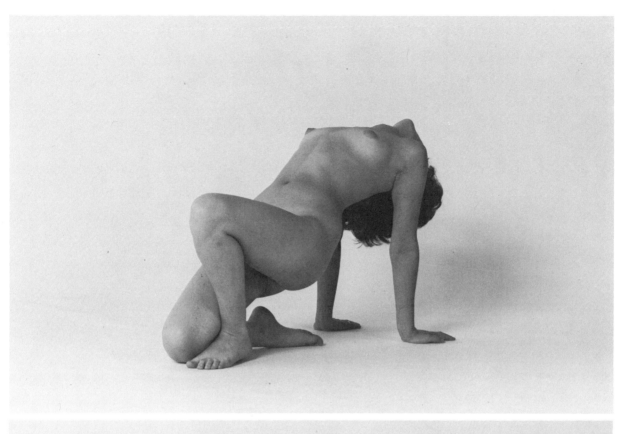

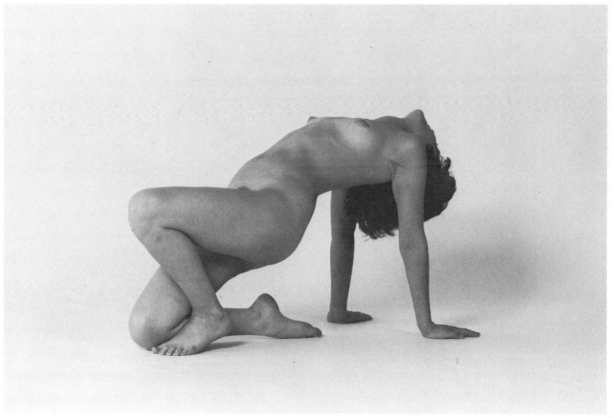

Foreshortened Views: Poses from Multiple Angles 13

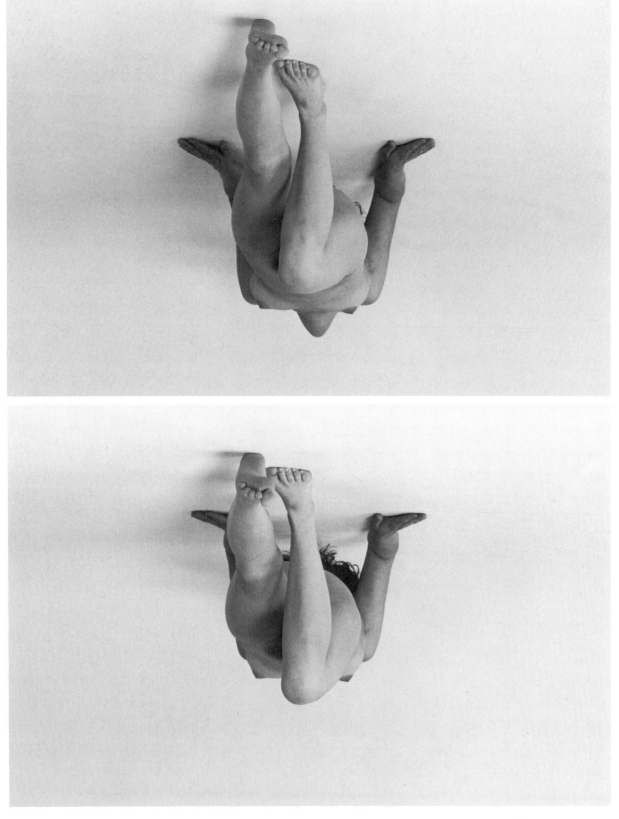

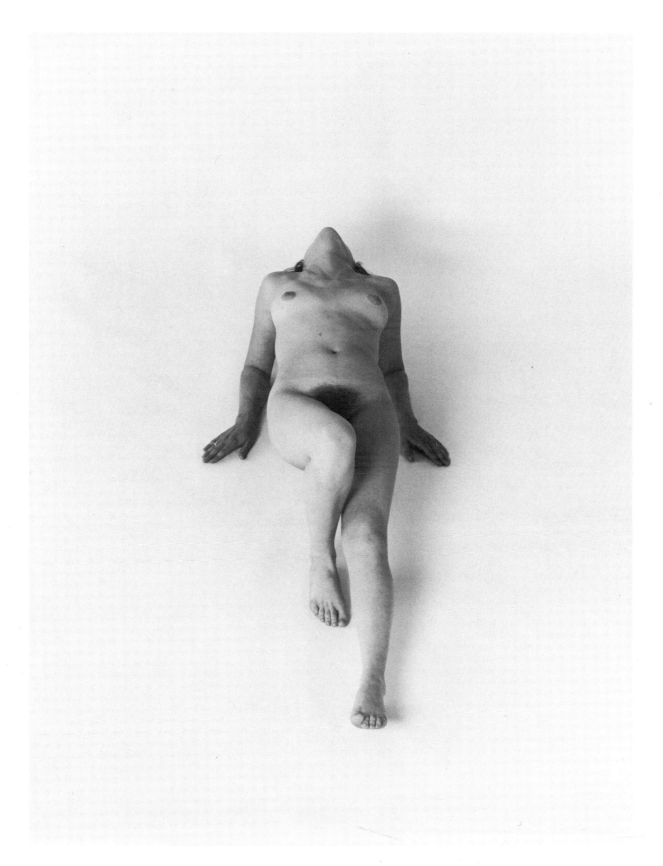

Foreshortened Views: Poses from Multiple Angles 15

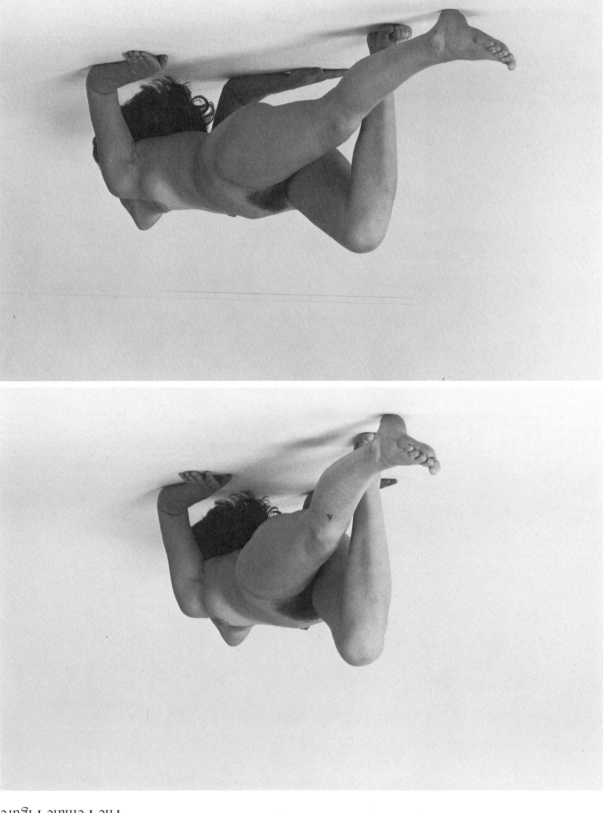

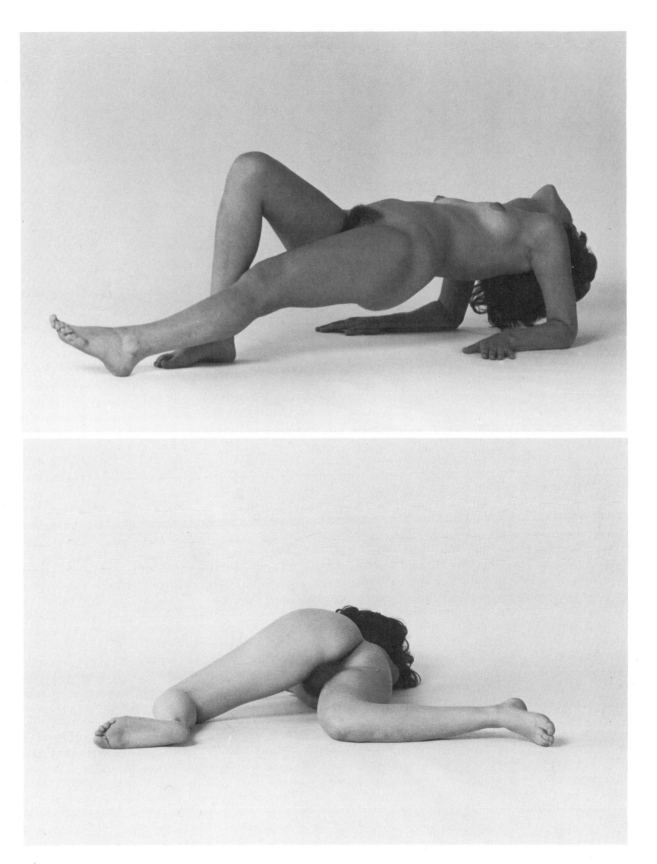

Foreshortened Views: Poses from Multiple Angles

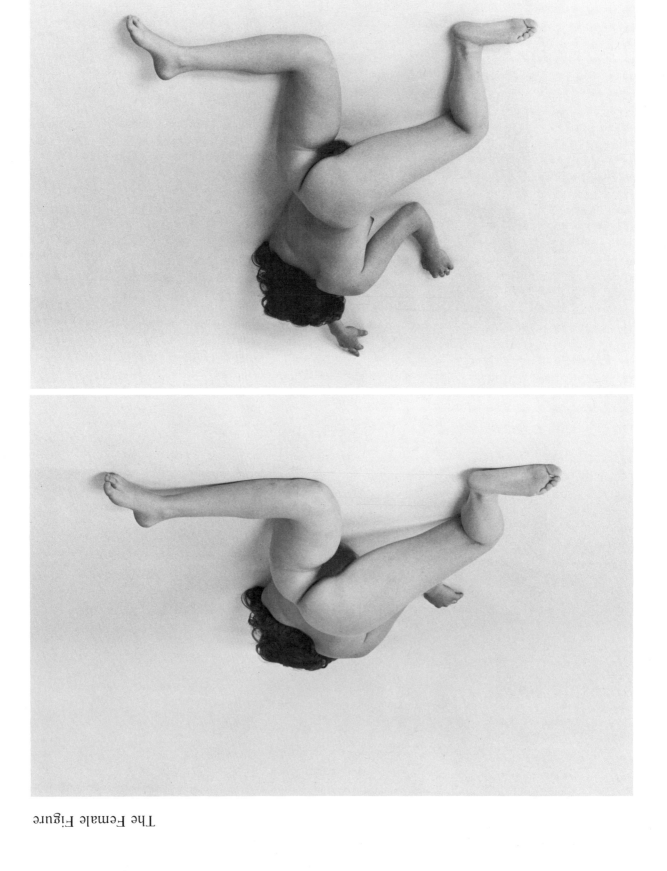

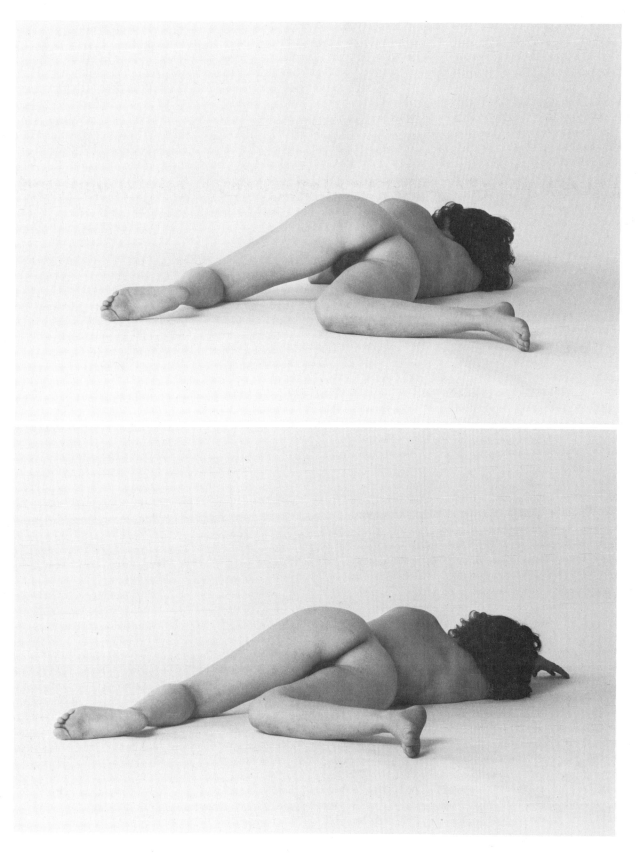

Foreshortened Views: Poses from Multiple Angles

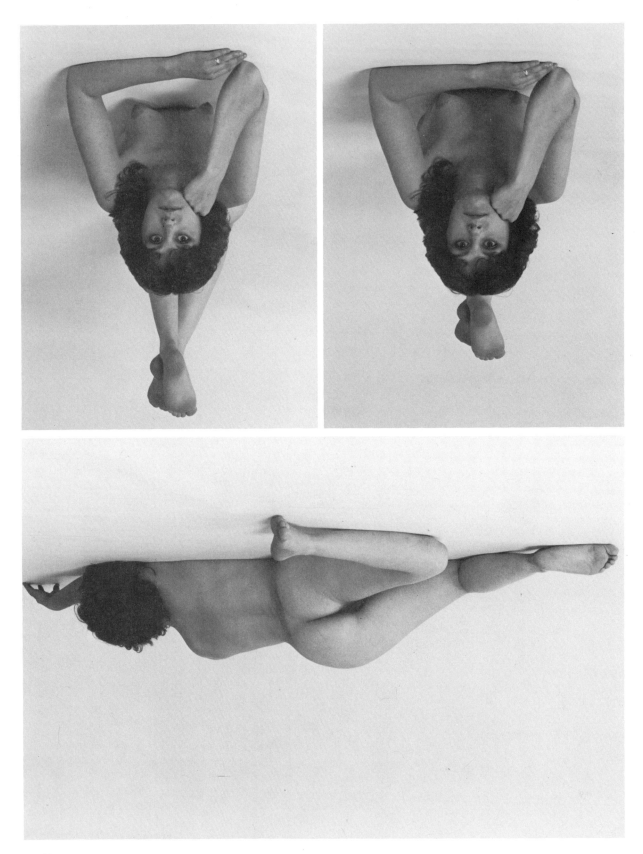

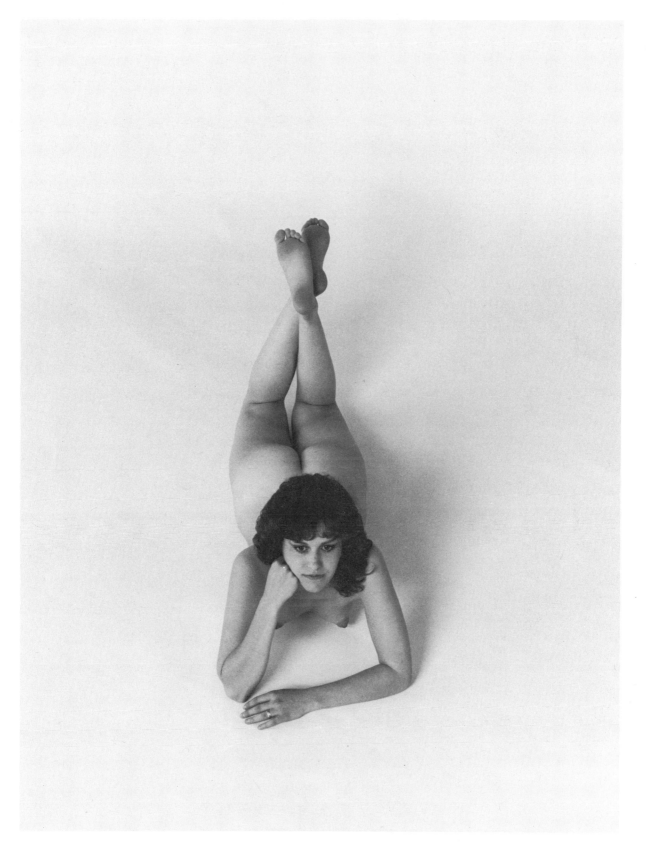

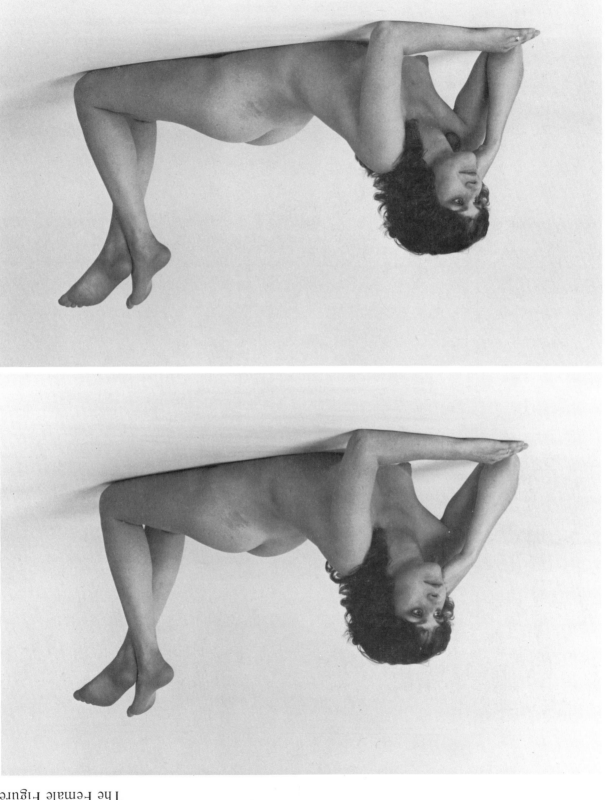

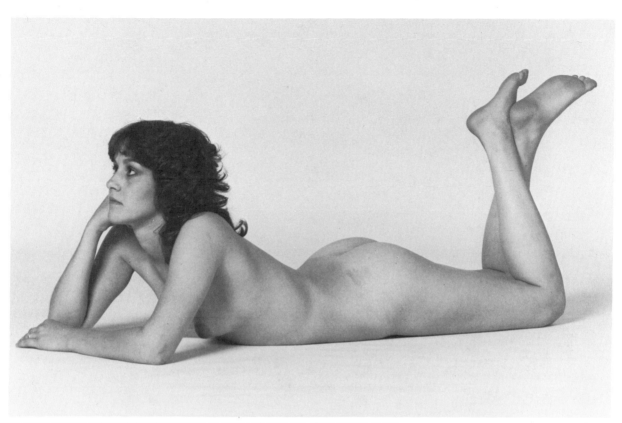

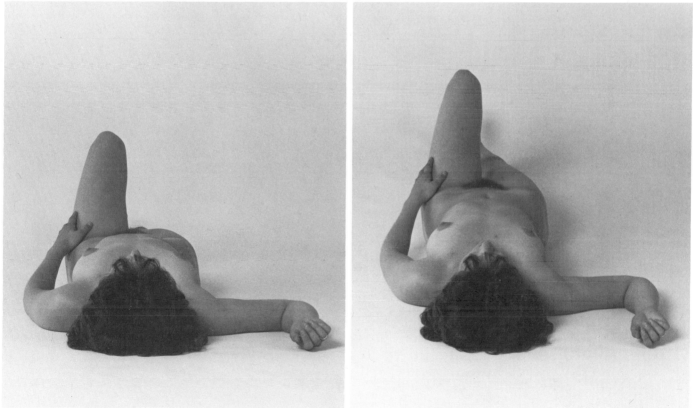

Foreshortened Views: Poses from Multiple Angles 23

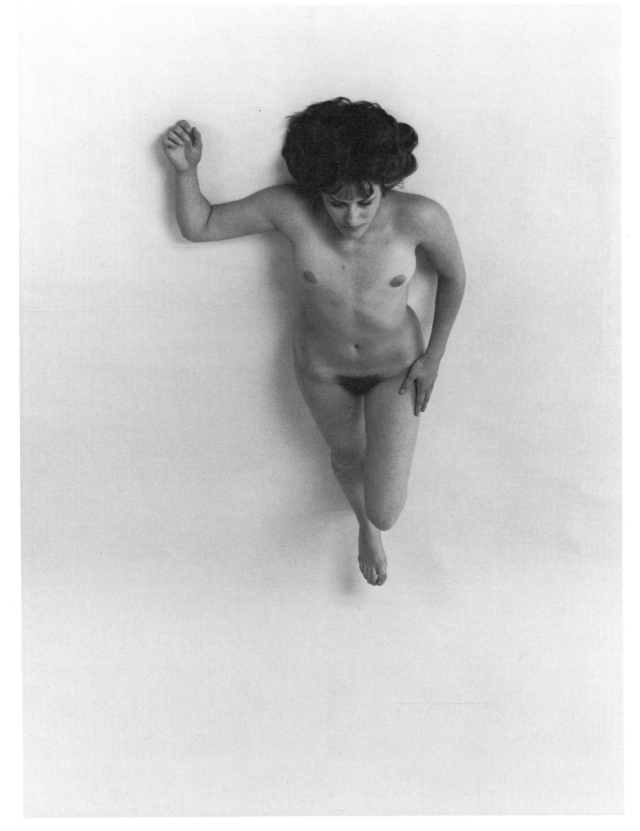

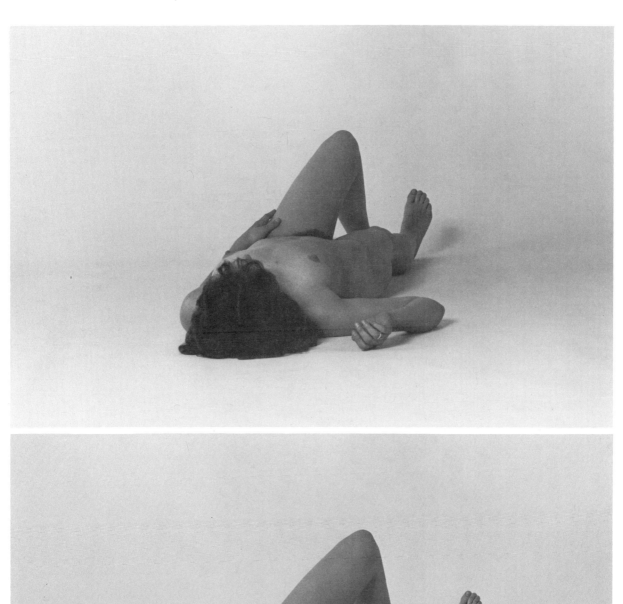

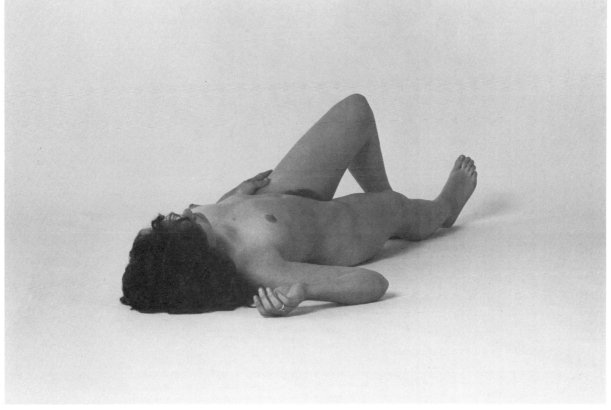

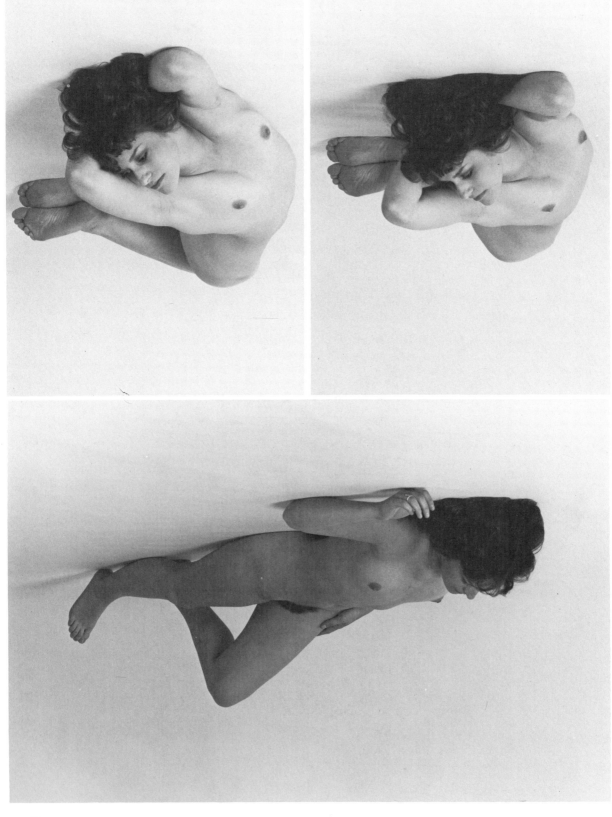

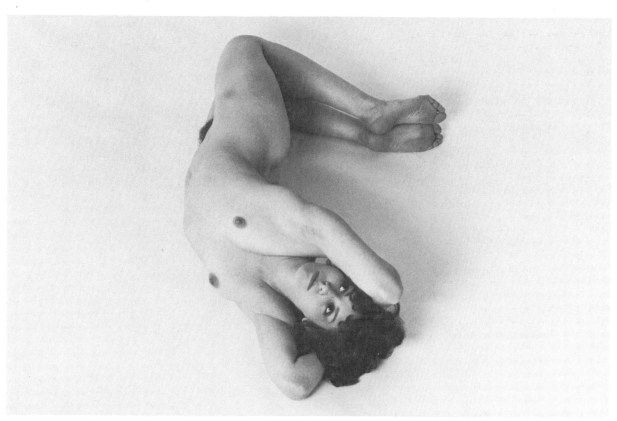

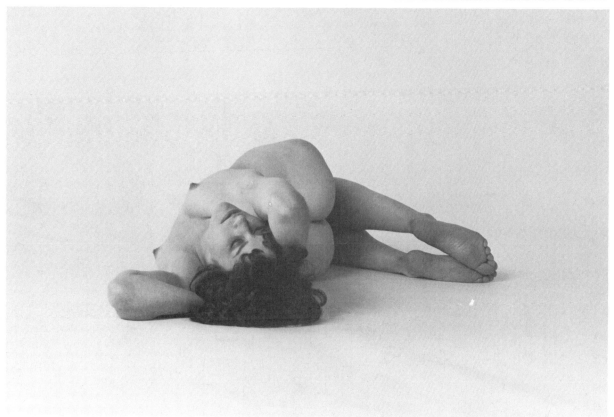

Foreshortened Views: Poses from Multiple Angles 27

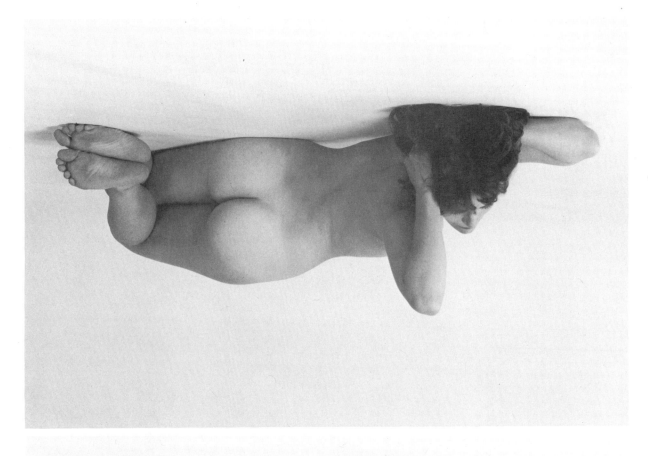

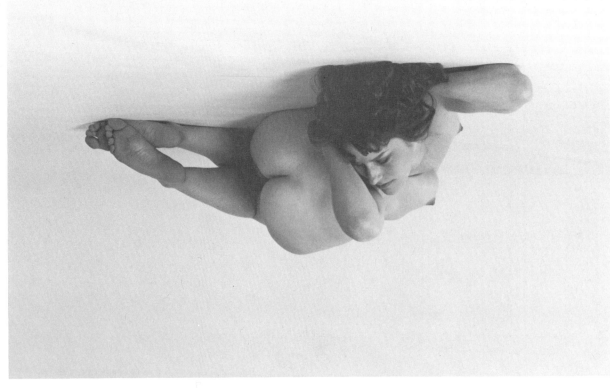

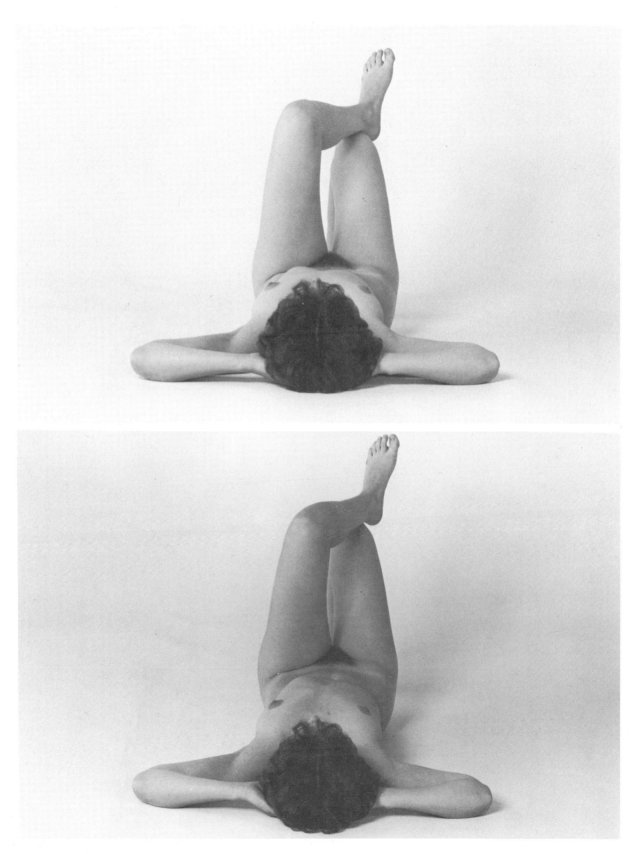

Foreshortened Views: Poses from Multiple Angles 29

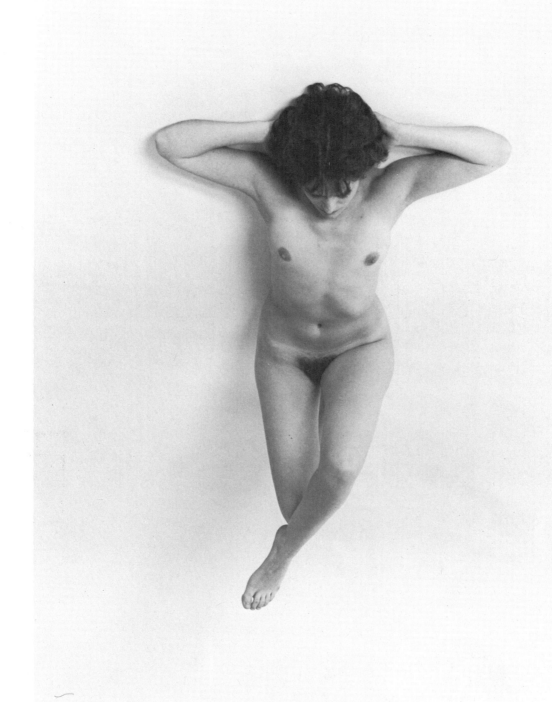

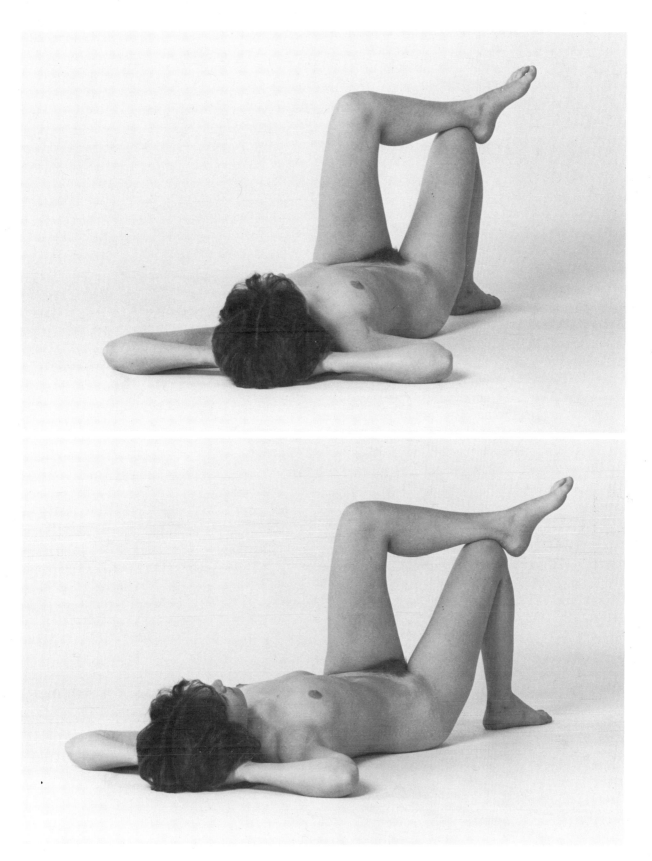

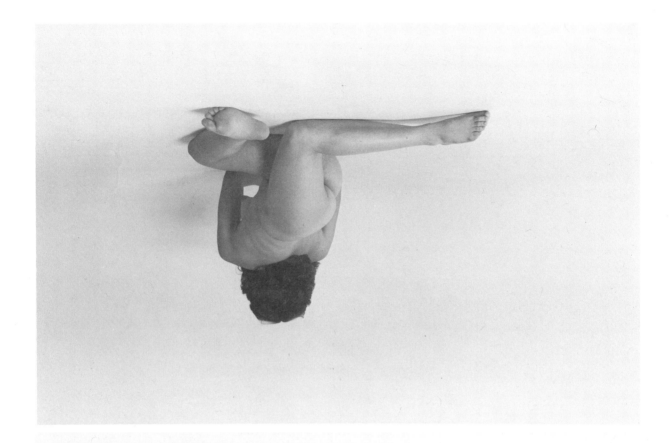

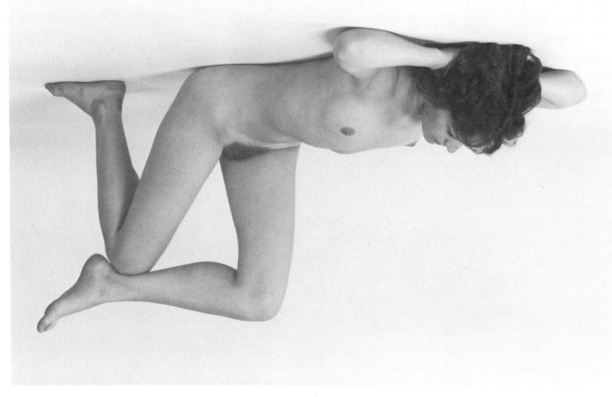

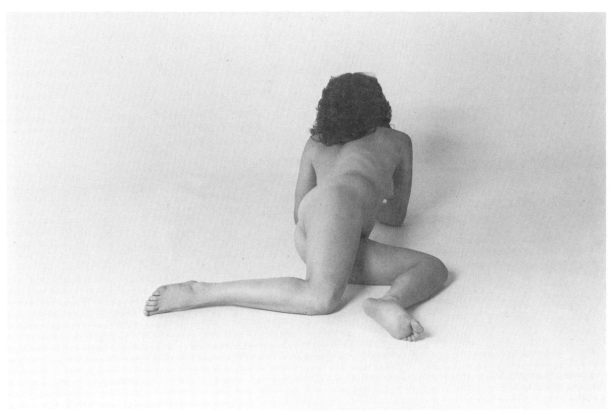

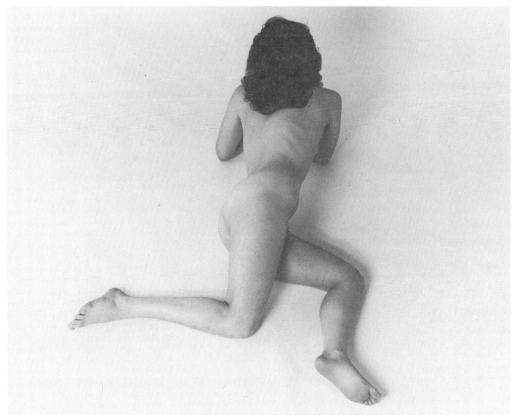

Foreshortened Views: Poses from Multiple Angles 33

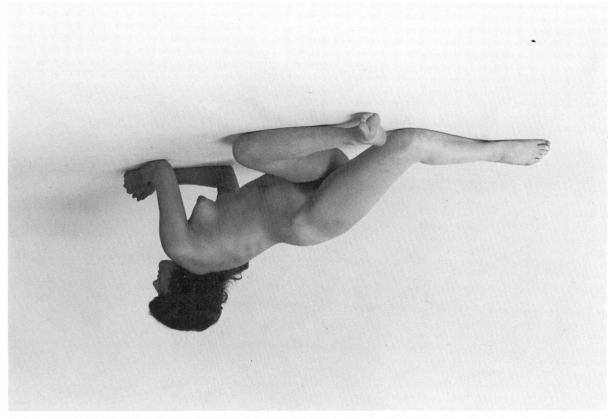

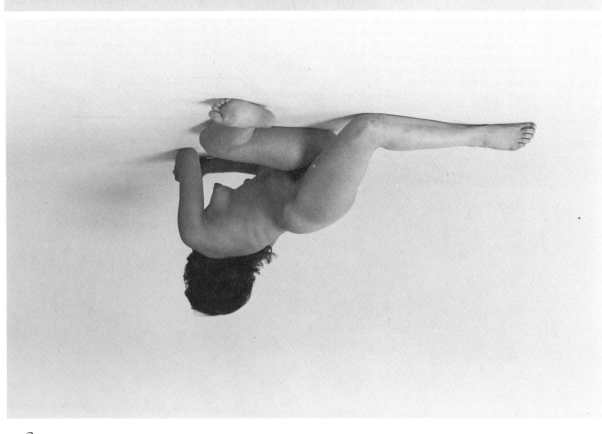

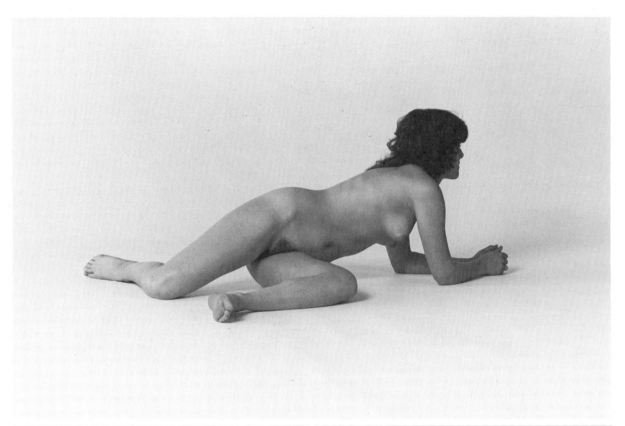

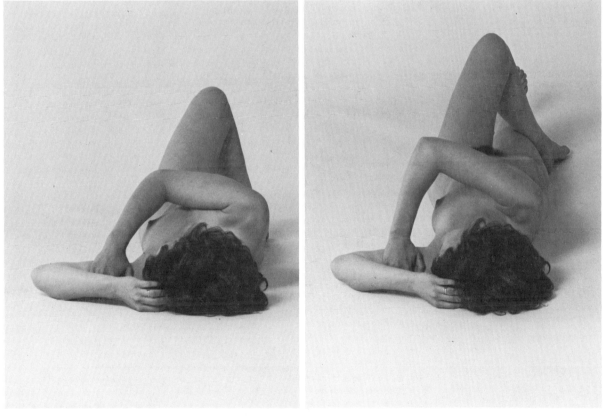

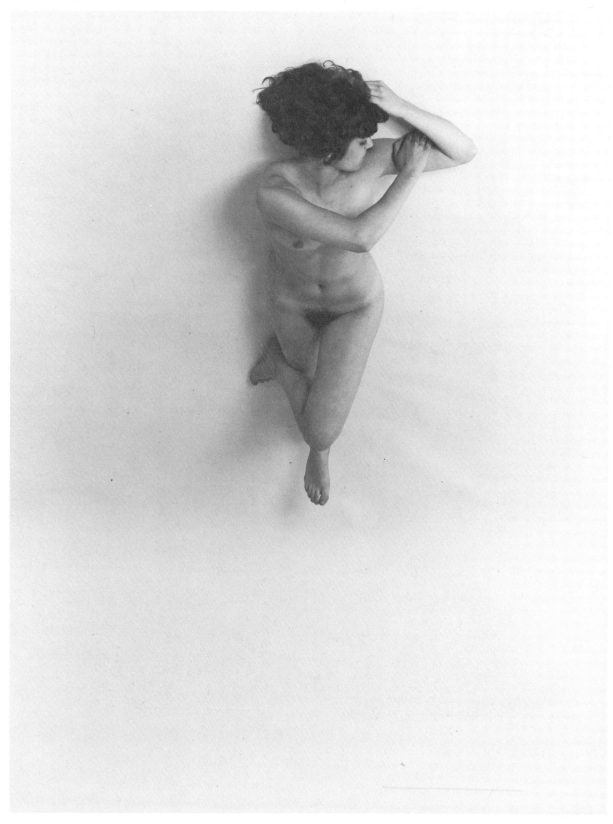

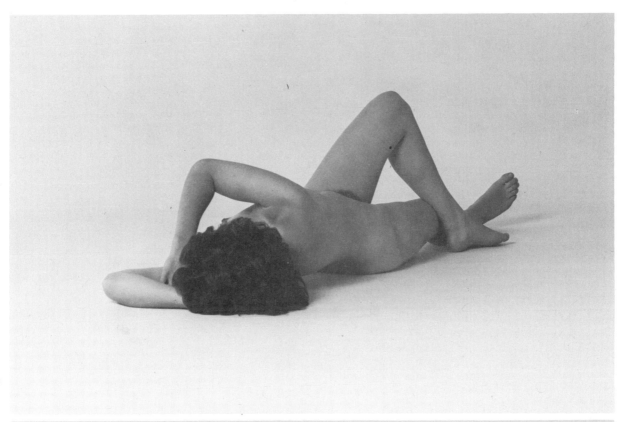

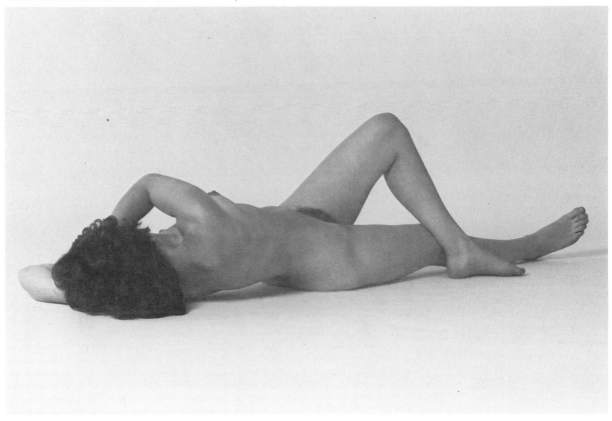

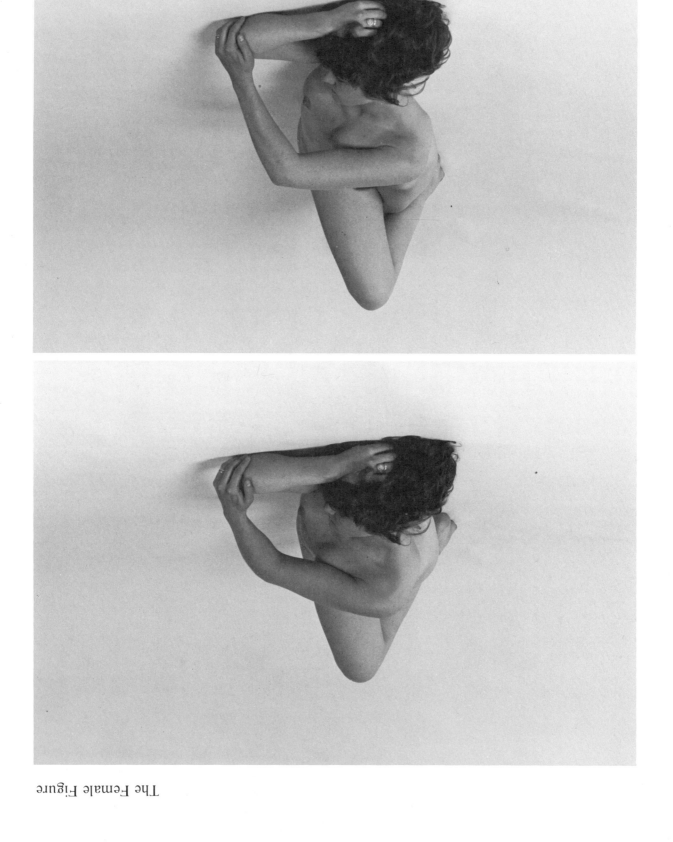

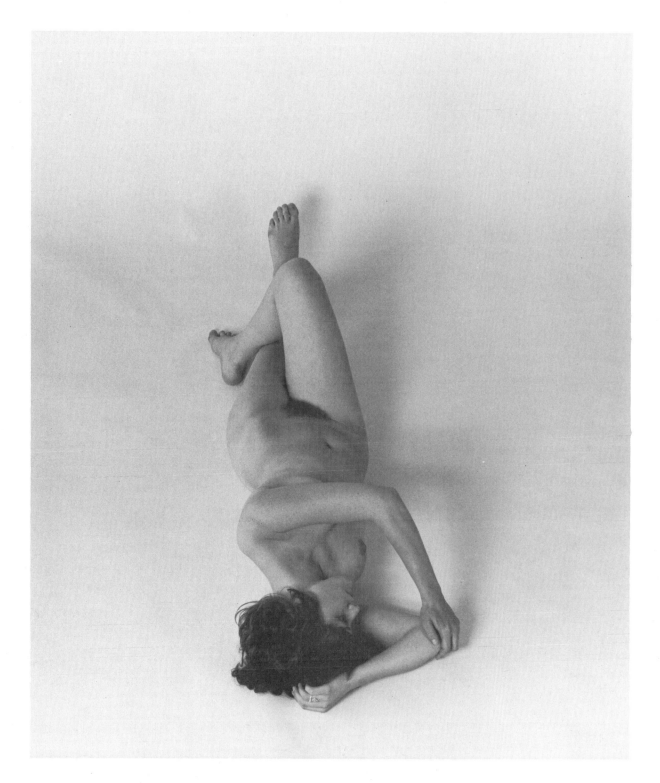

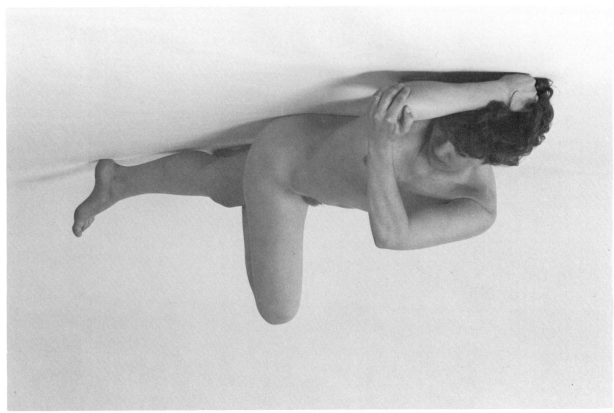

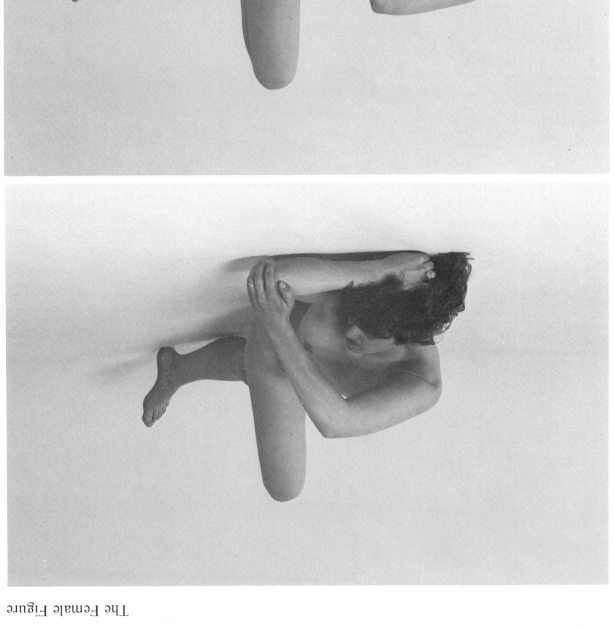

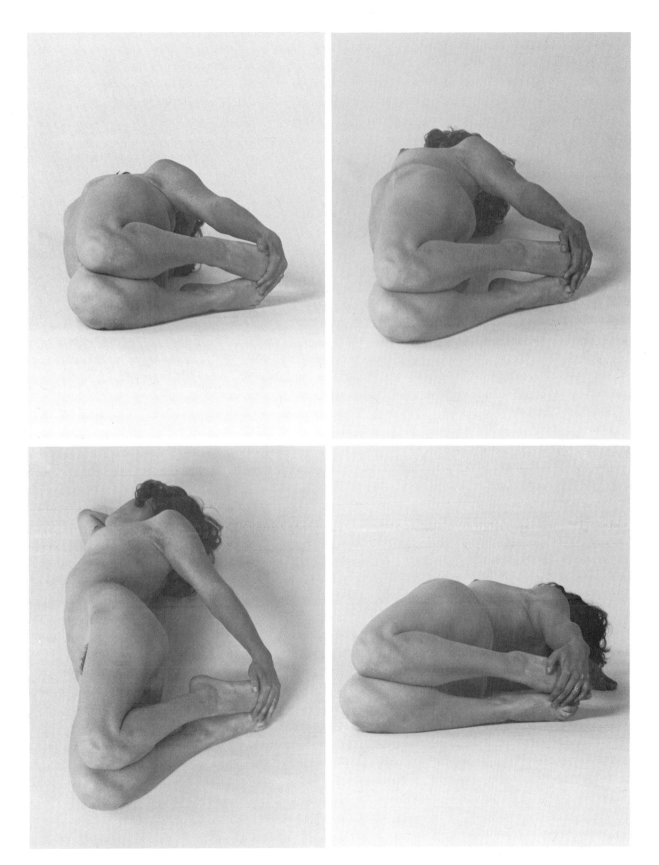

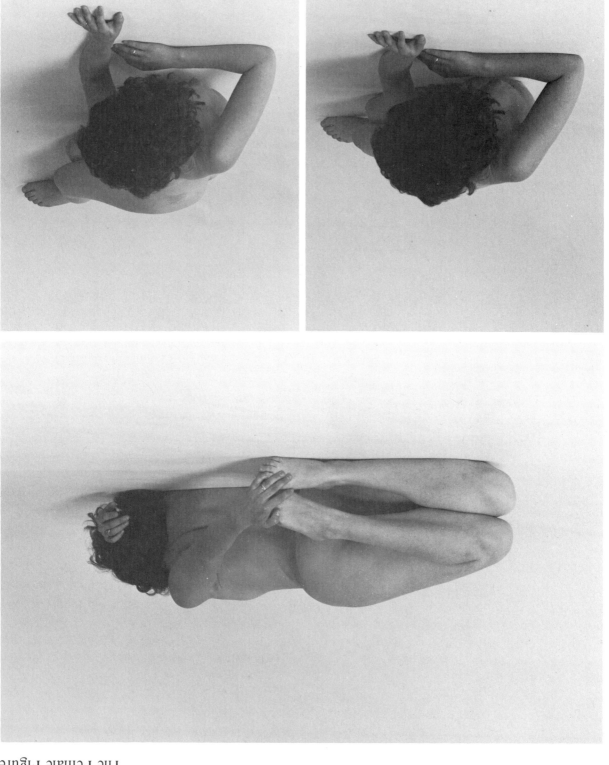

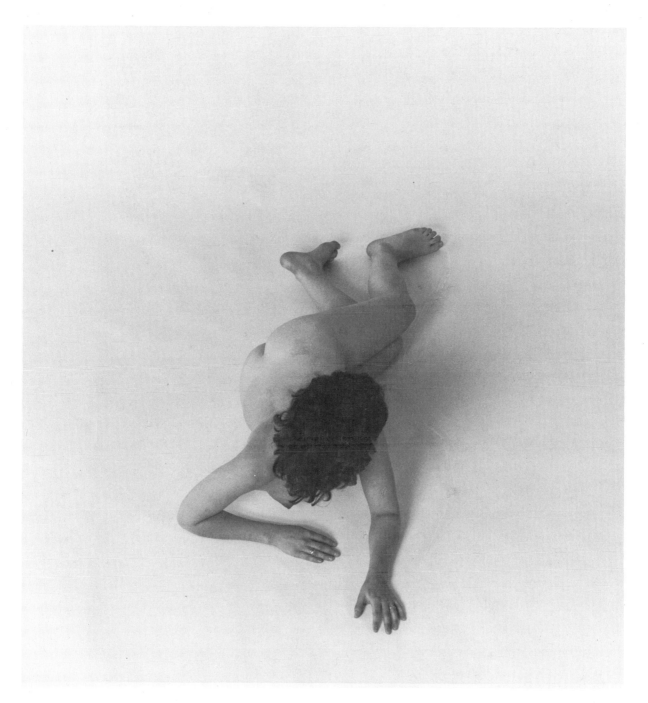

Foreshortened Views: Poses from Multiple Angles 43

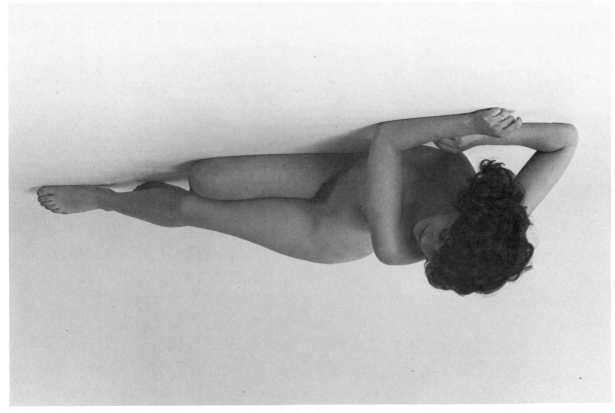

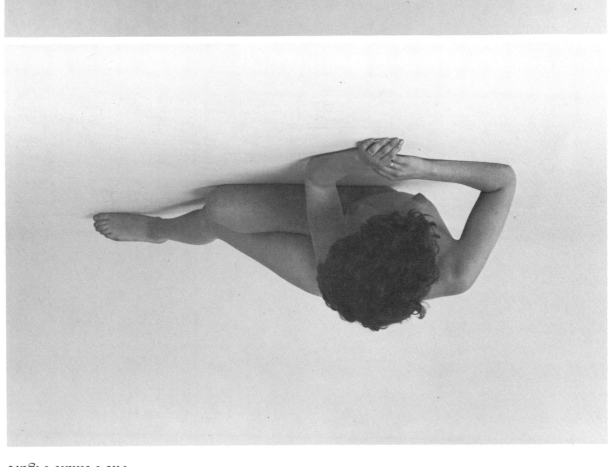

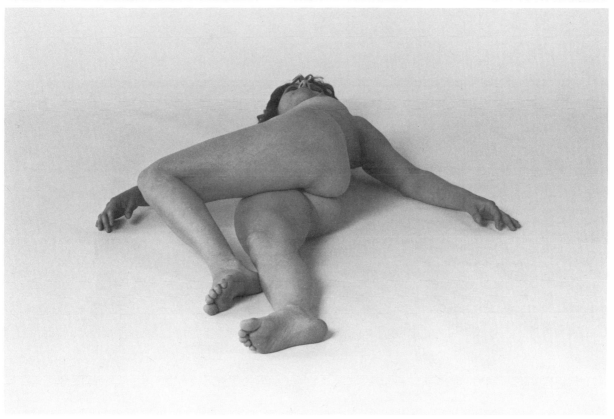

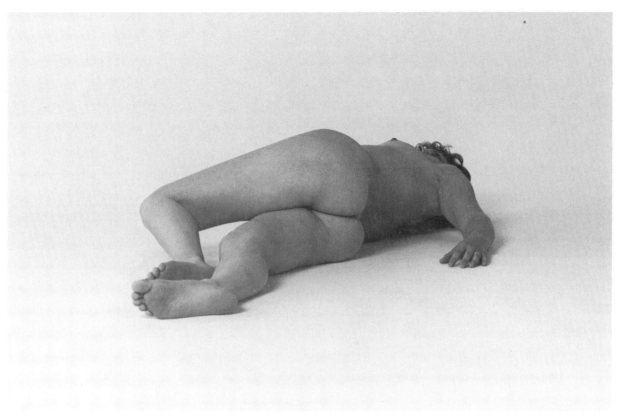

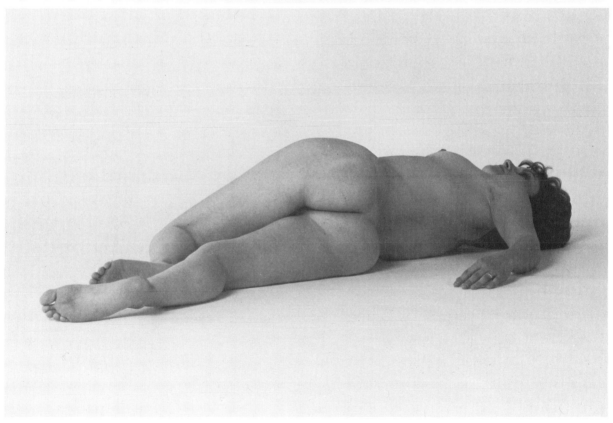

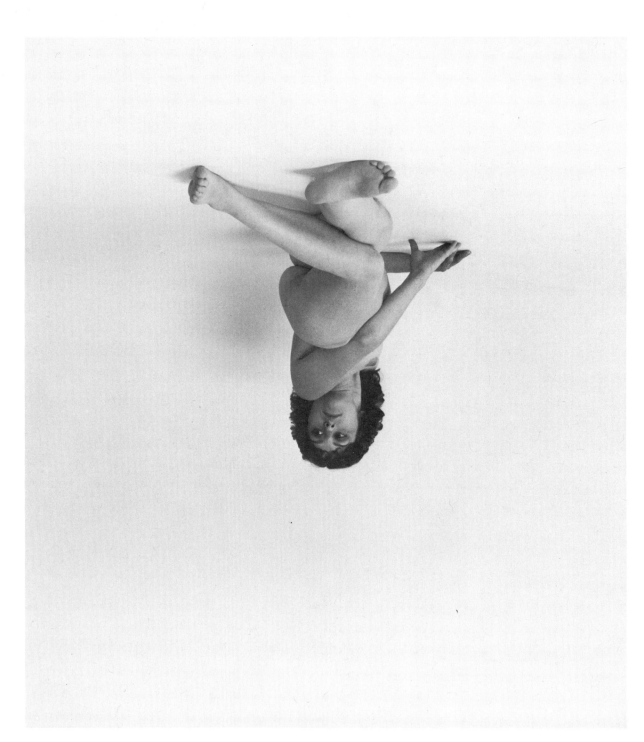

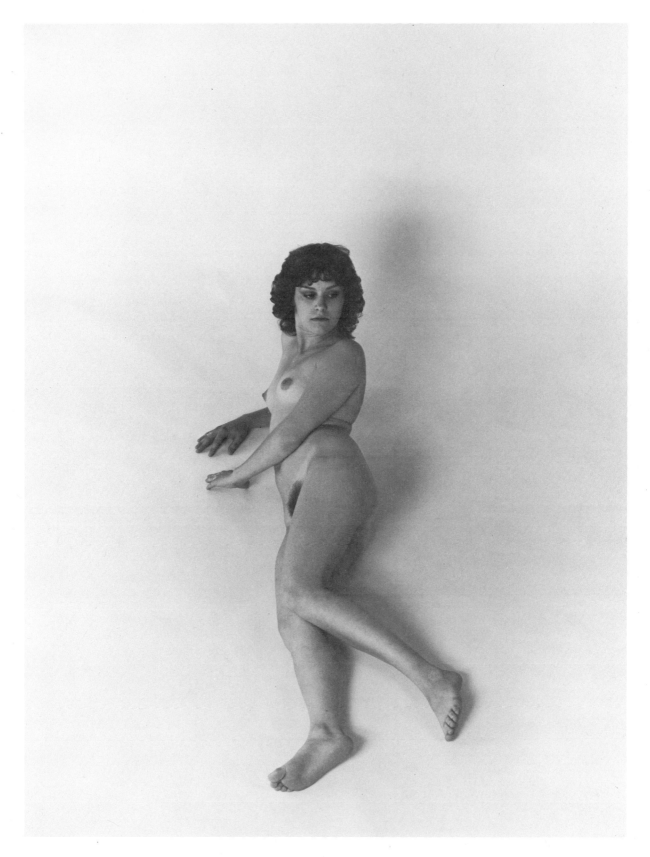

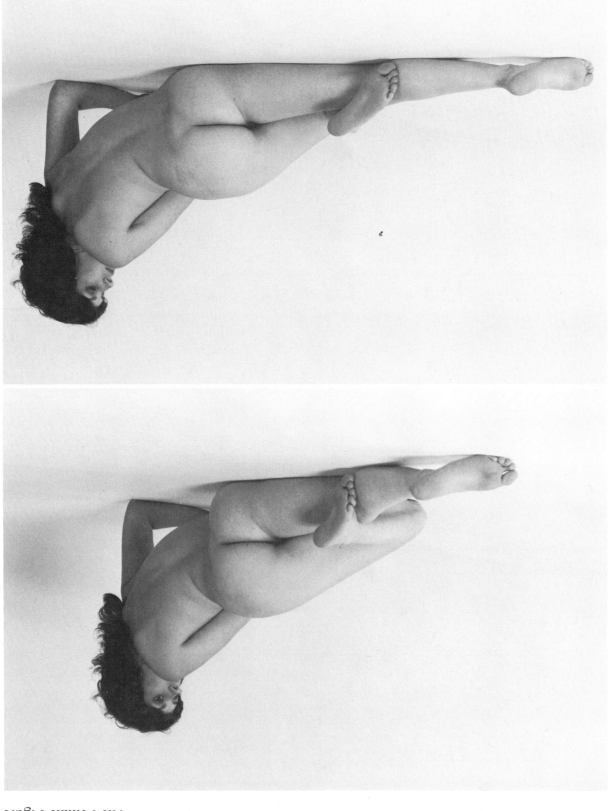

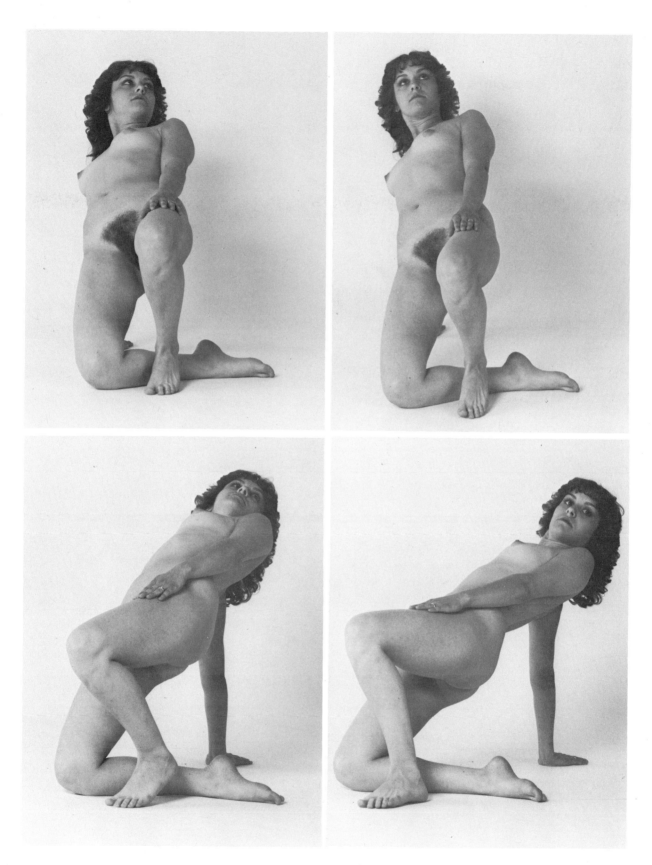

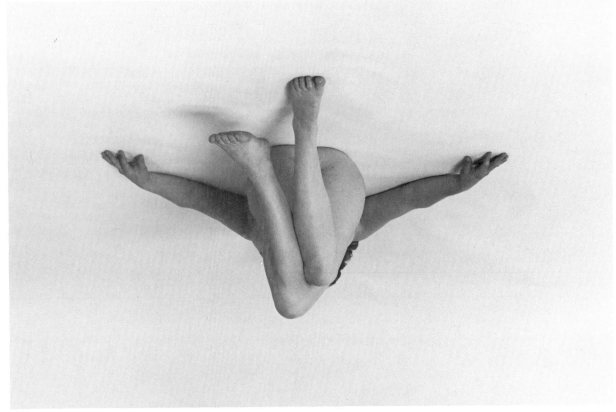

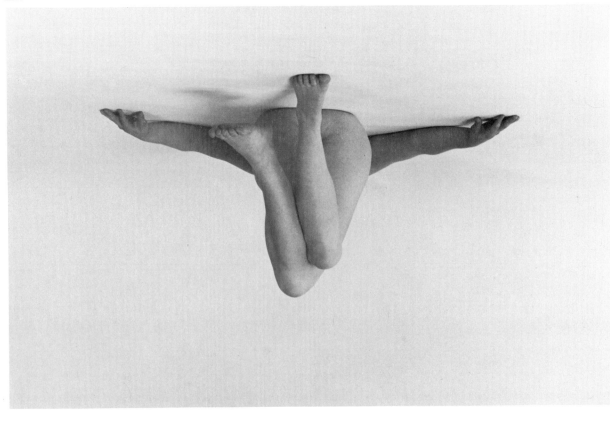

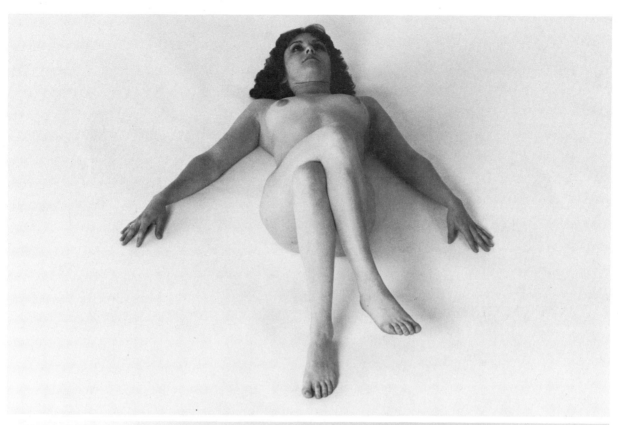

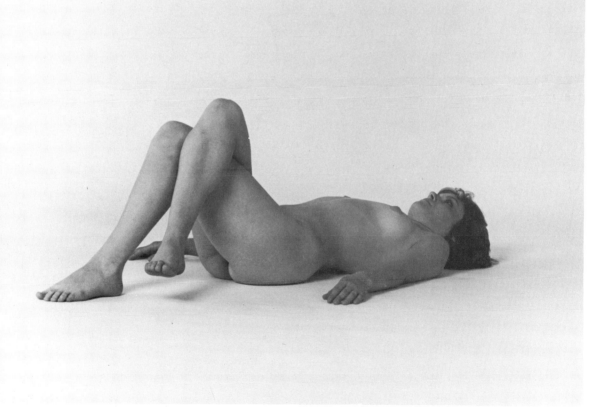

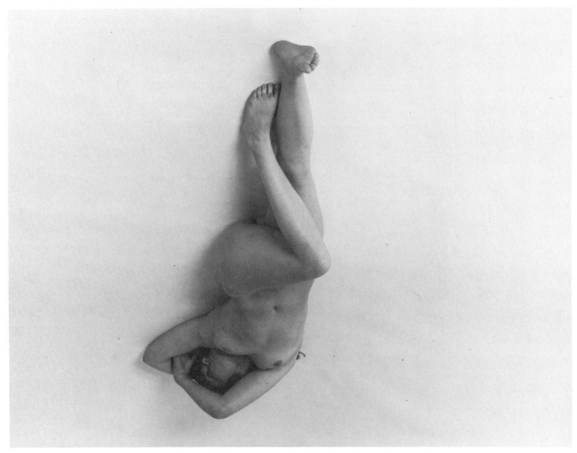

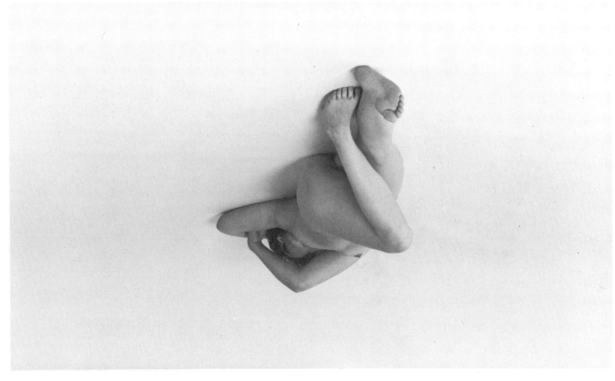

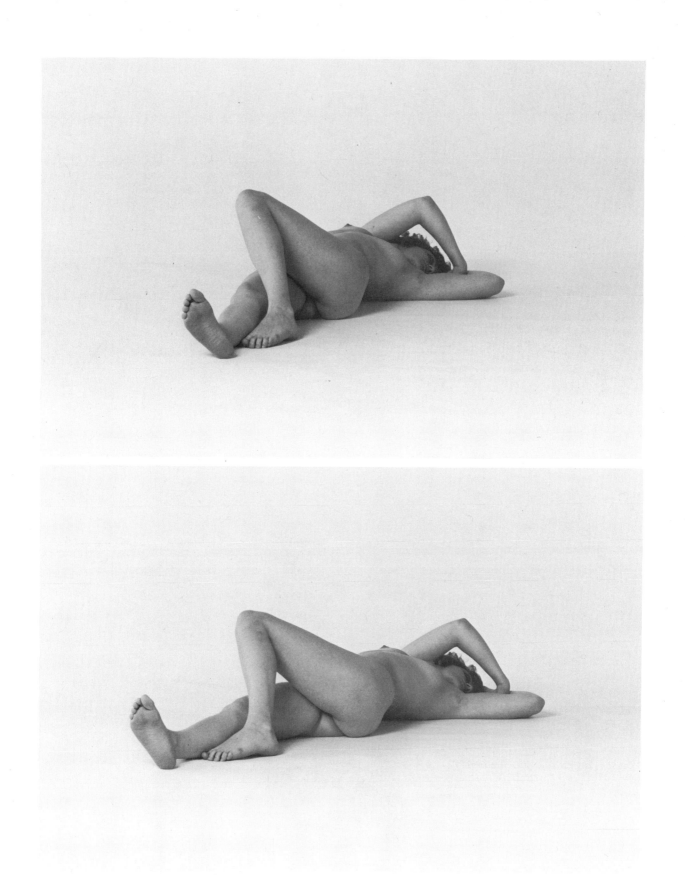

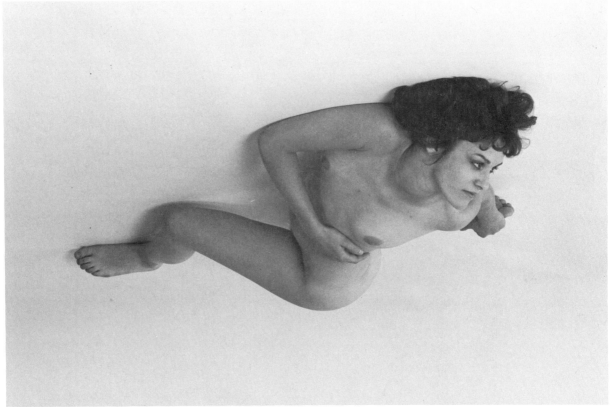

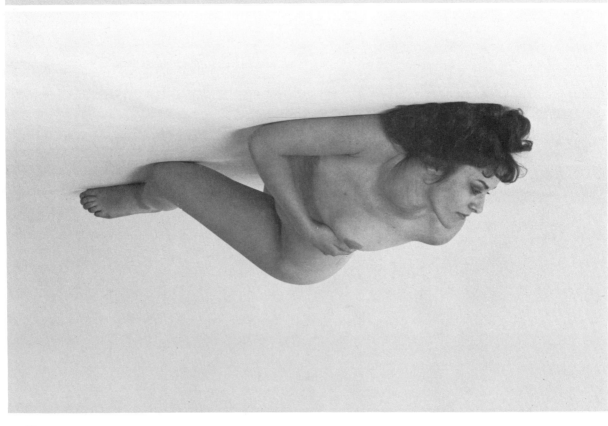

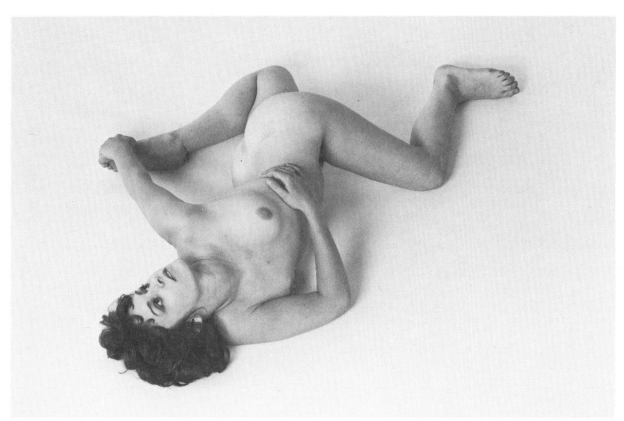

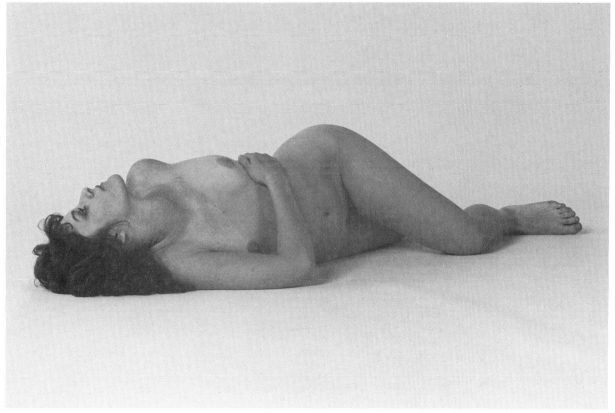

Foreshortened Views: Poses from Multiple Angles 57

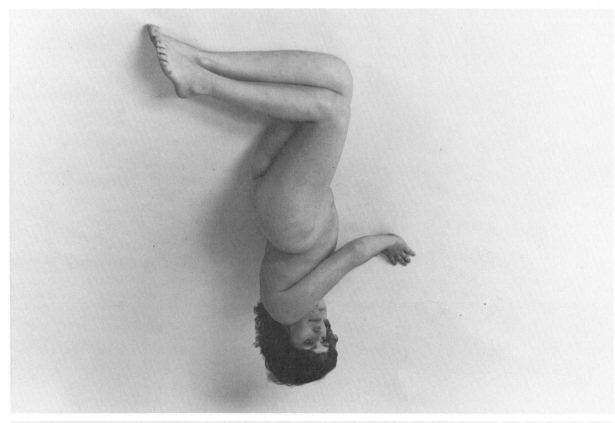

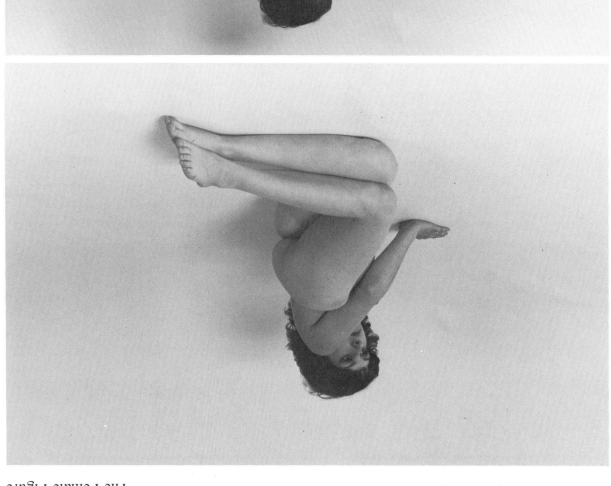

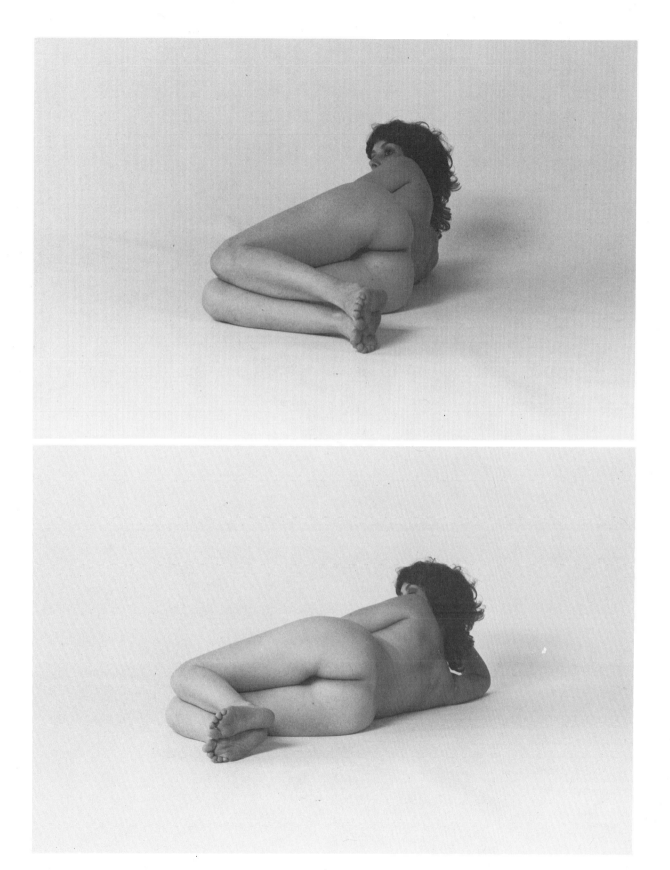

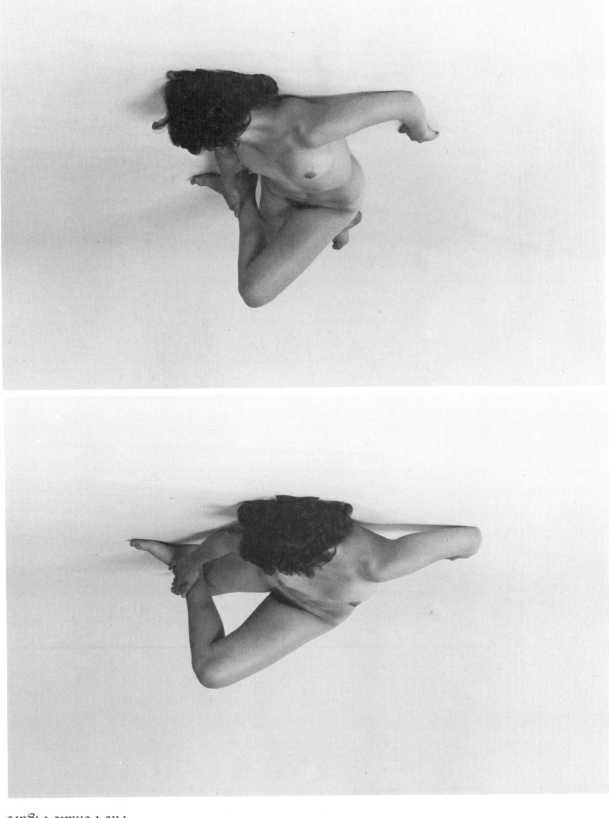

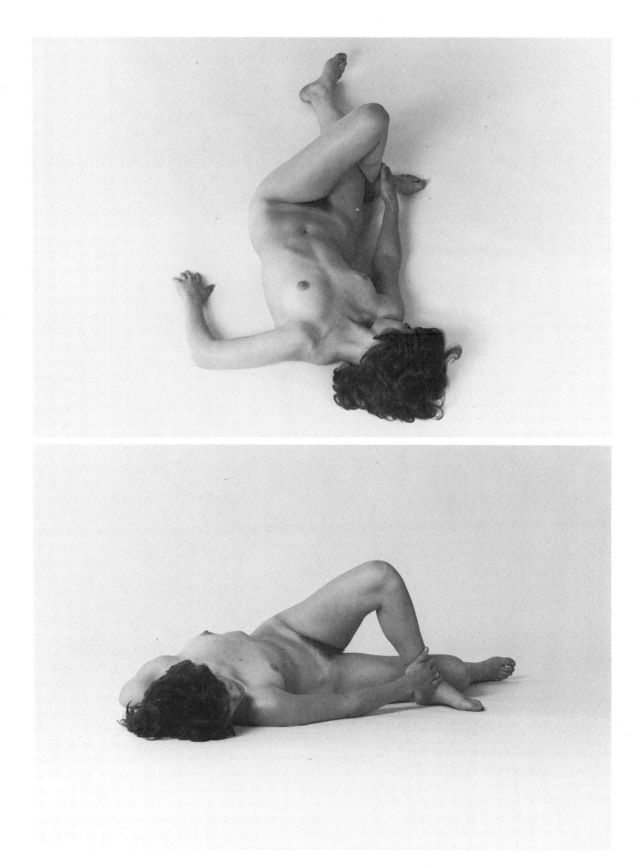

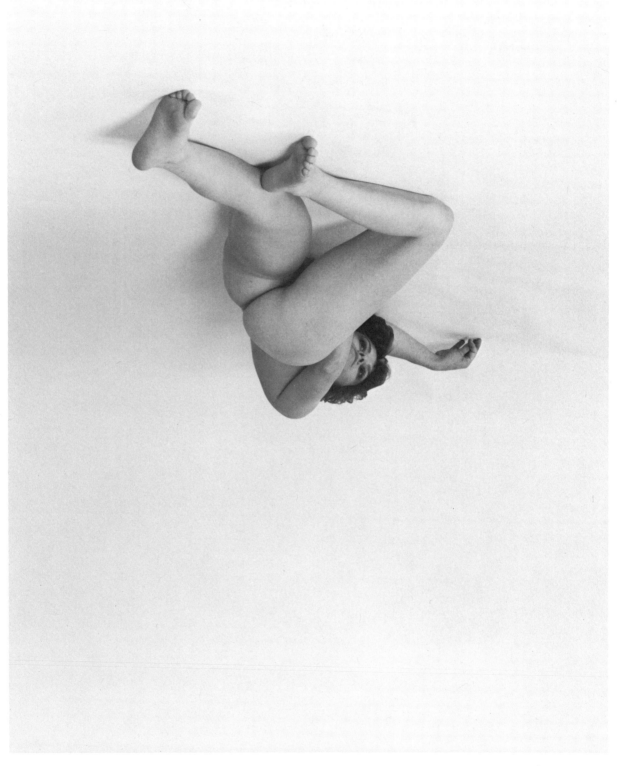

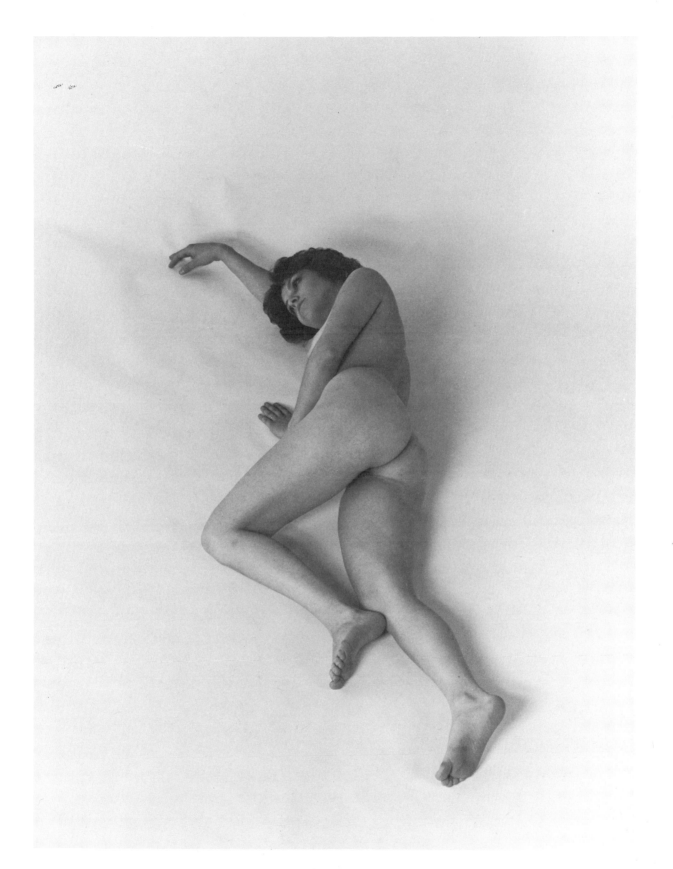

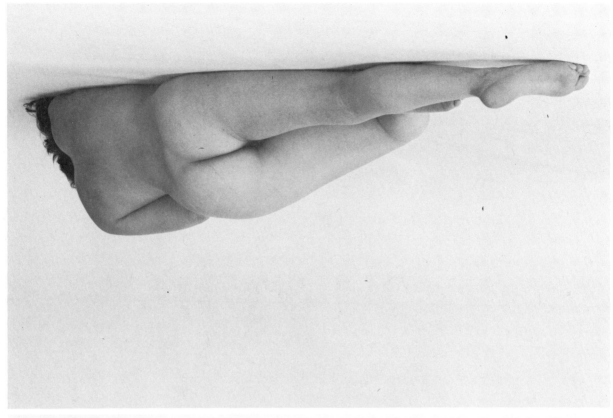

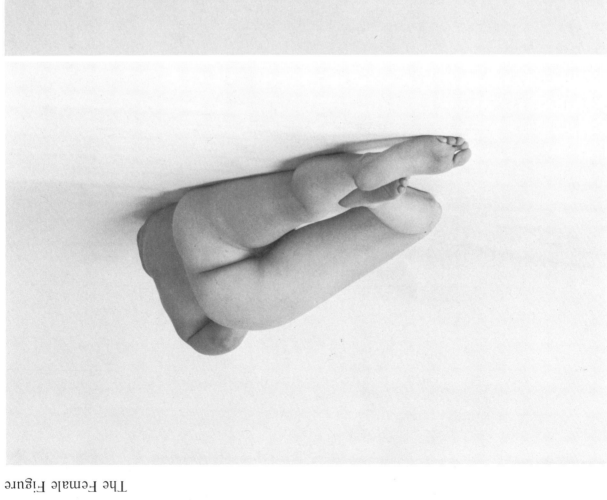

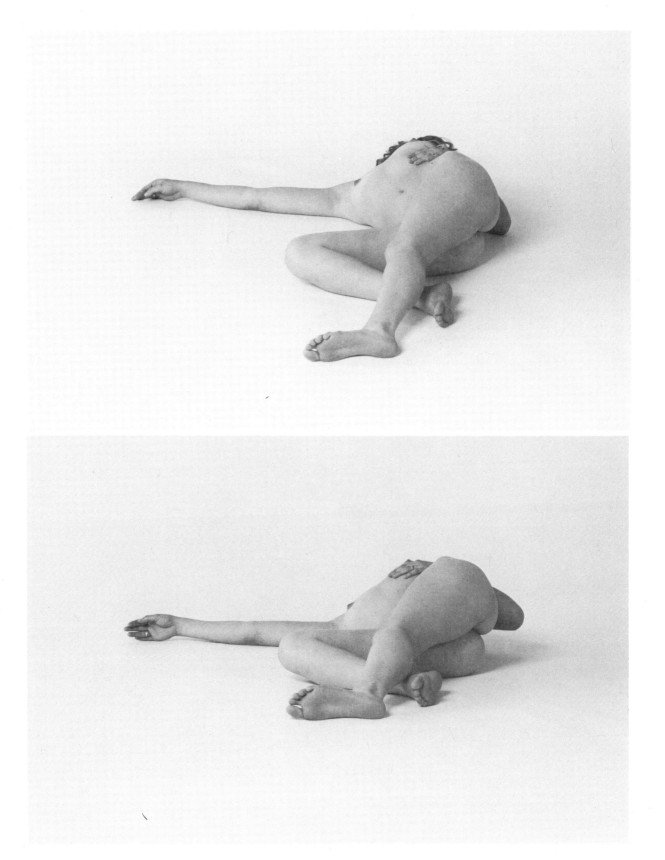

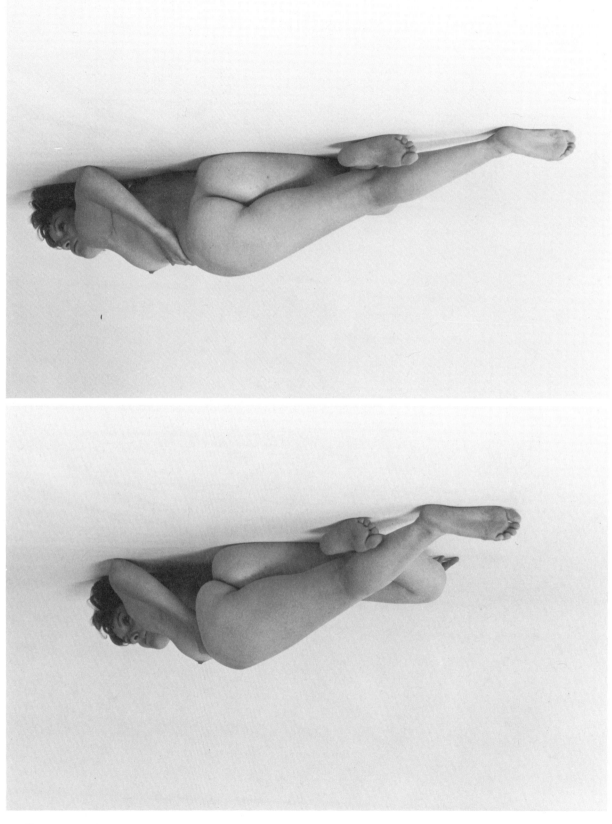

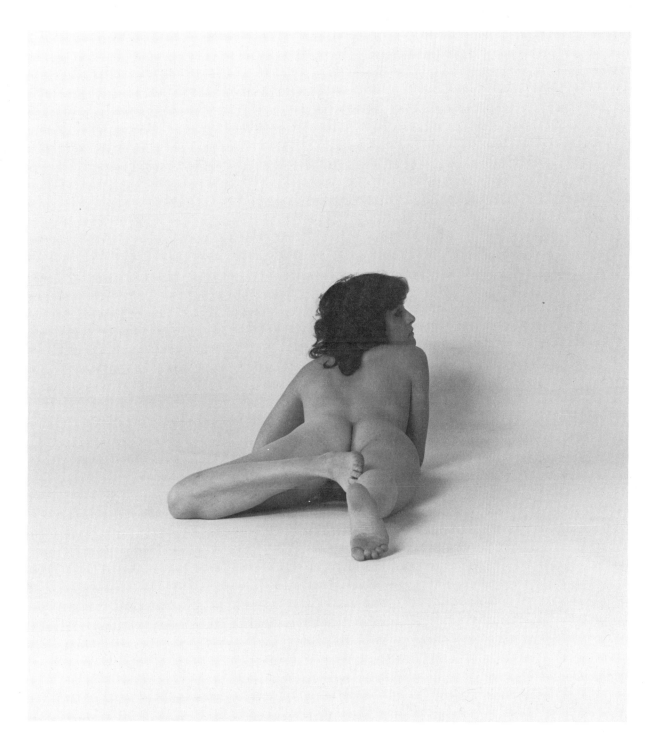

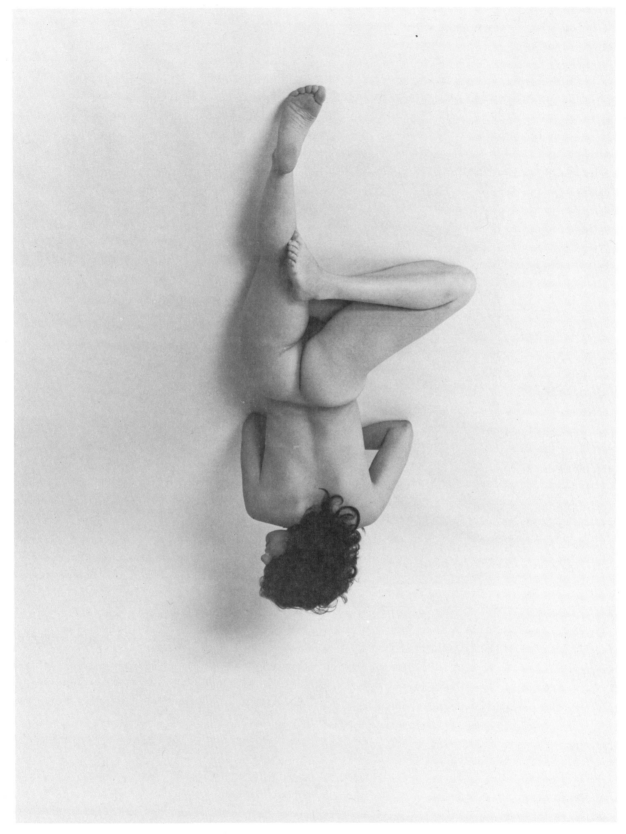

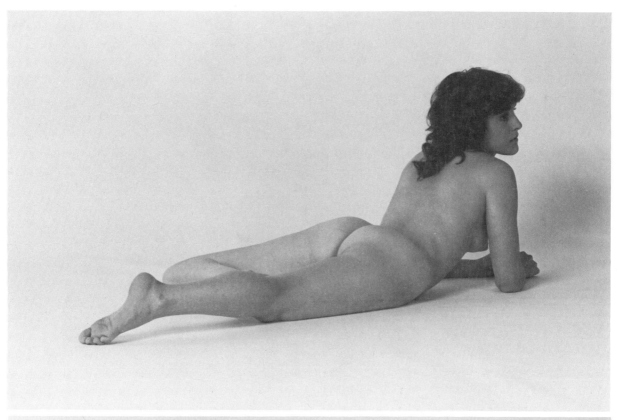

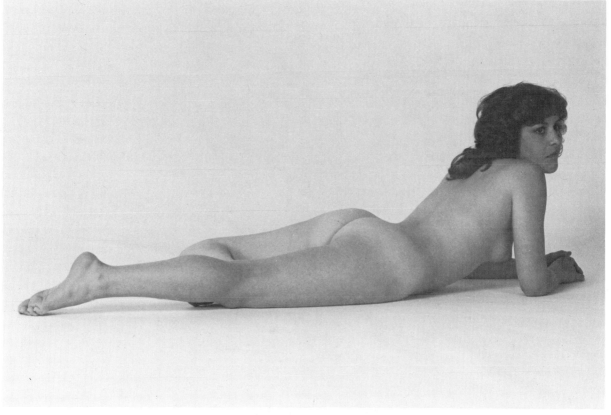

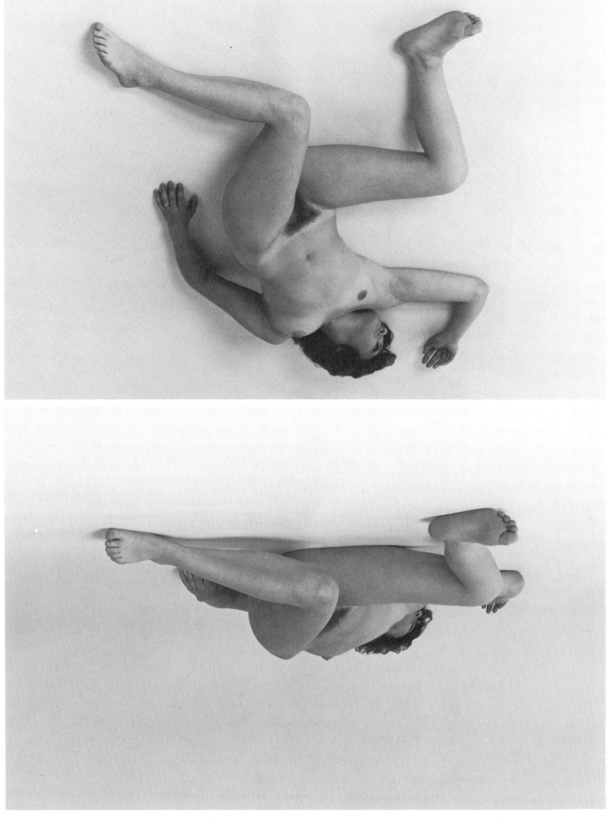

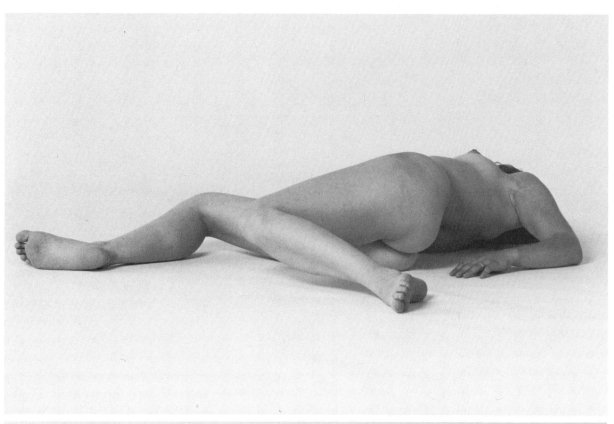

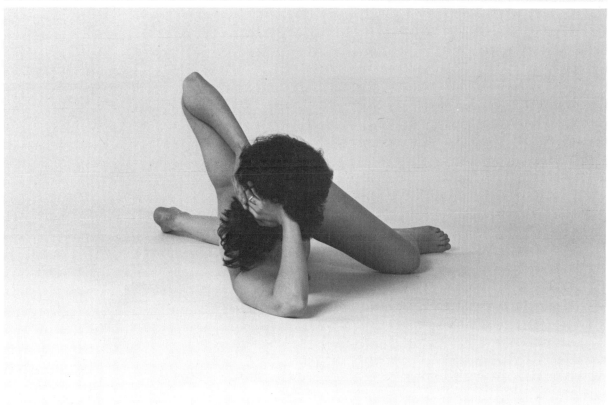

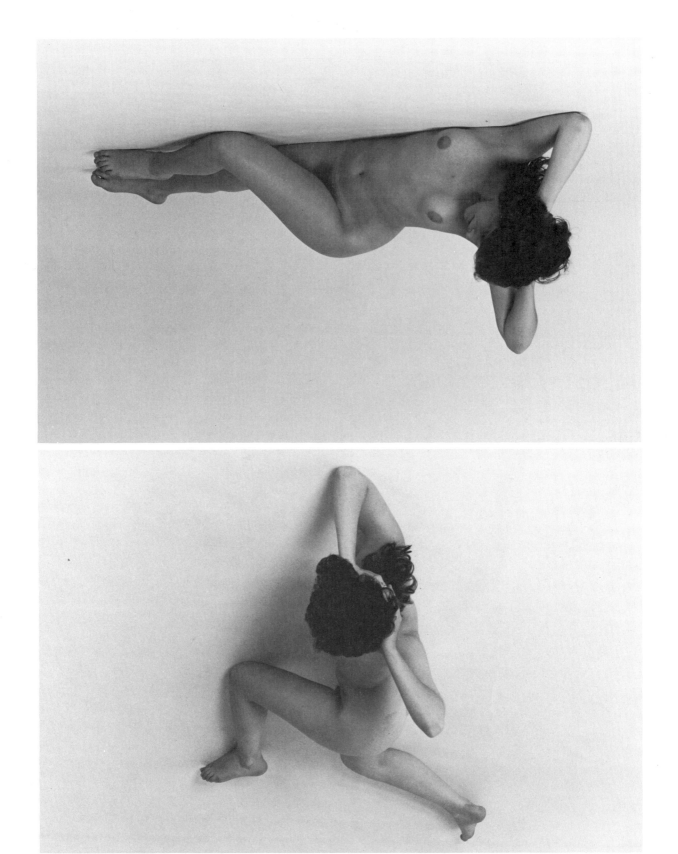

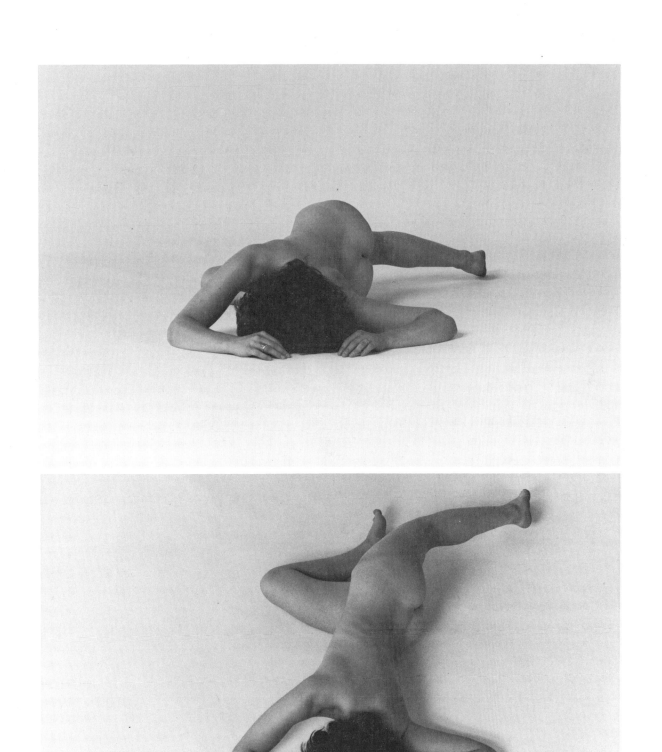

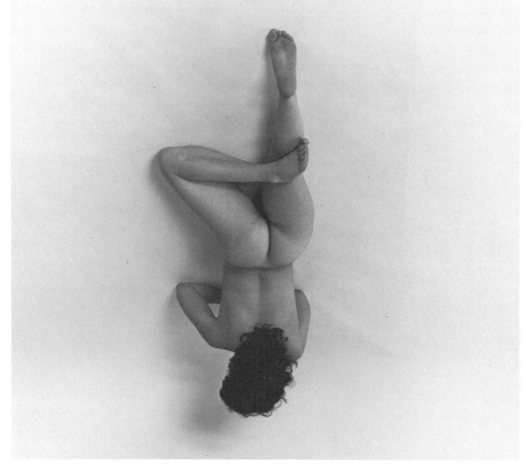

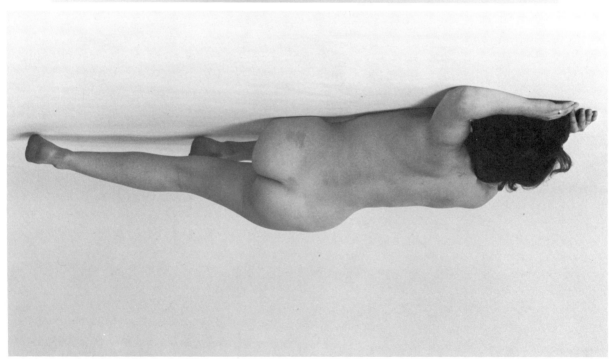

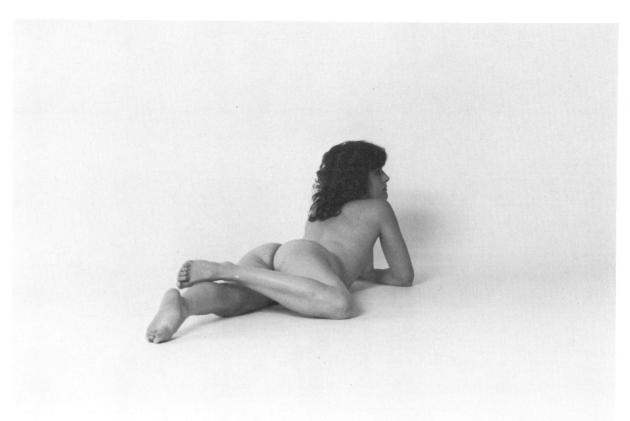

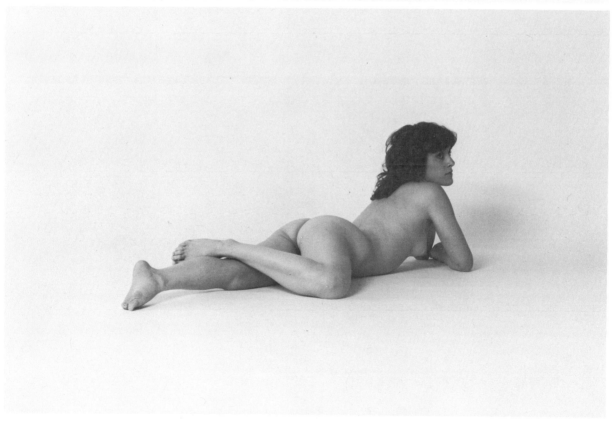

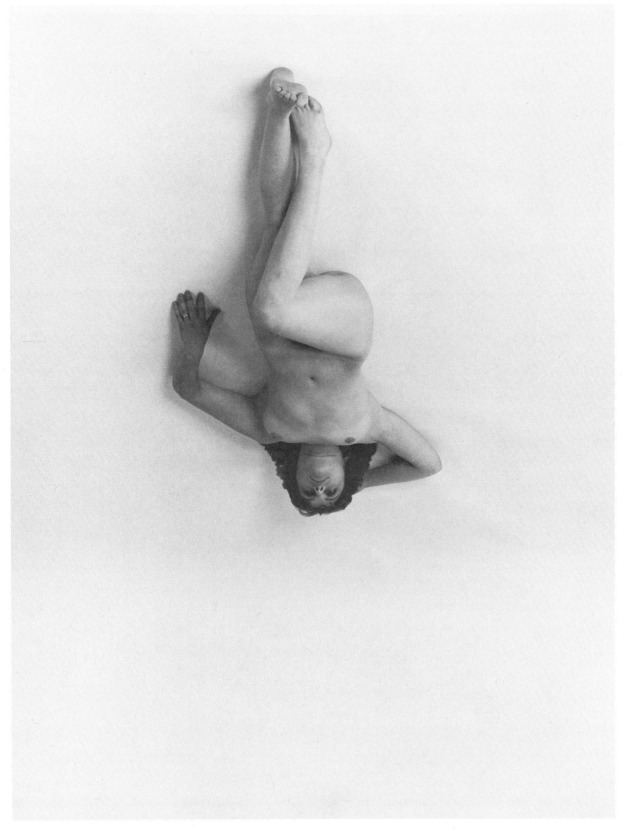

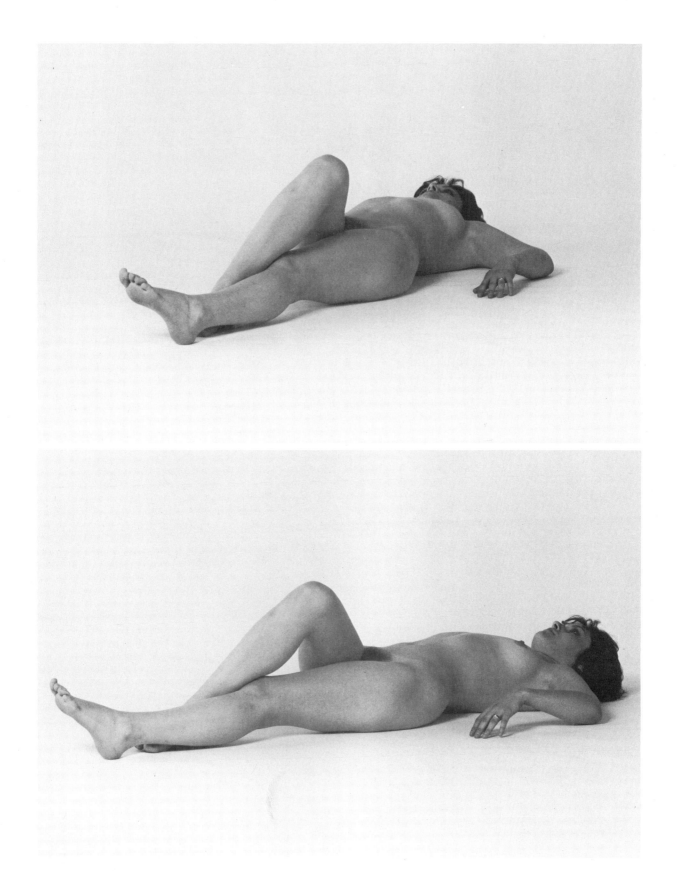

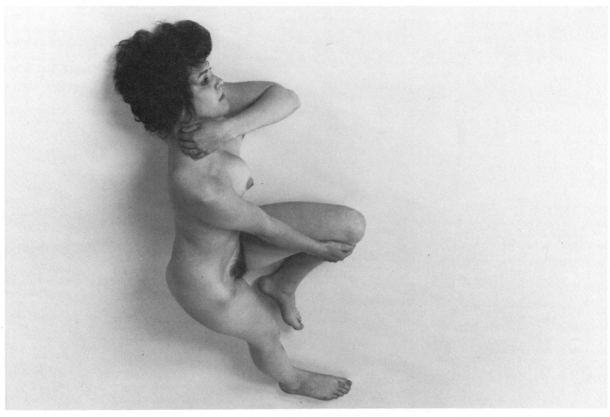

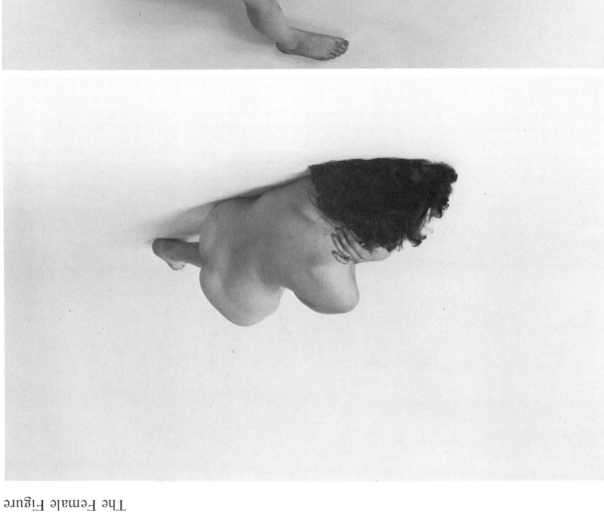

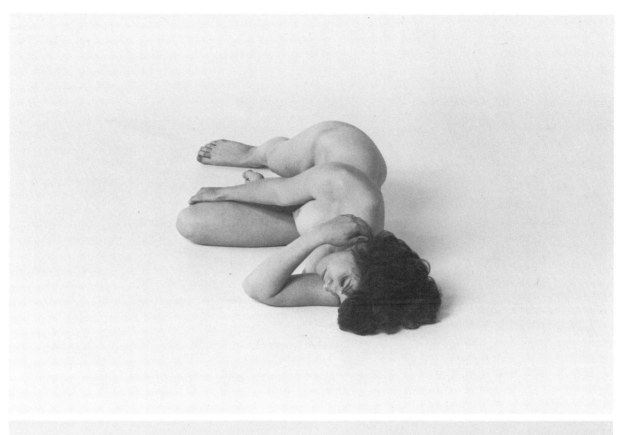

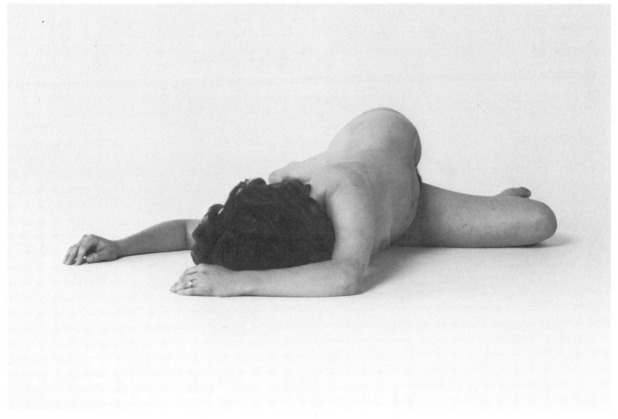

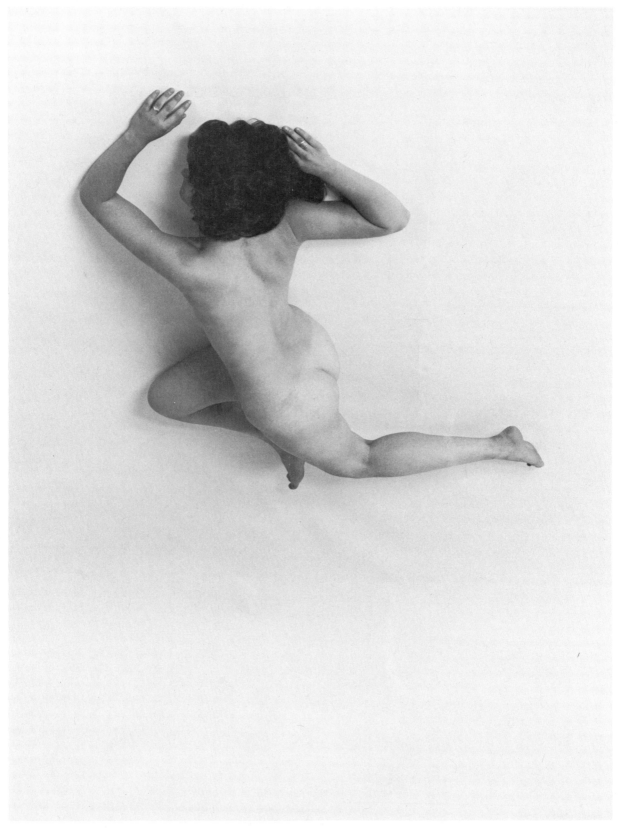

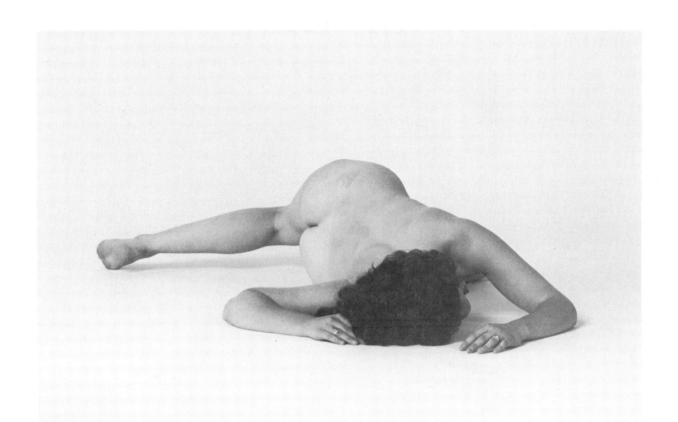

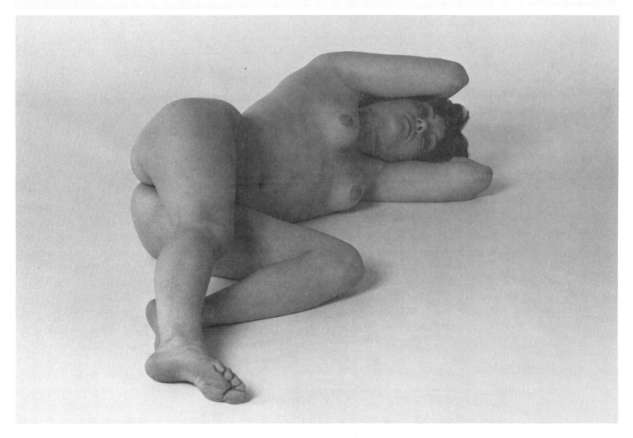

Foreshortened Views: Poses from Multiple Angles 81

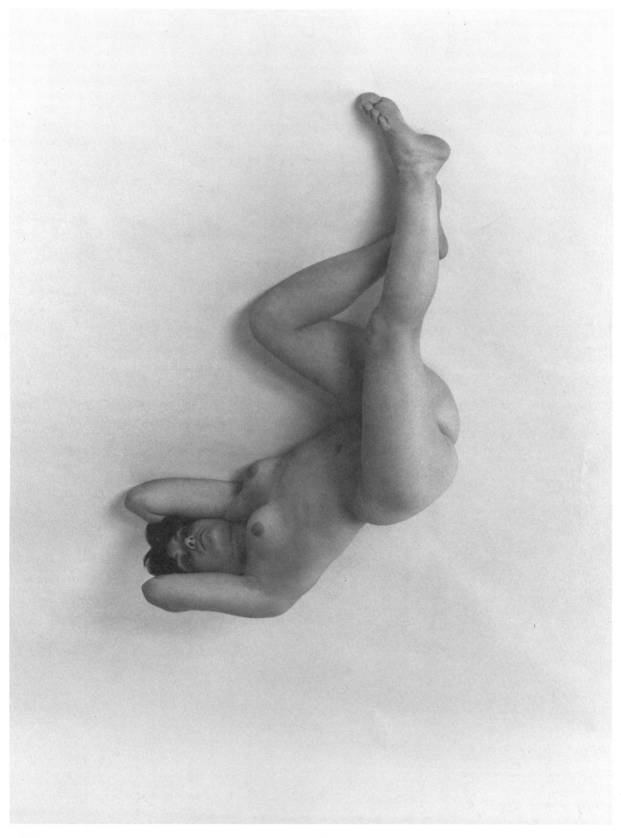

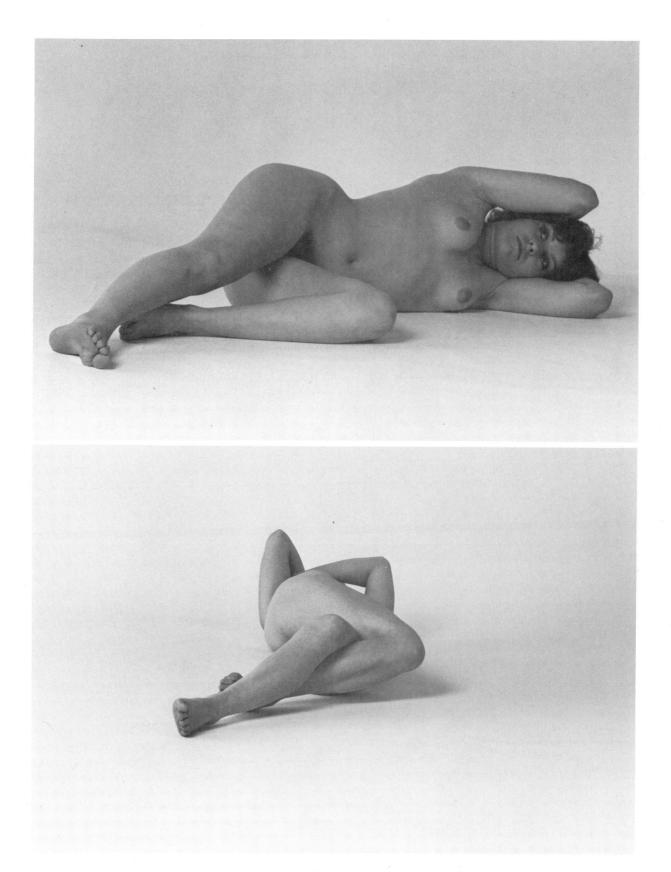

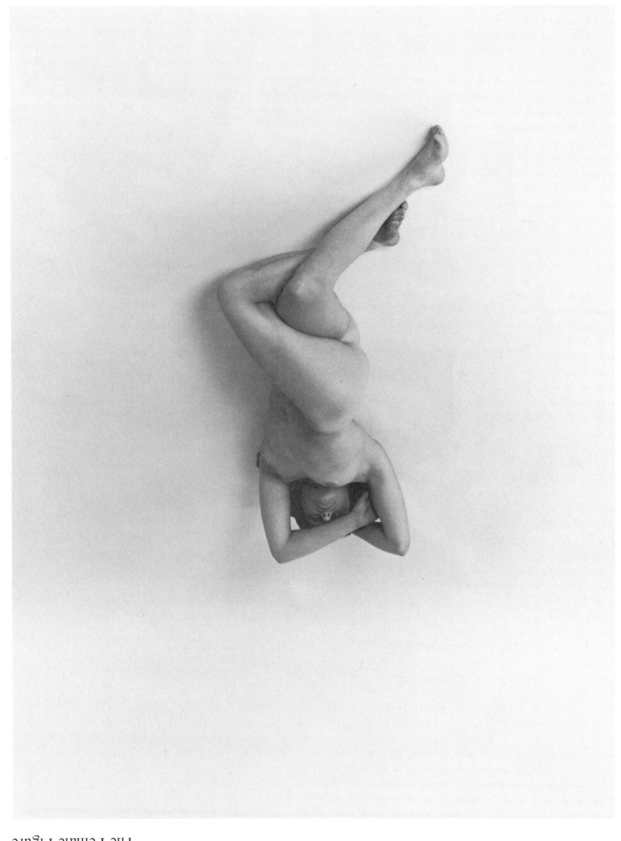

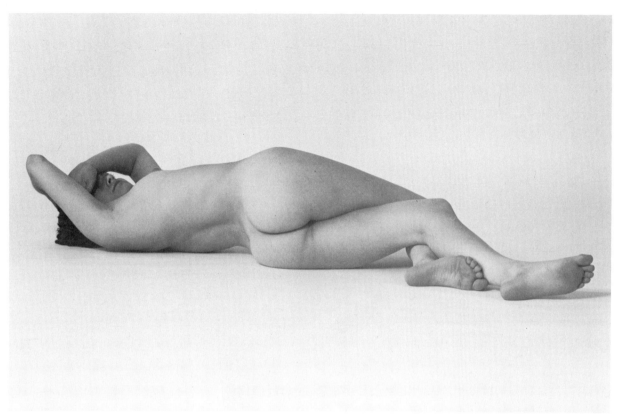

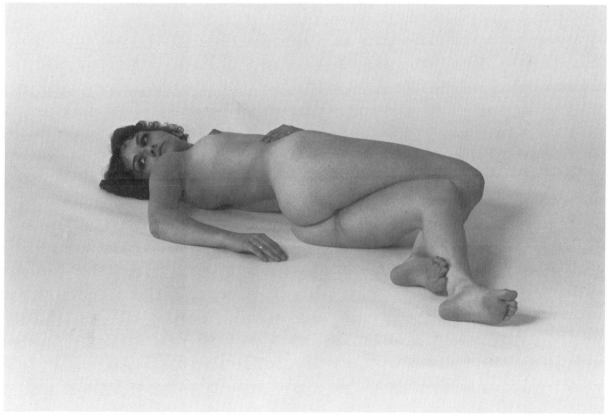

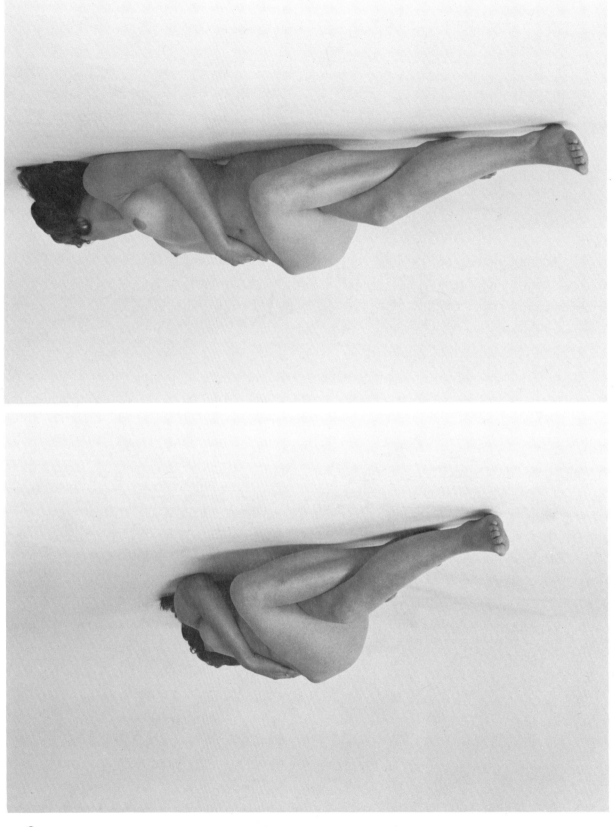

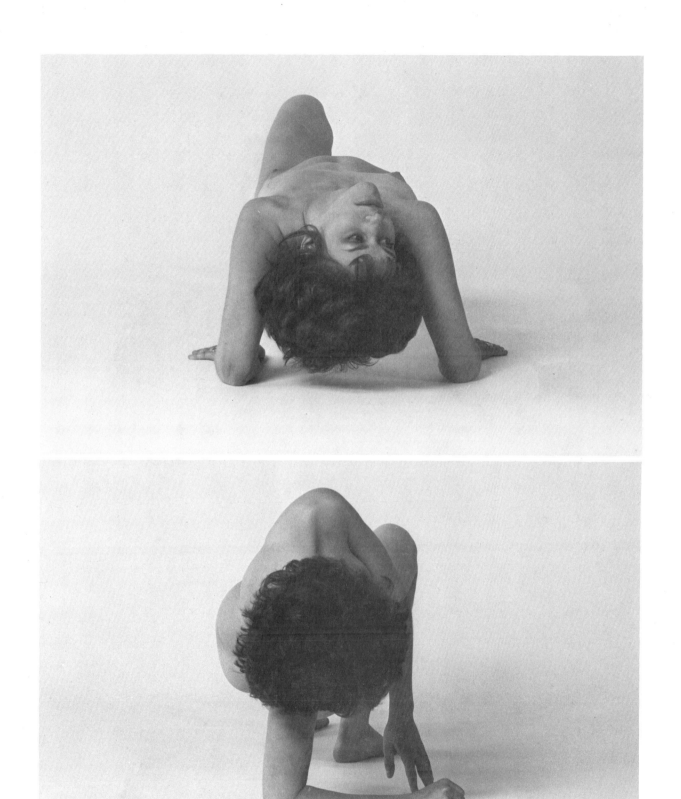

Foreshortened Views: Poses with Marked Foreshortening 87

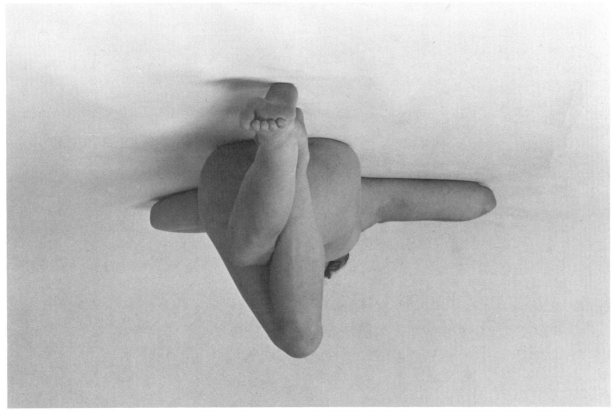

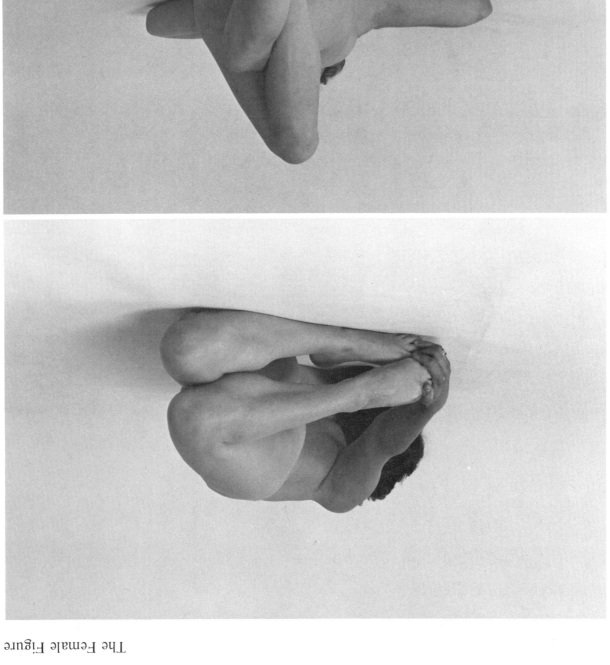

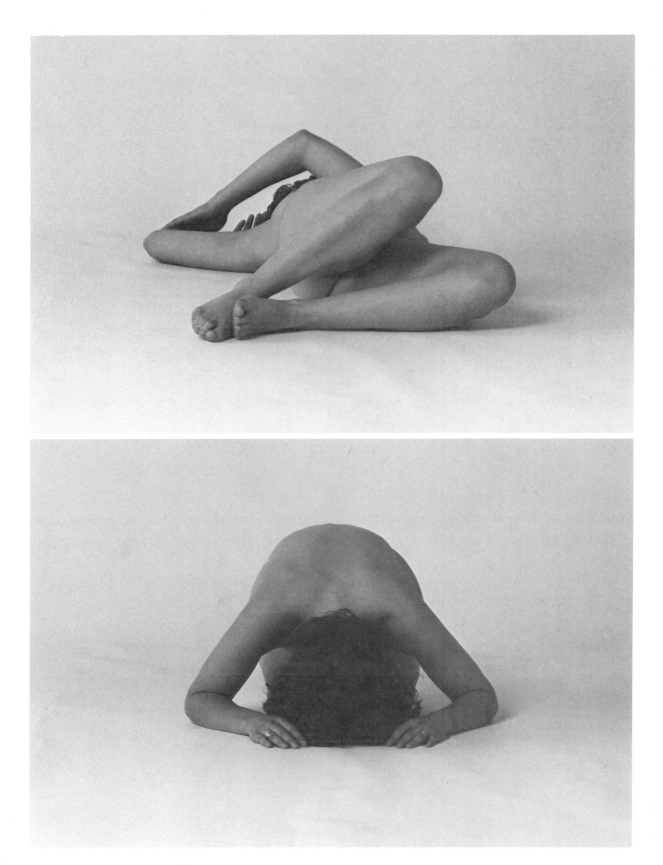

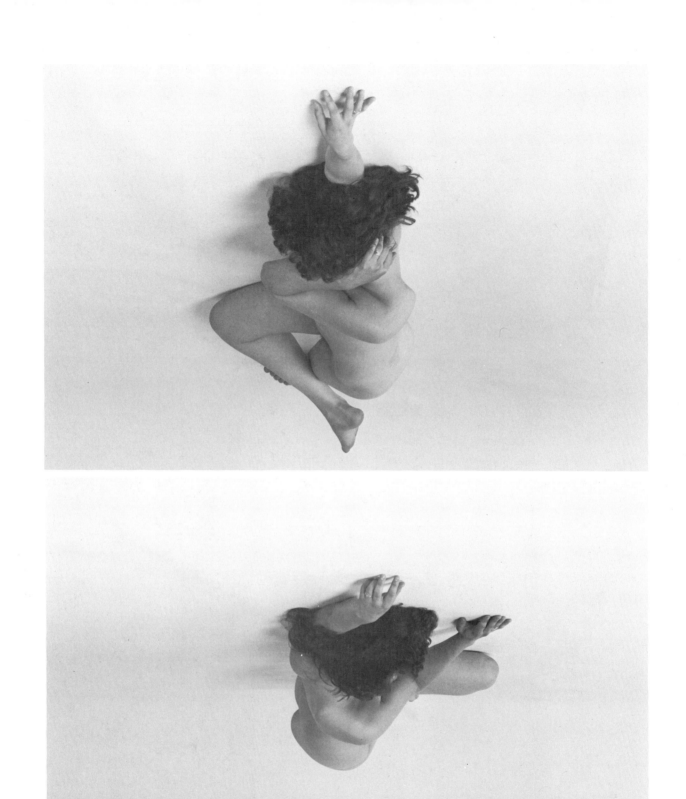

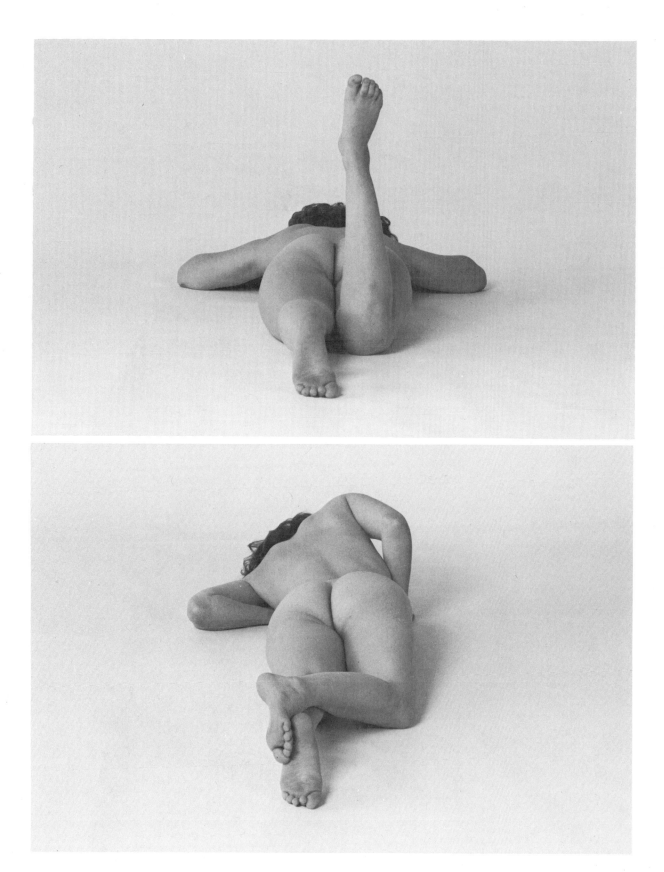

Foreshortened Views: Poses with Marked Foreshortening 91

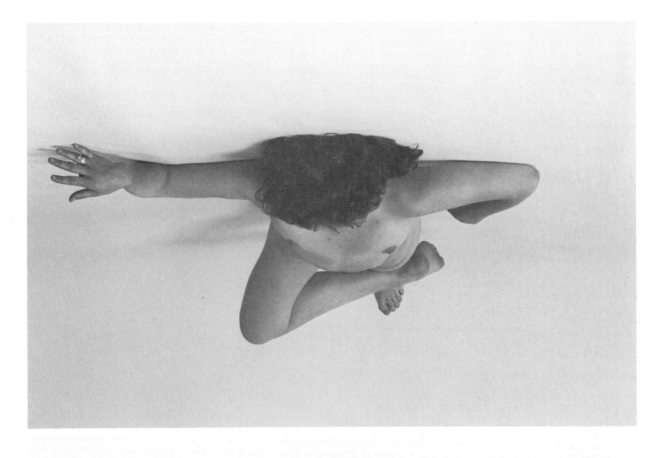

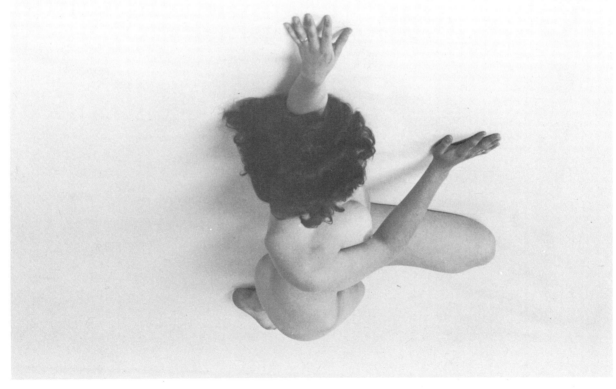

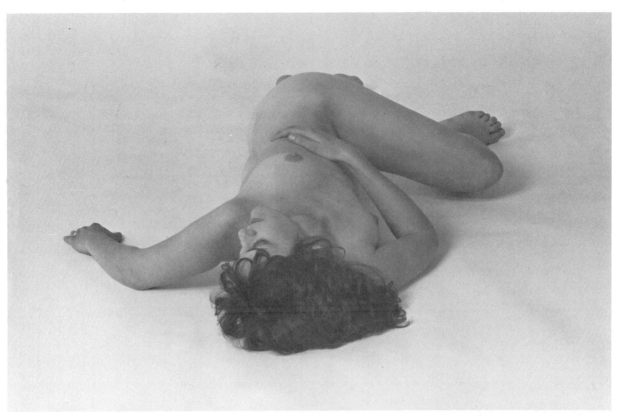

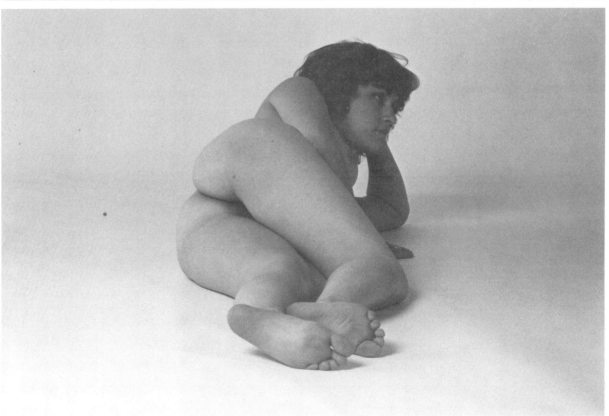

Foreshortened Views: Poses with Marked Foreshortening 93

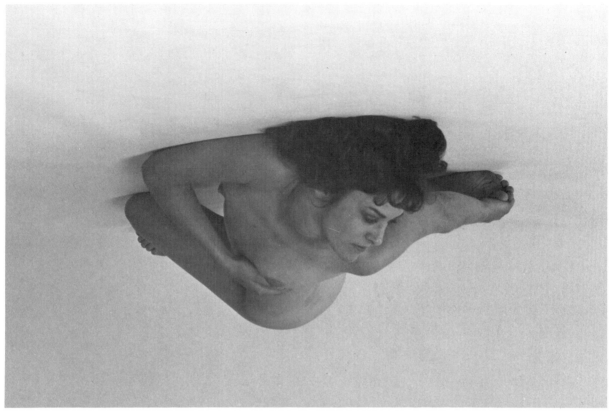

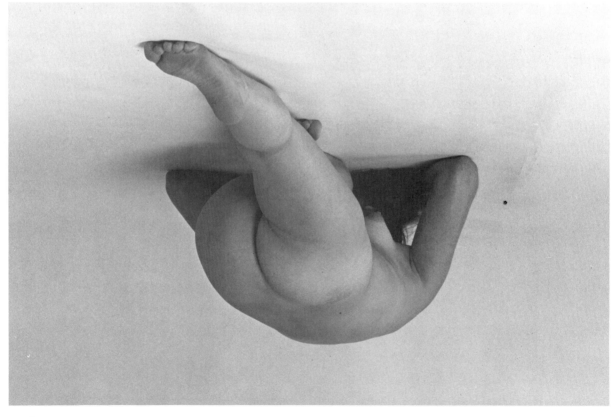

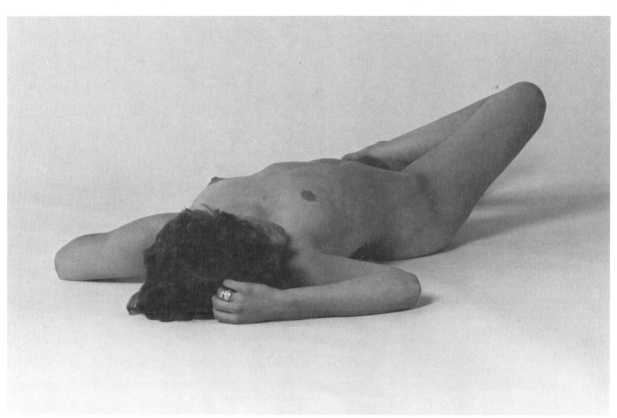

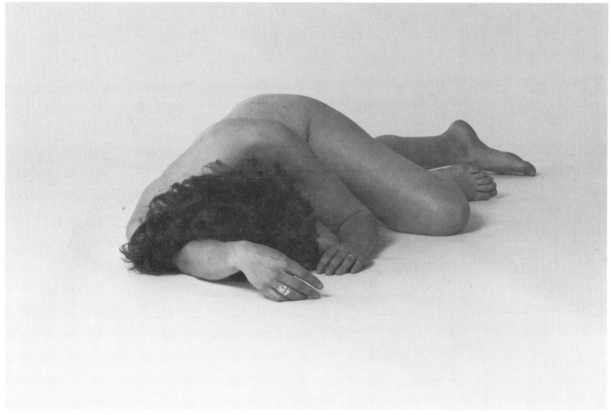

Foreshortened Views: Poses with Marked Foreshortening　　95

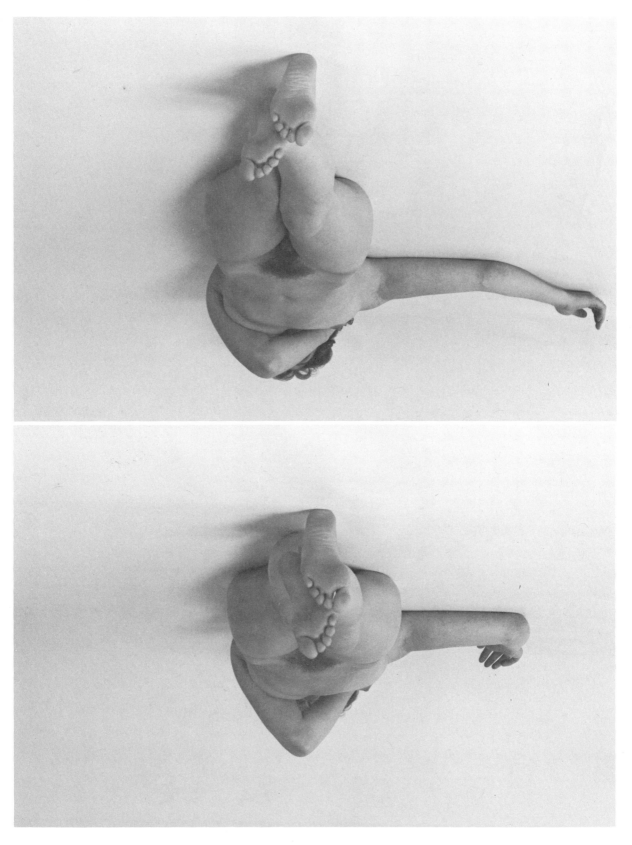

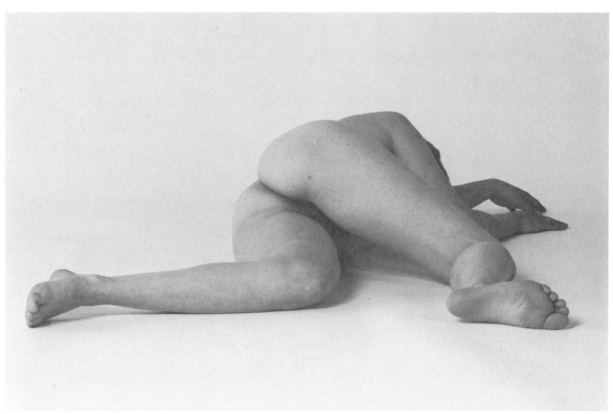

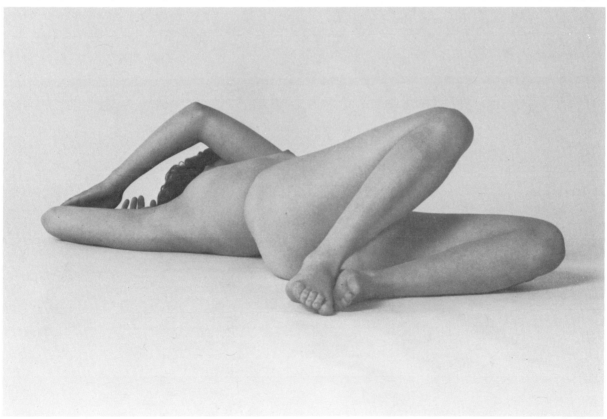

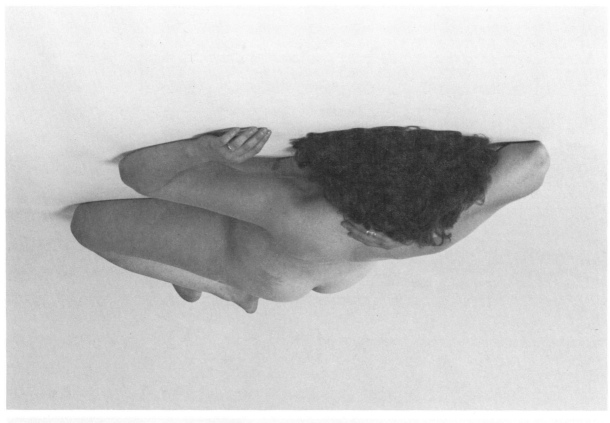

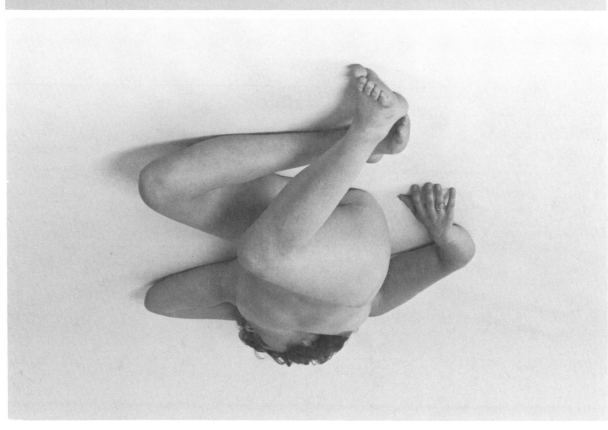

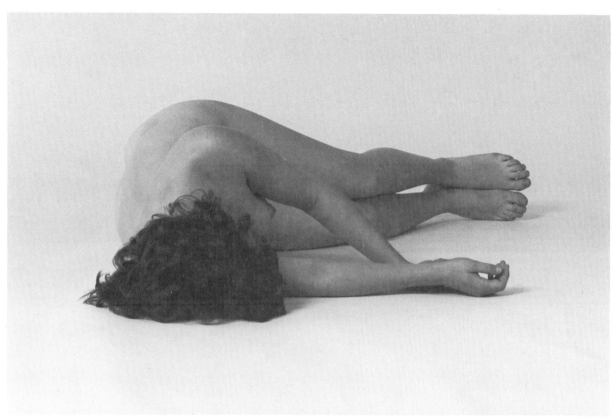

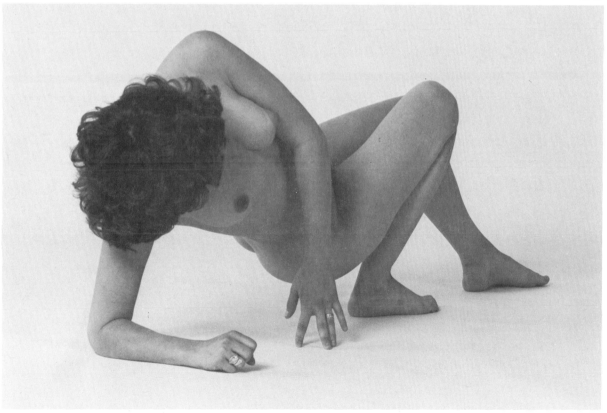

Foreshortened Views: Poses with Marked Foreshortening 99

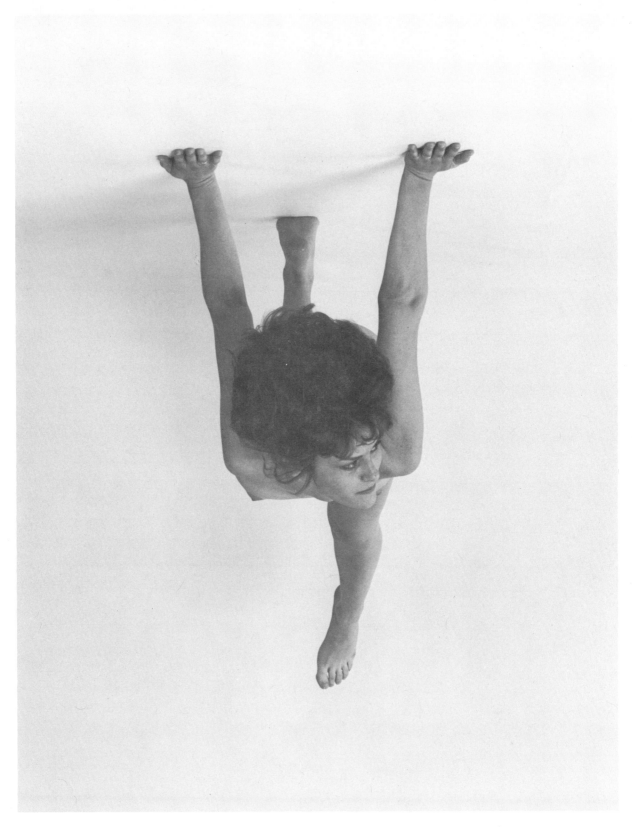

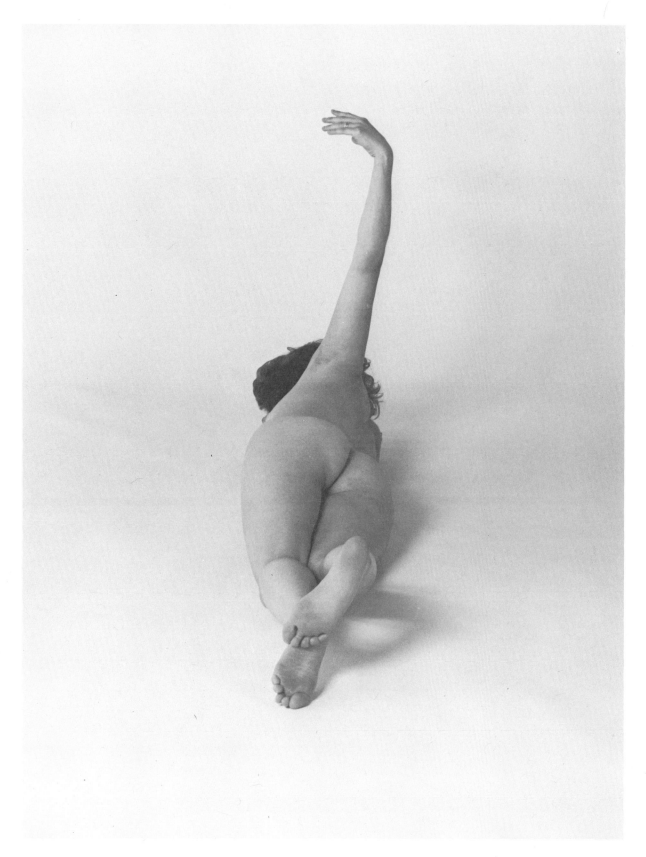

Foreshortened Views: Poses with Marked Foreshortening 101

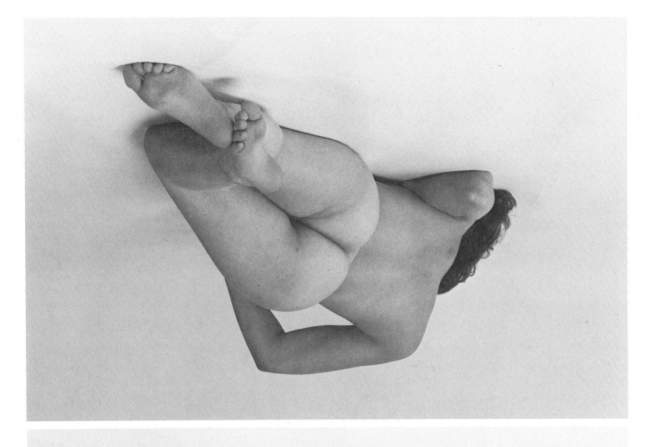

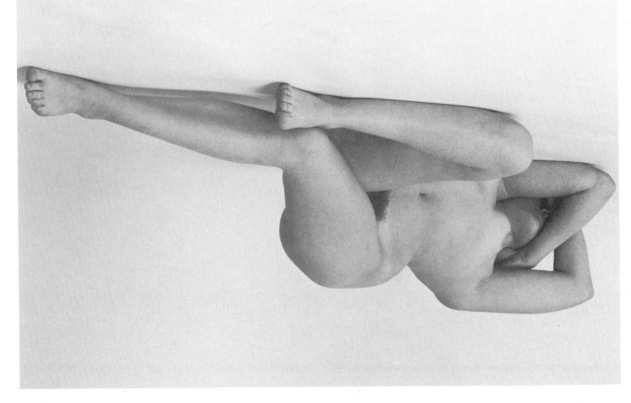

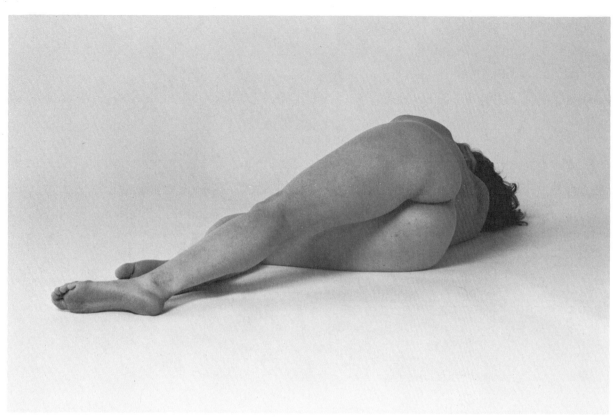

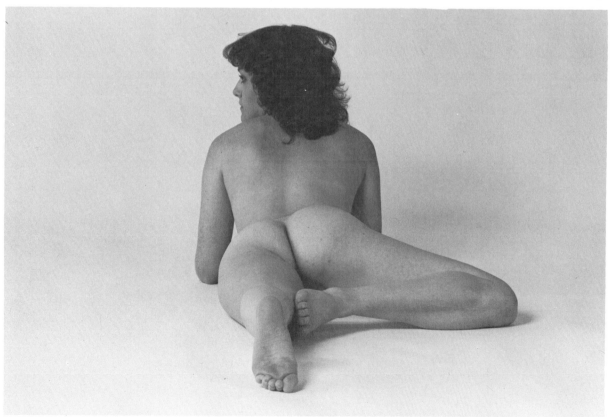

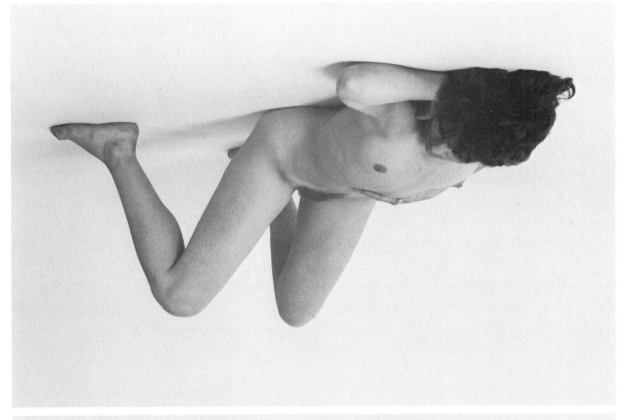

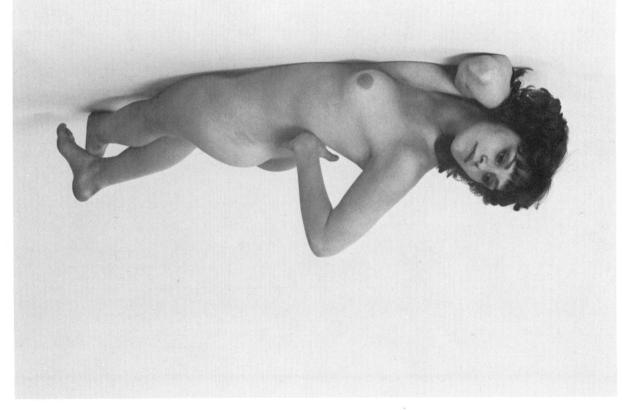

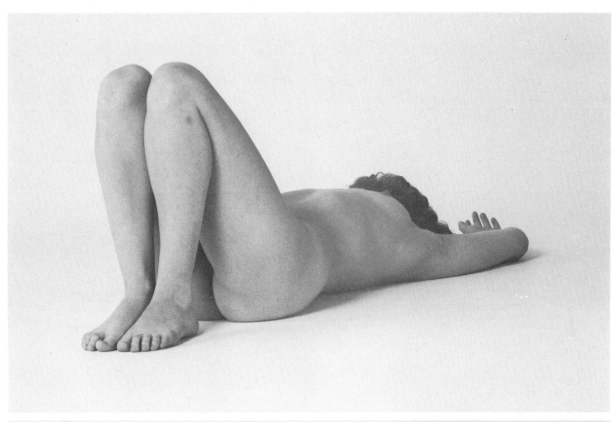

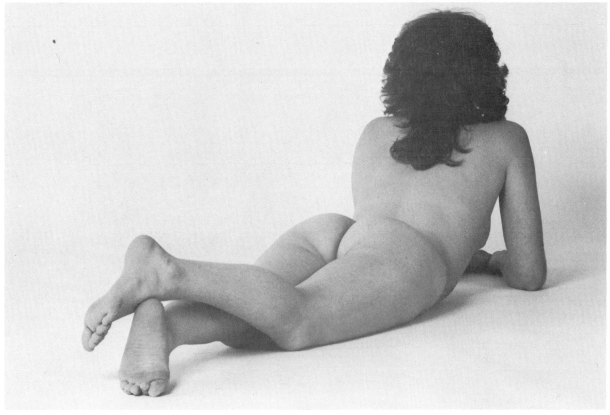

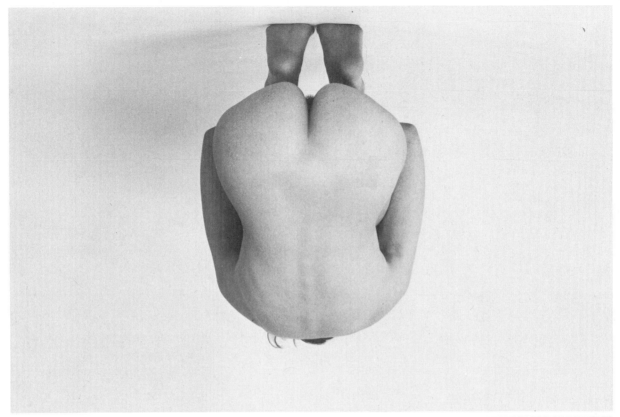

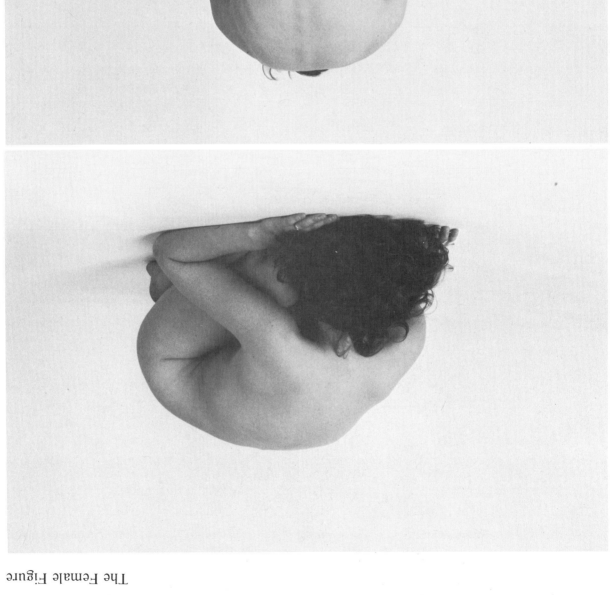

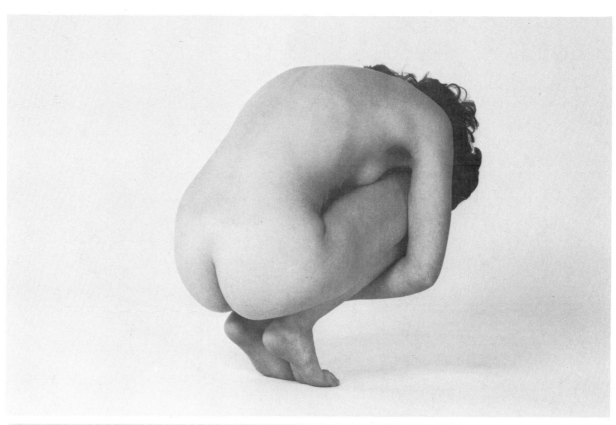

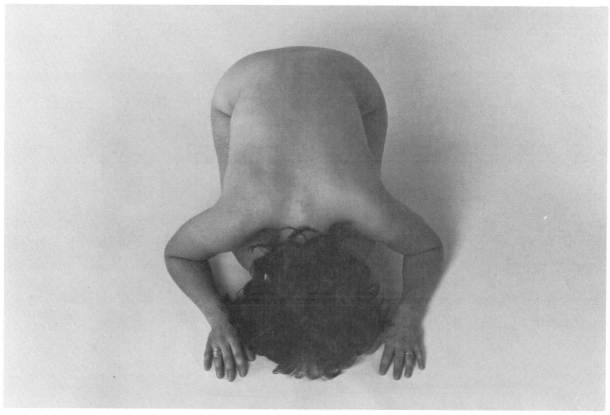

Foreshortened Views: Poses with Moderate Foreshortening 107

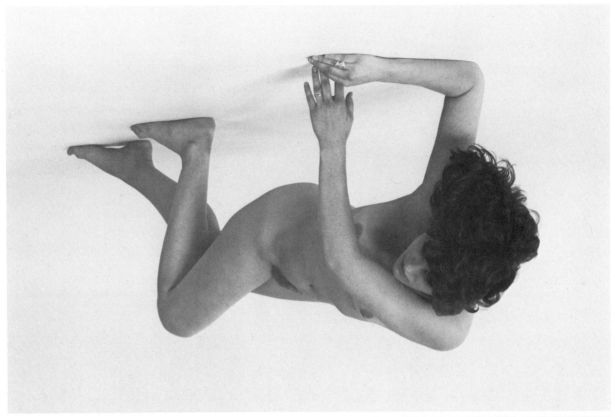

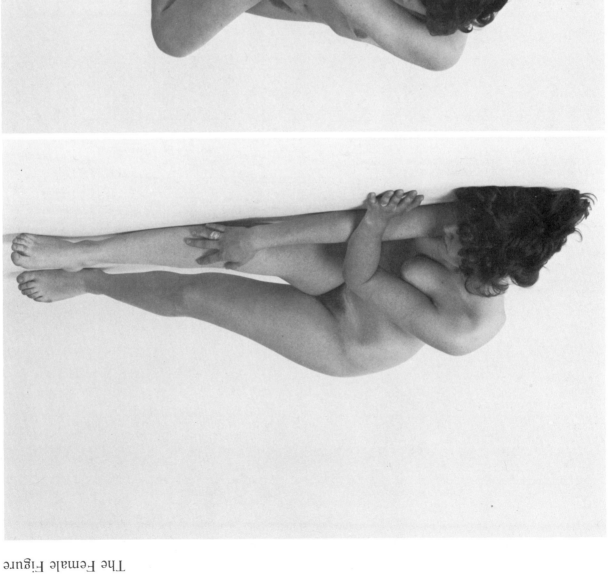

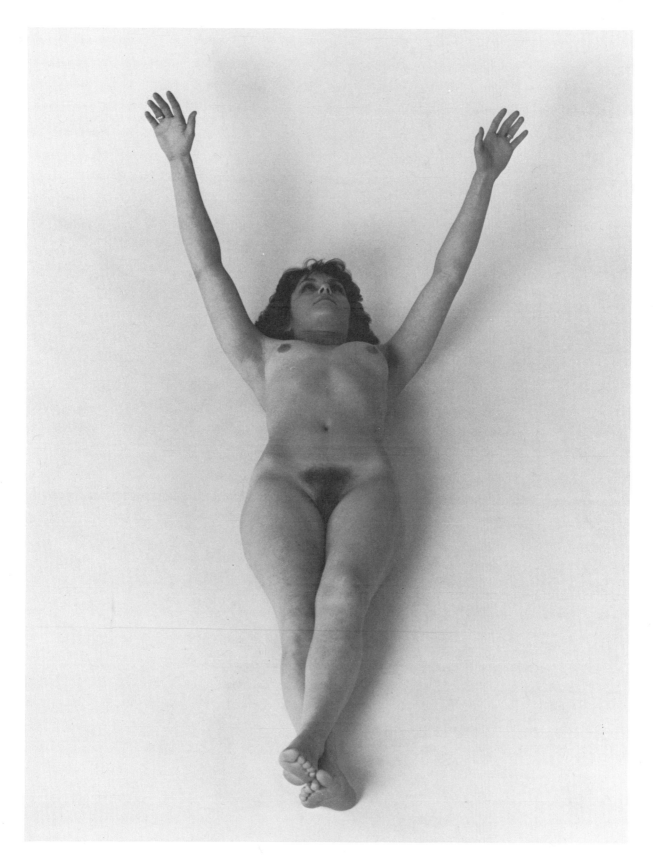

Foreshortened Views: Poses with Moderate Foreshortening 109

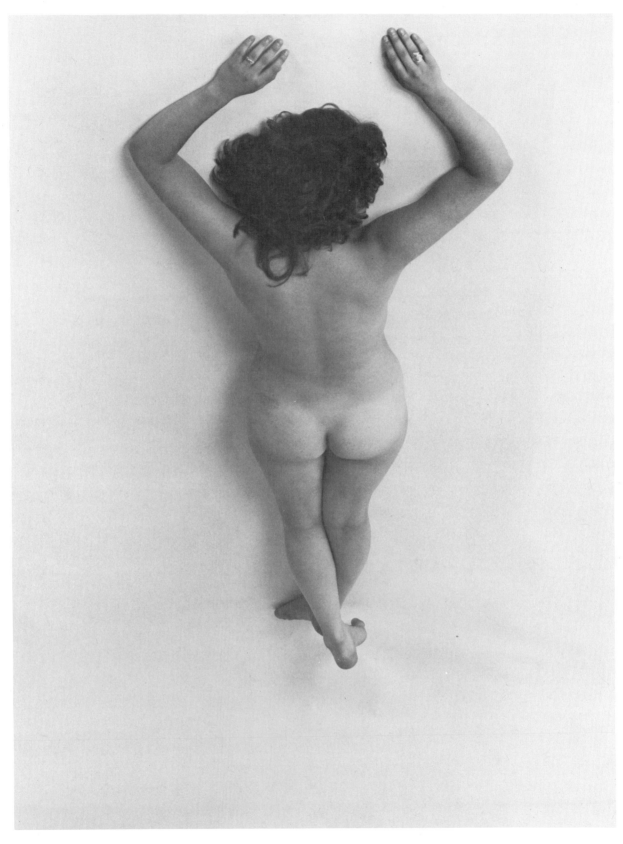

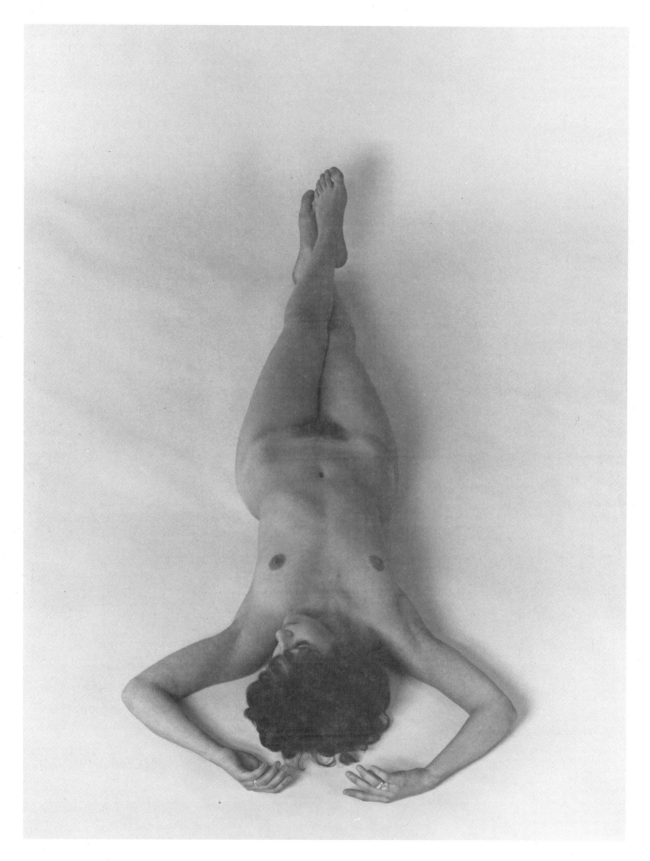

Foreshortened Views: Poses with Moderate Foreshortening **111**

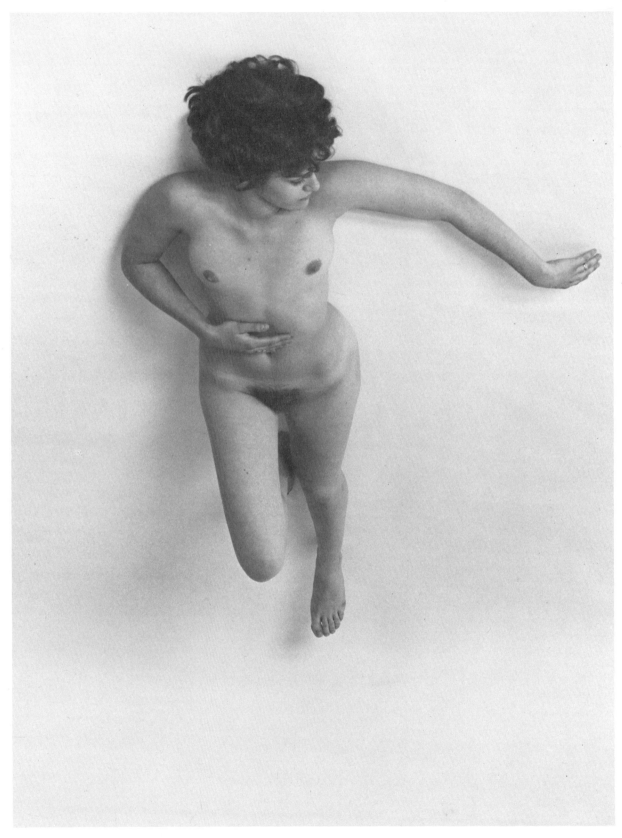

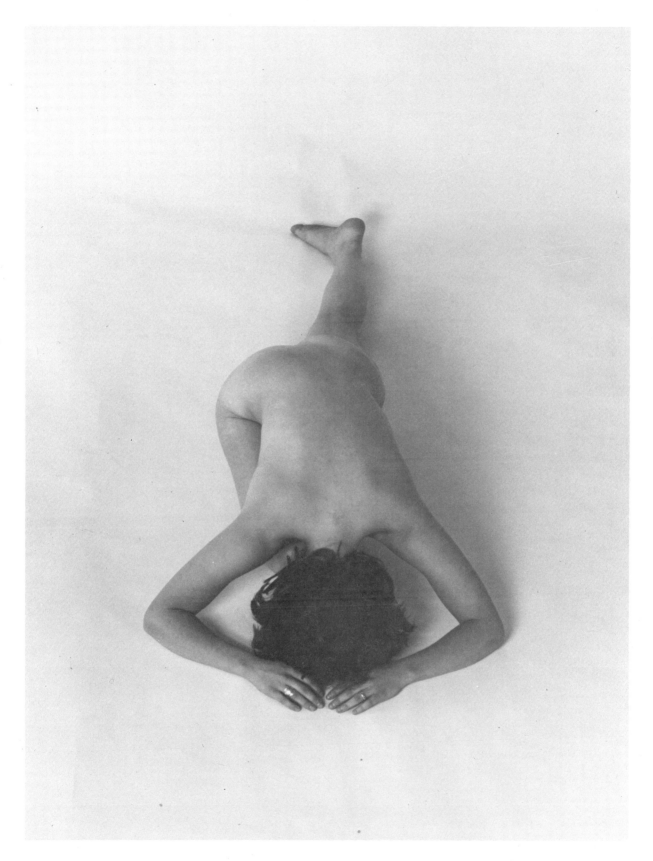

Foreshortened Views: Poses with Moderate Foreshortening 113

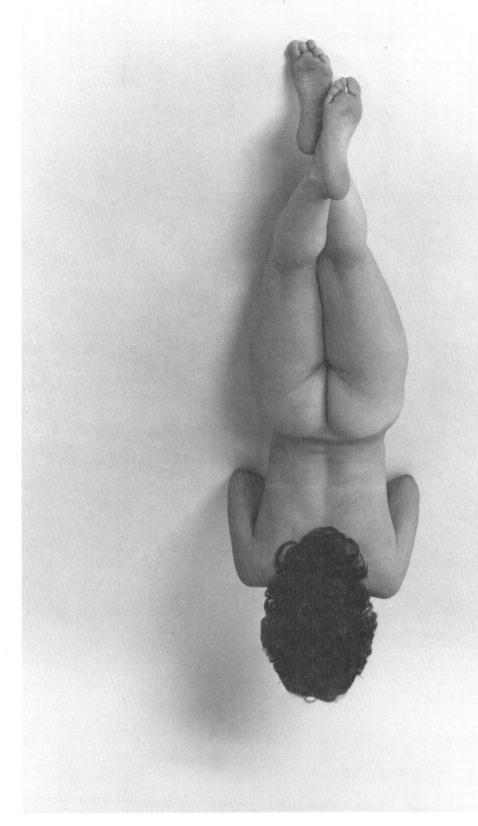

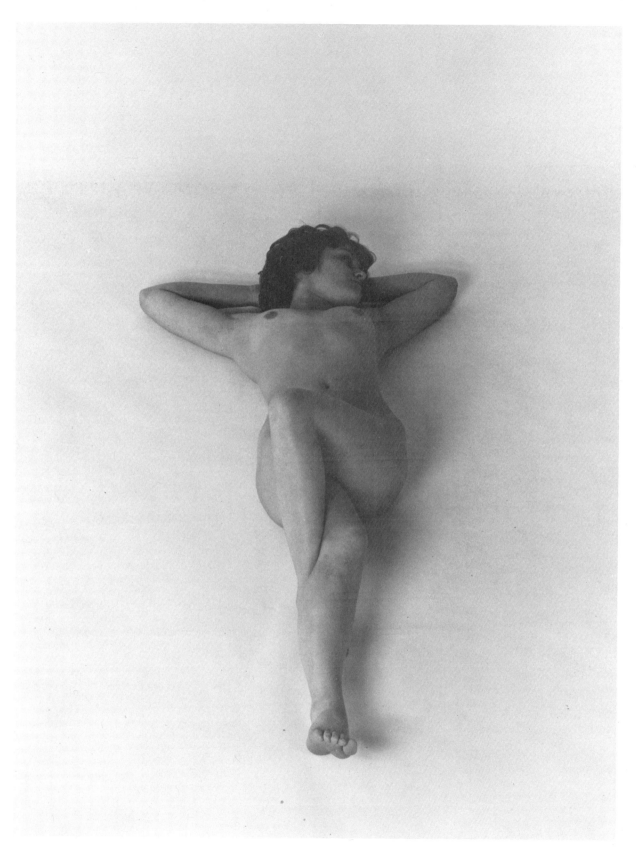

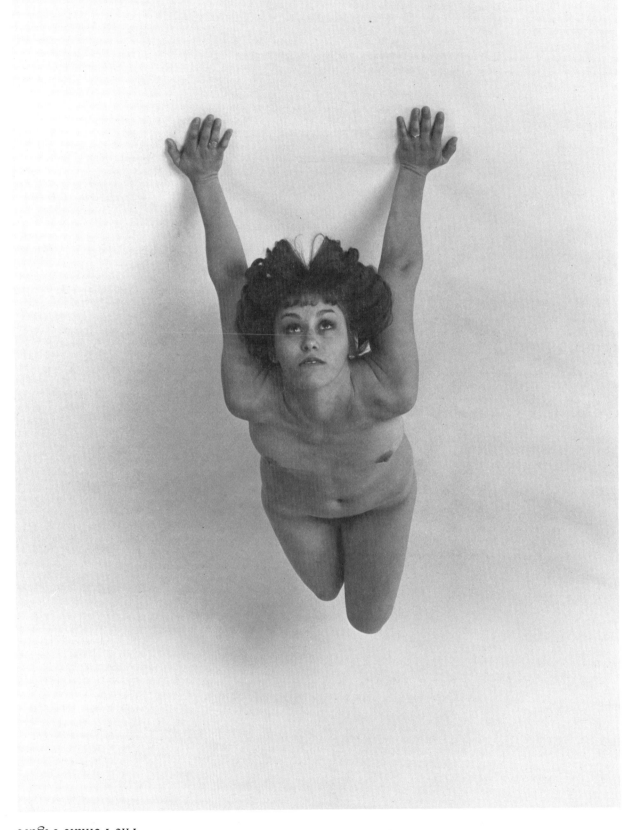

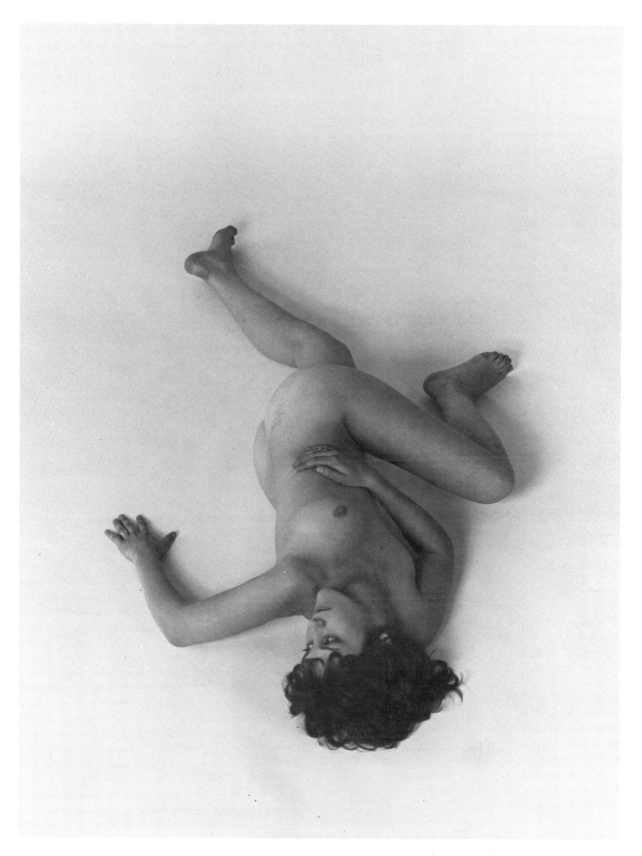

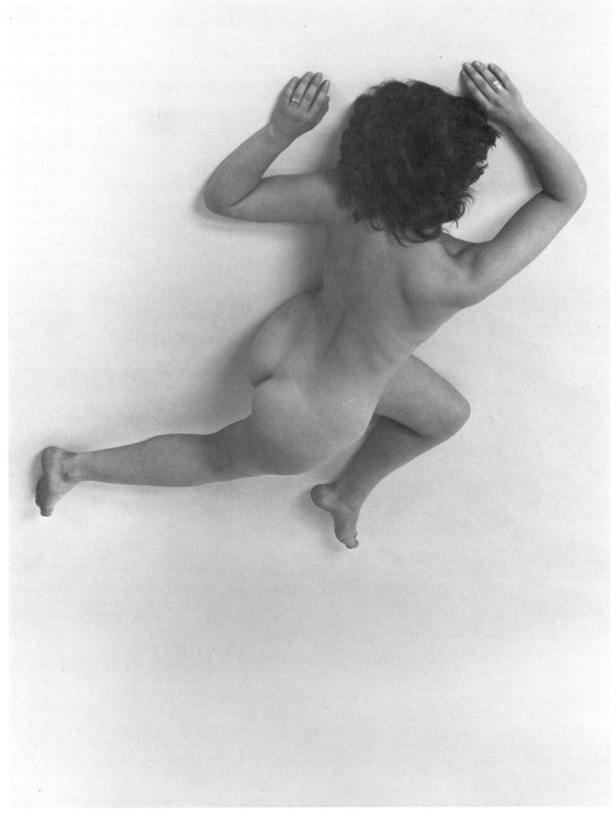

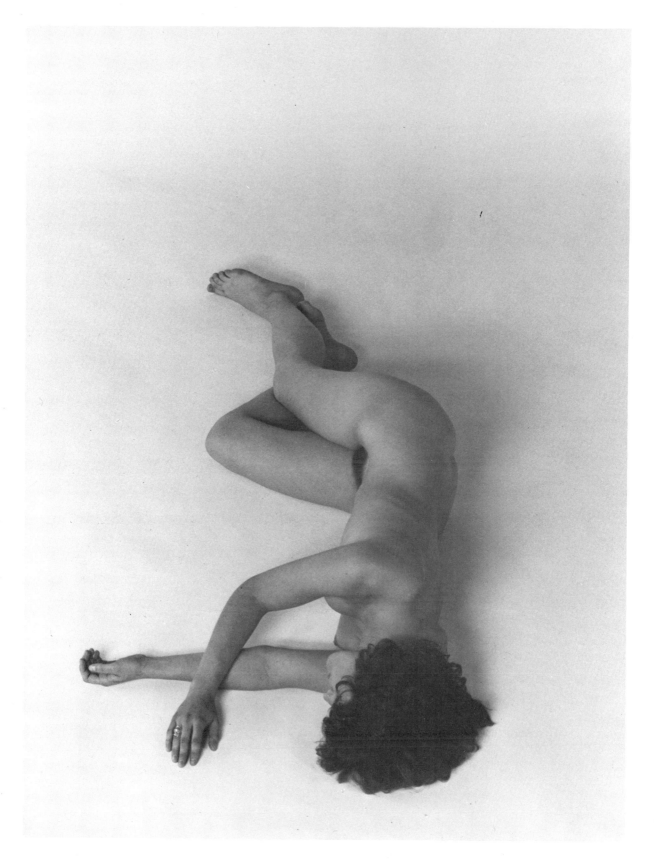

Foreshortened Views: Poses with Moderate Foreshortening 119

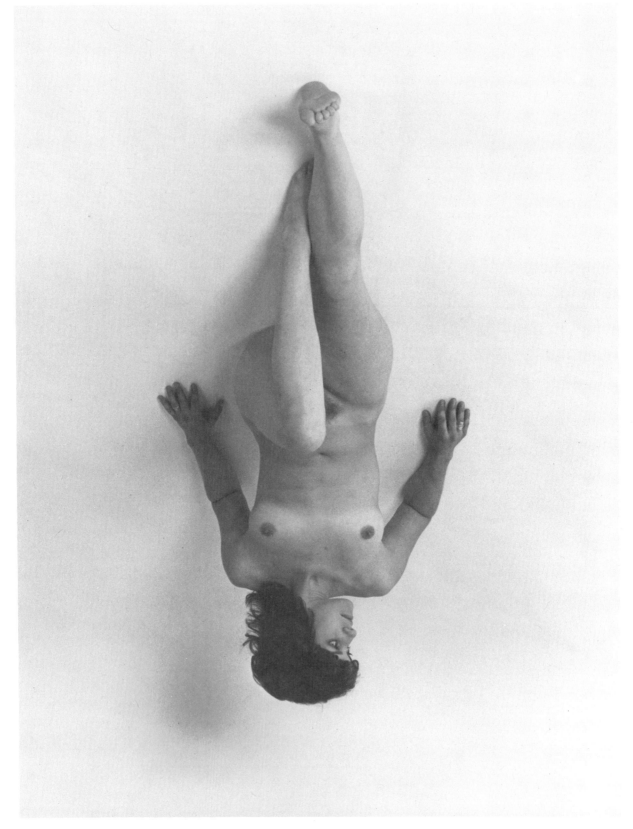

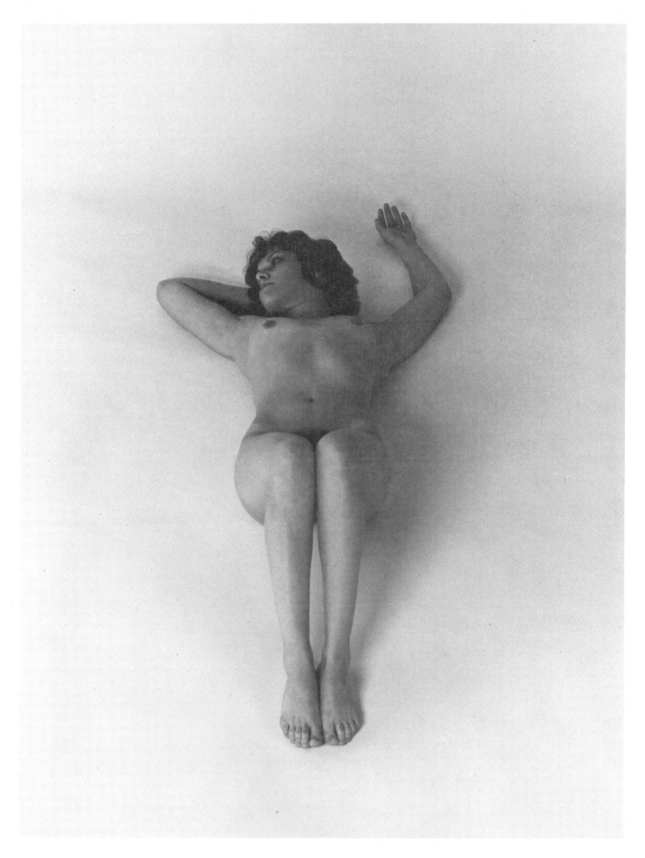

Foreshortened Views: Poses with Moderate Foreshortening 121

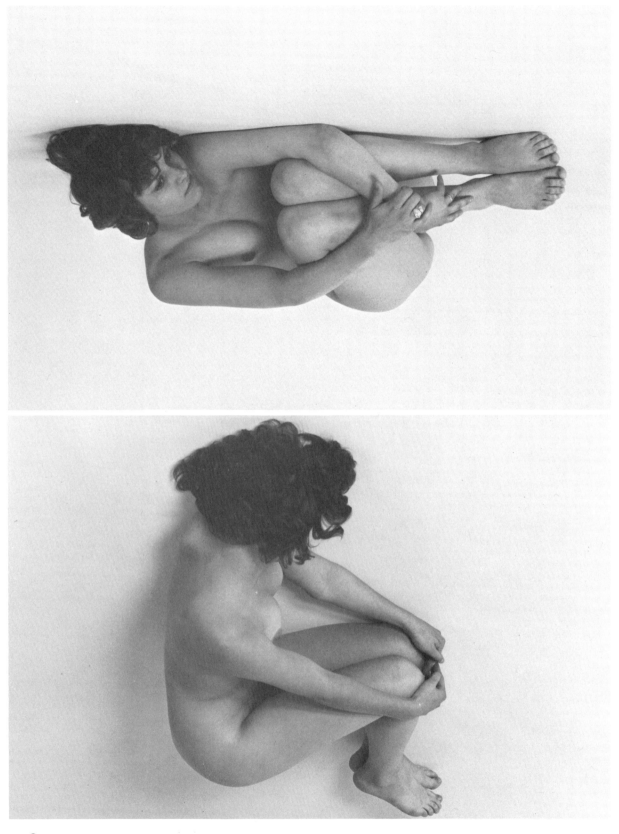

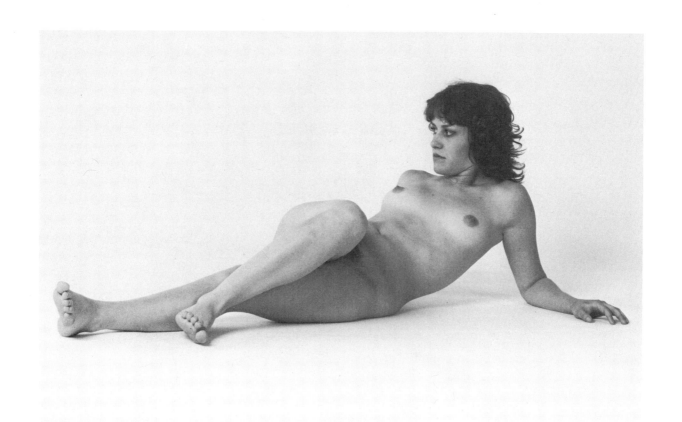

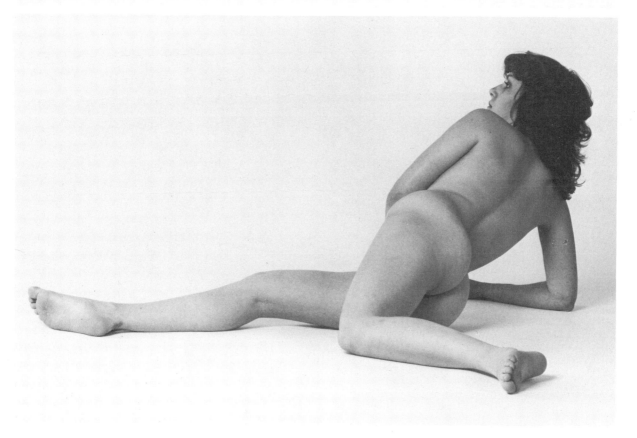

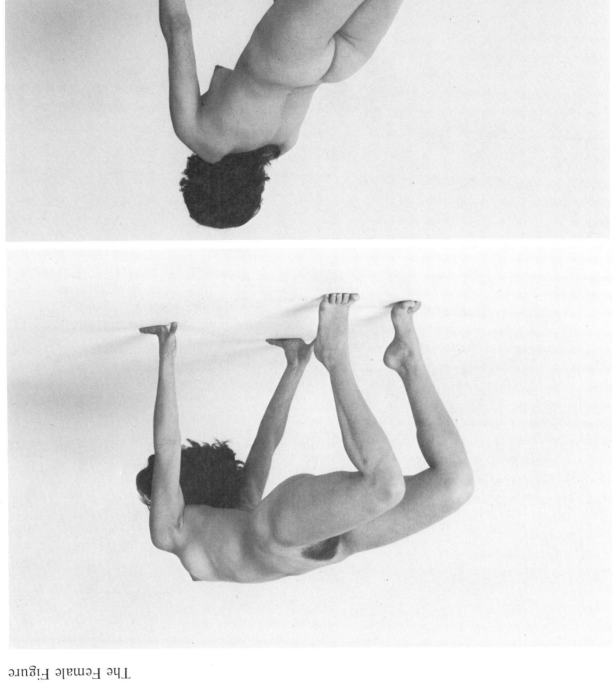

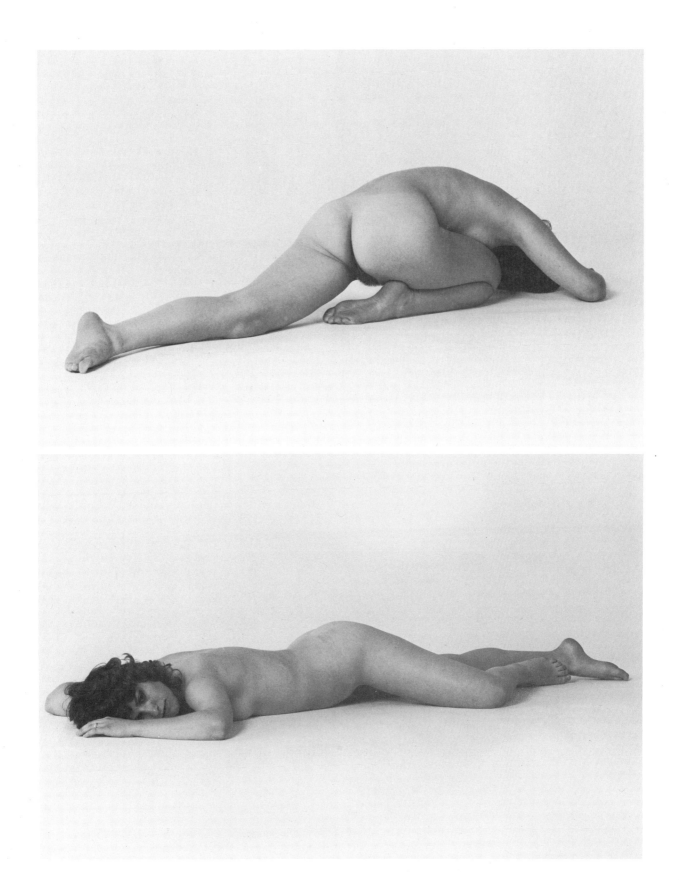

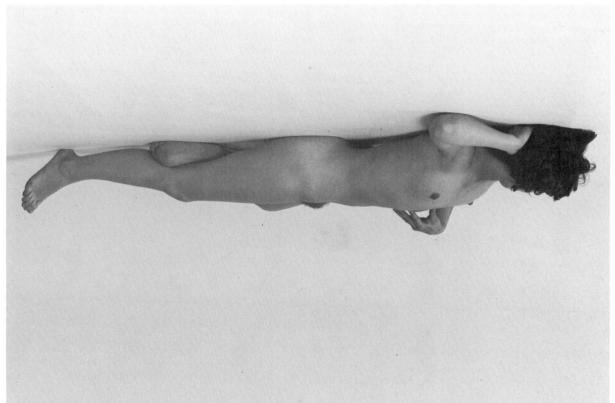

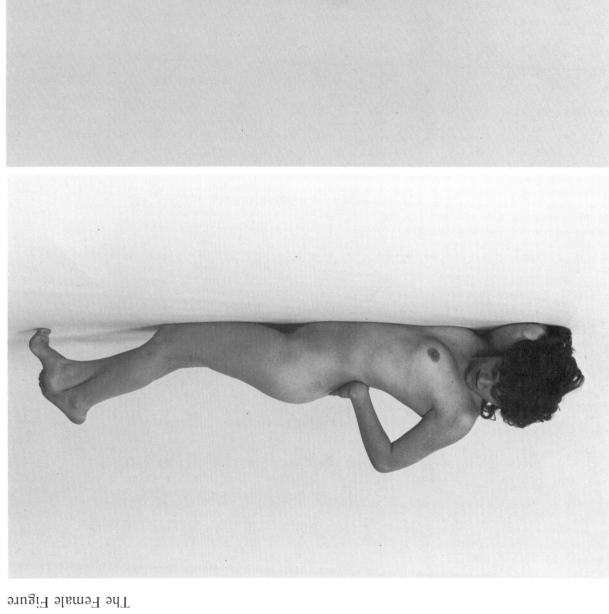

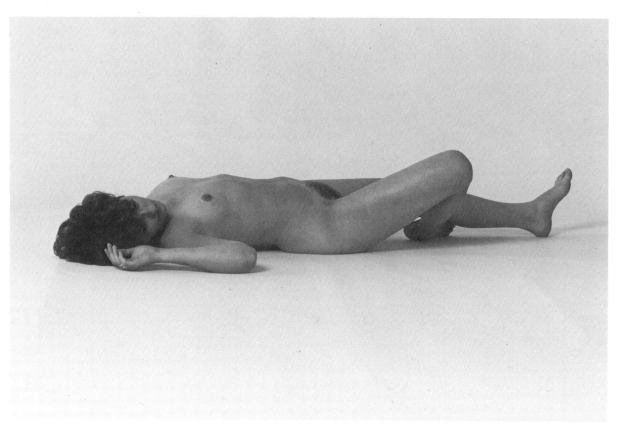

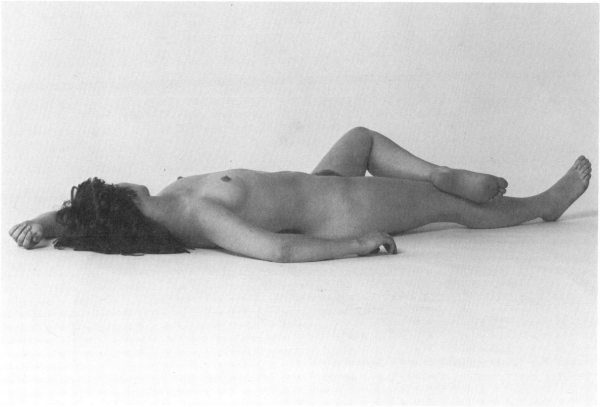

Foreshortened Views: Poses with Slight Foreshortening 127

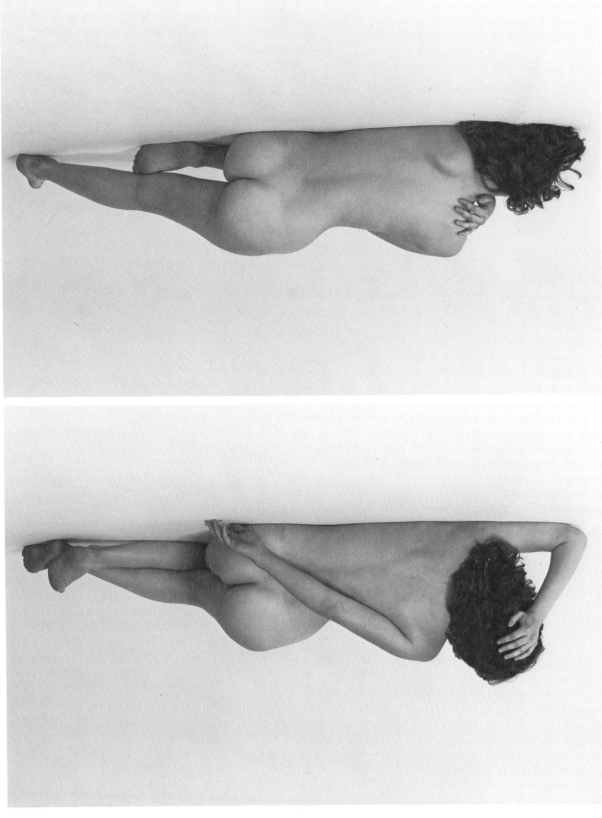

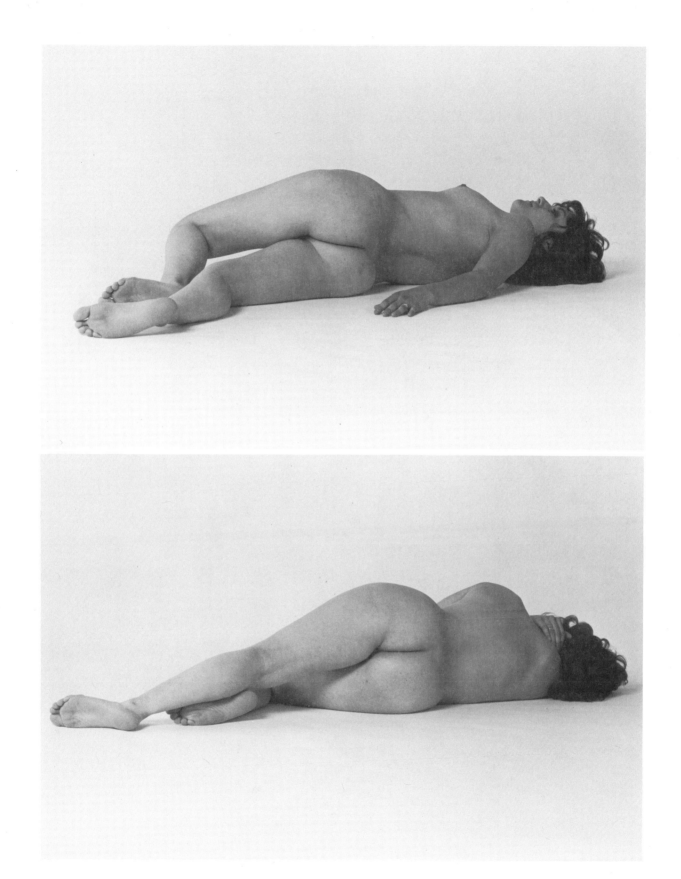

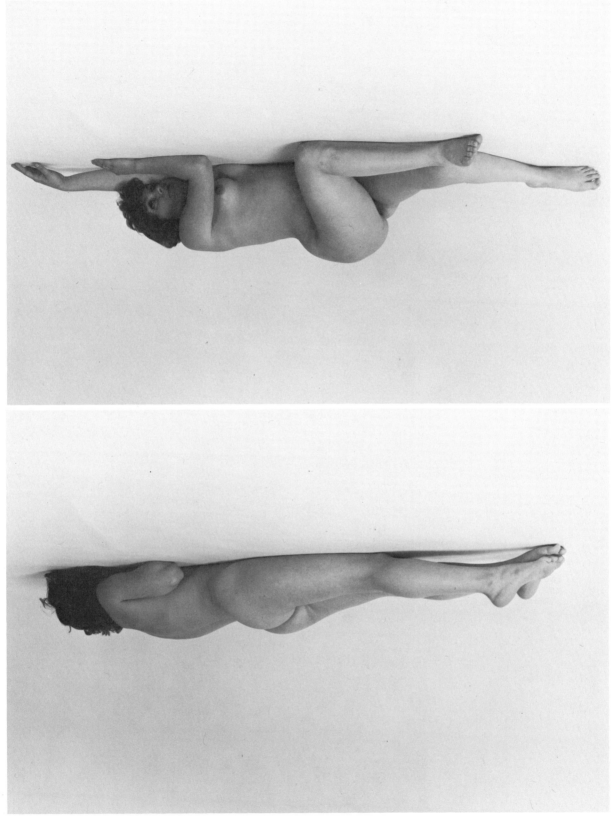

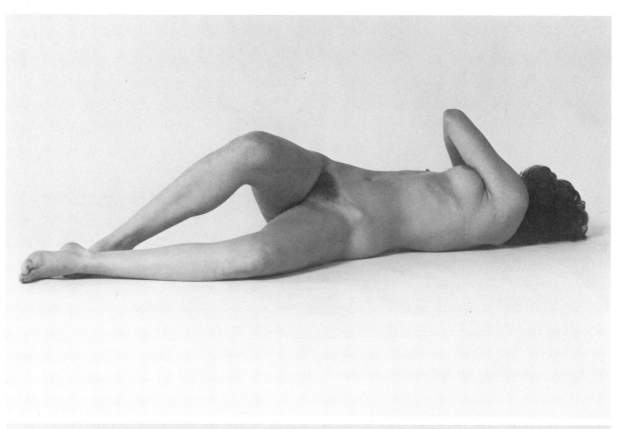

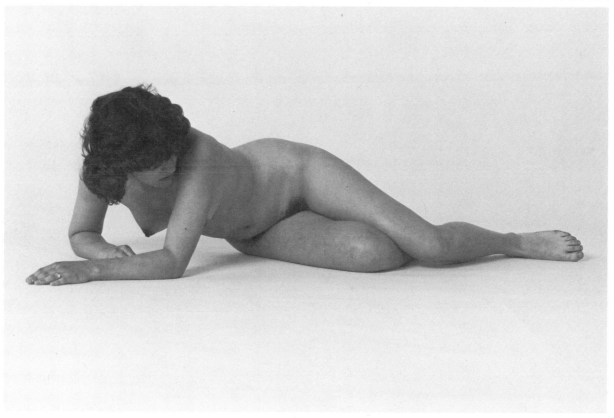

Foreshortened Views: Poses with Slight Foreshortening 131

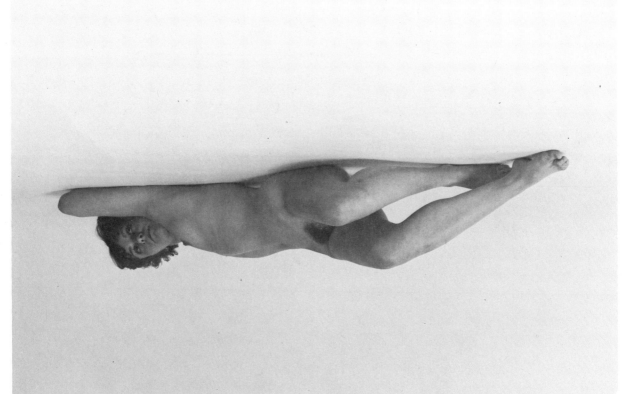

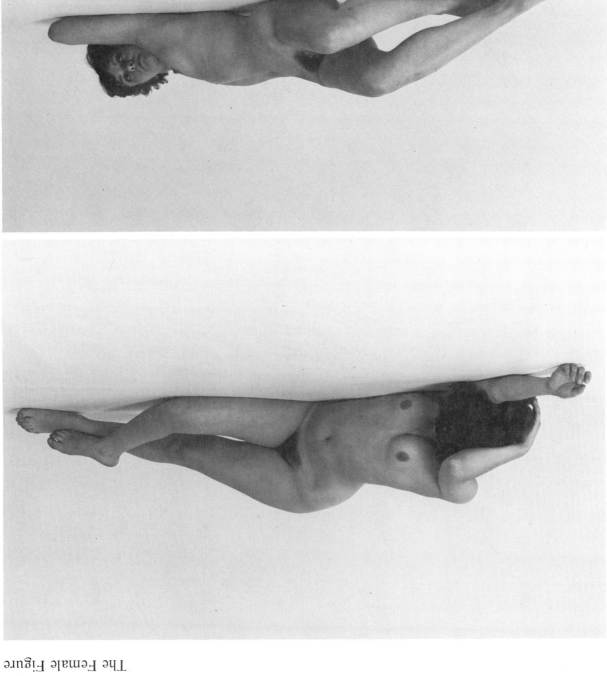

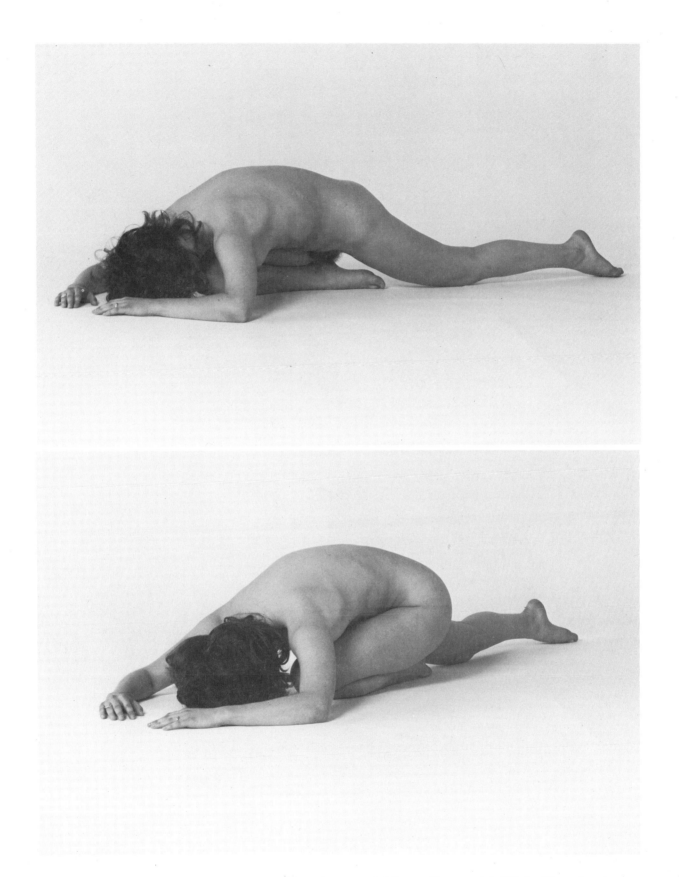

Foreshortened Views: Poses with Slight Foreshortening 133

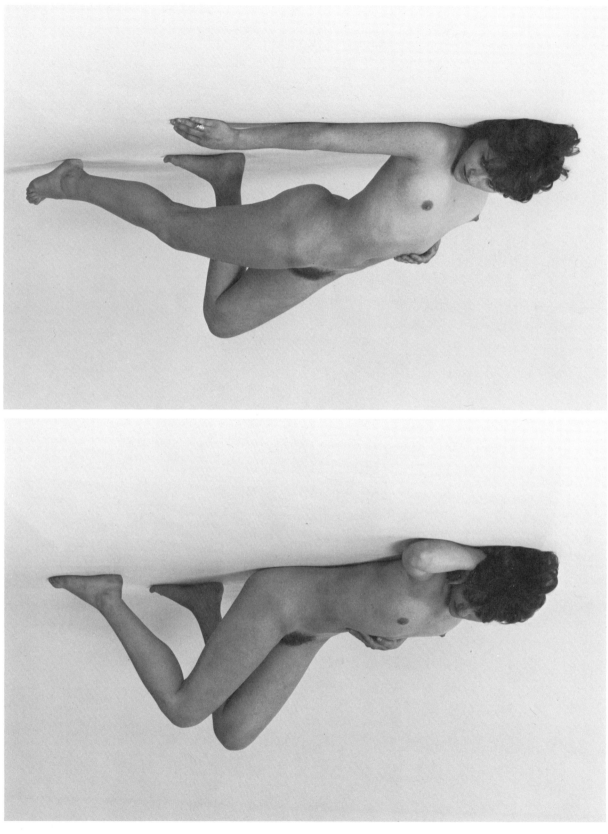

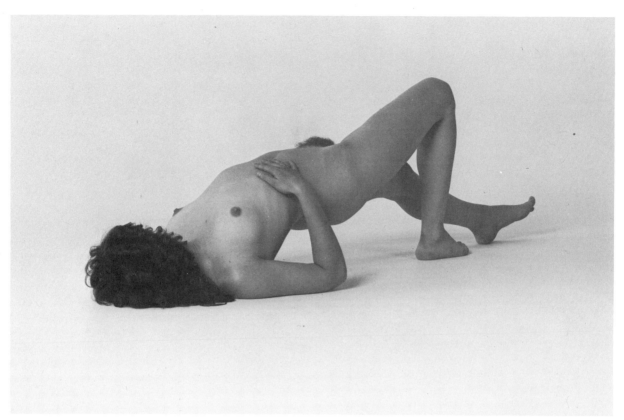

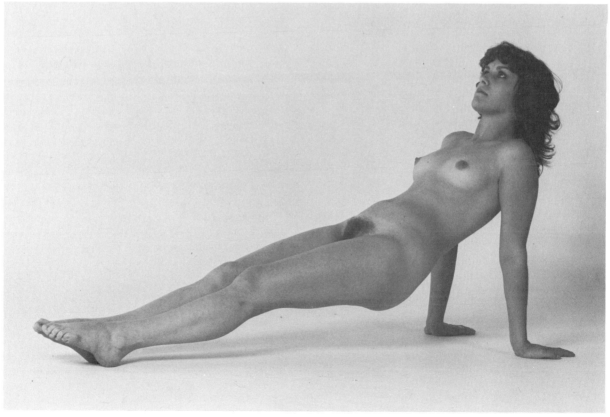

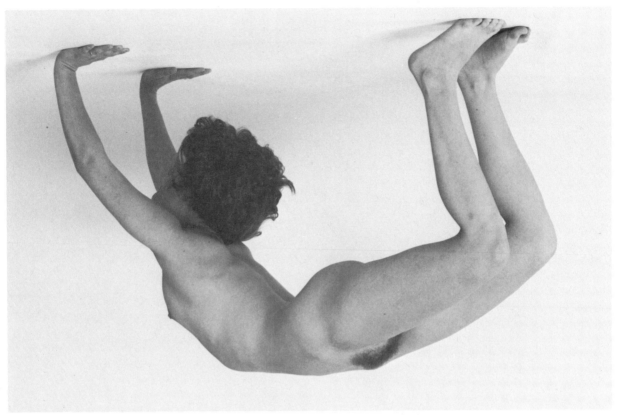

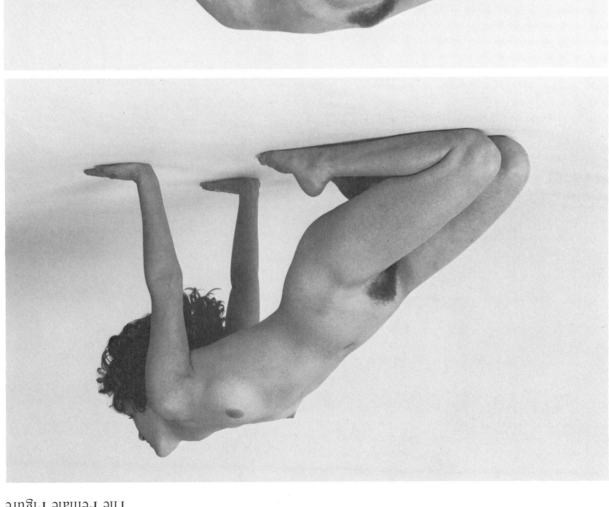

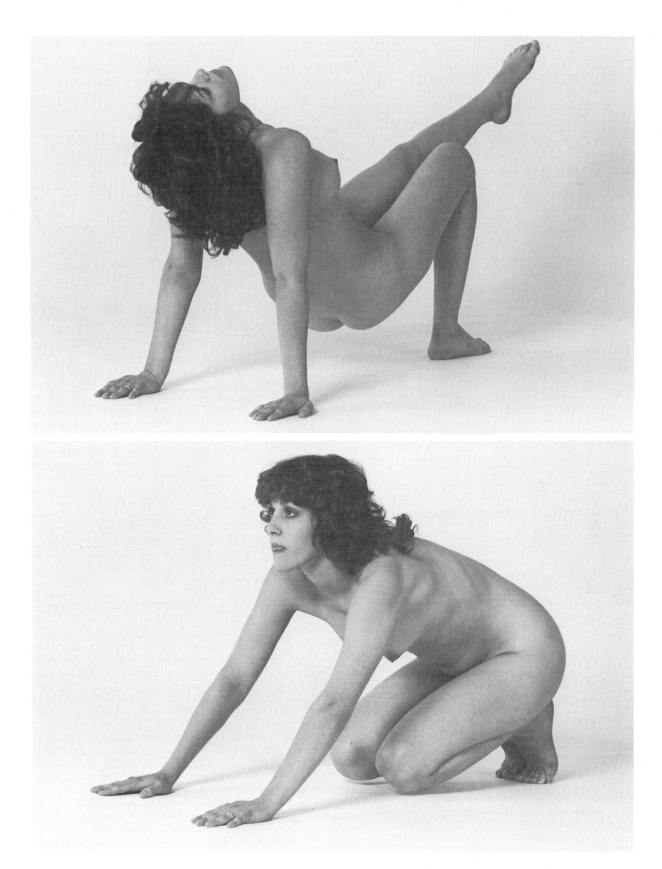

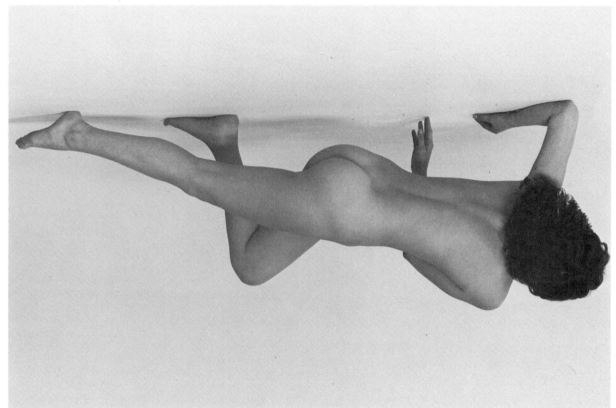

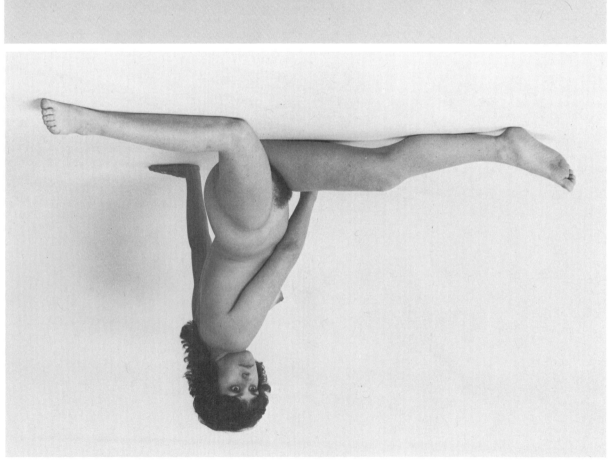

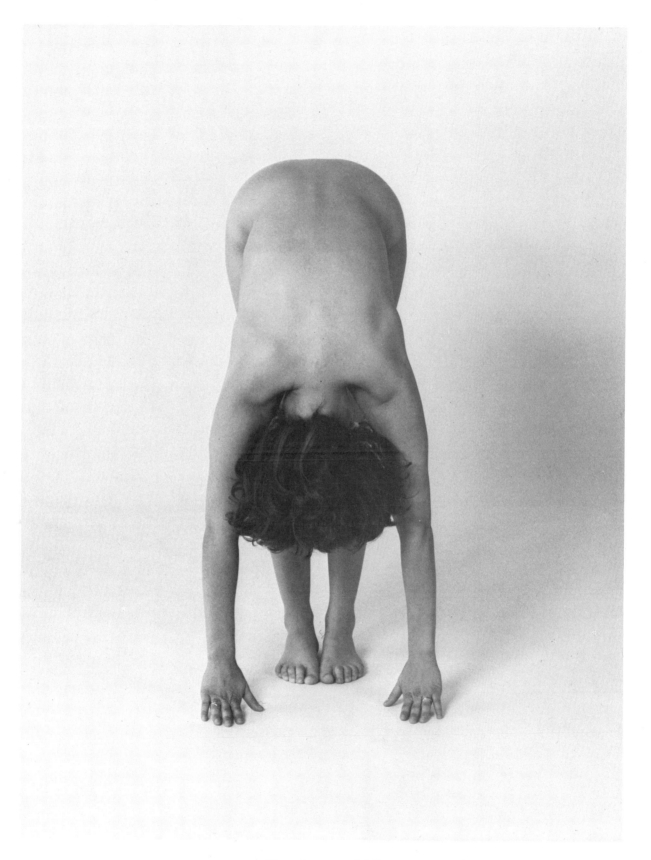

Foreshortened Views: Poses with Slight Foreshortening 139

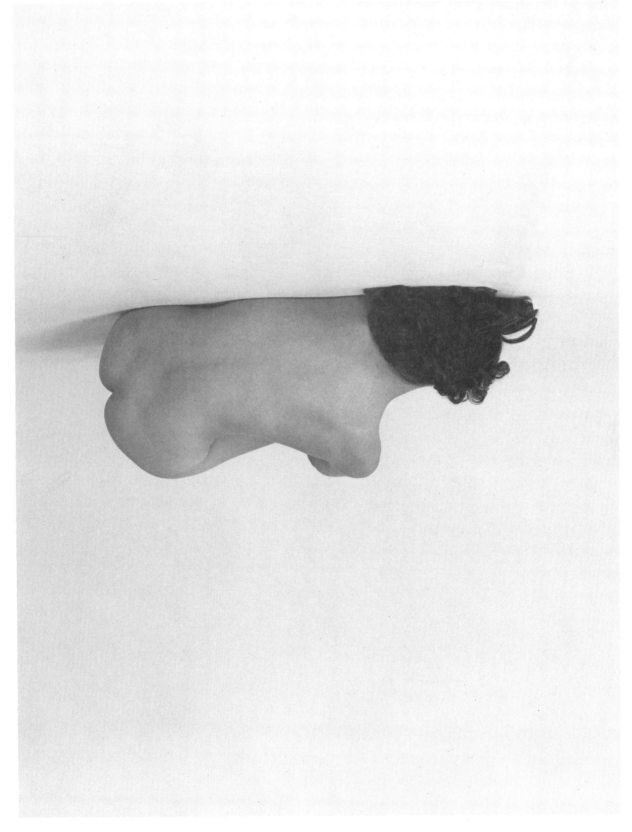

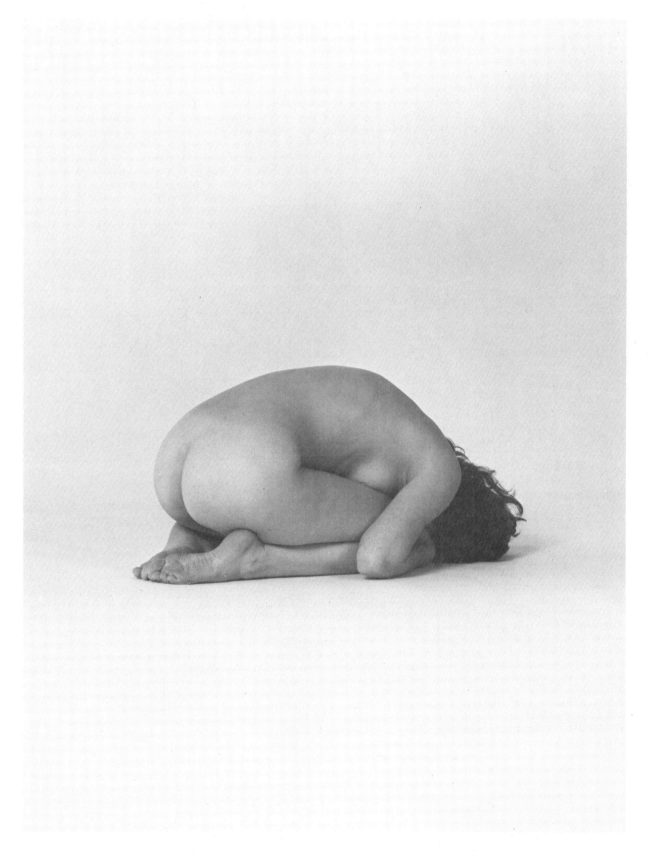

PART II
THE MALE FIGURE

Nonforeshortened Views: A Point of Reference

Foreshortened Views

Poses from Multiple Angles
Poses with Marked Foreshortening
Poses with Moderate Foreshortening
Poses with Slight Foreshortening

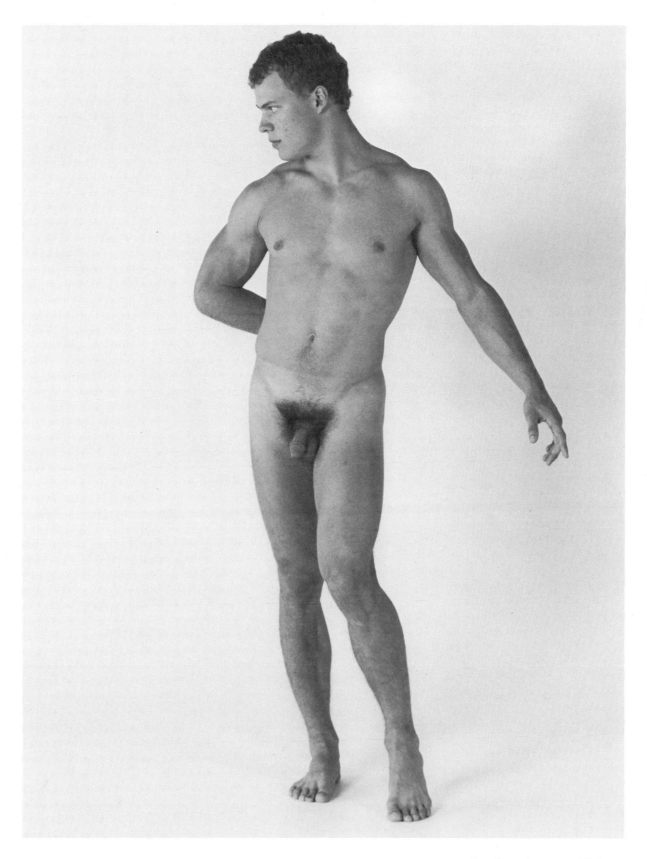

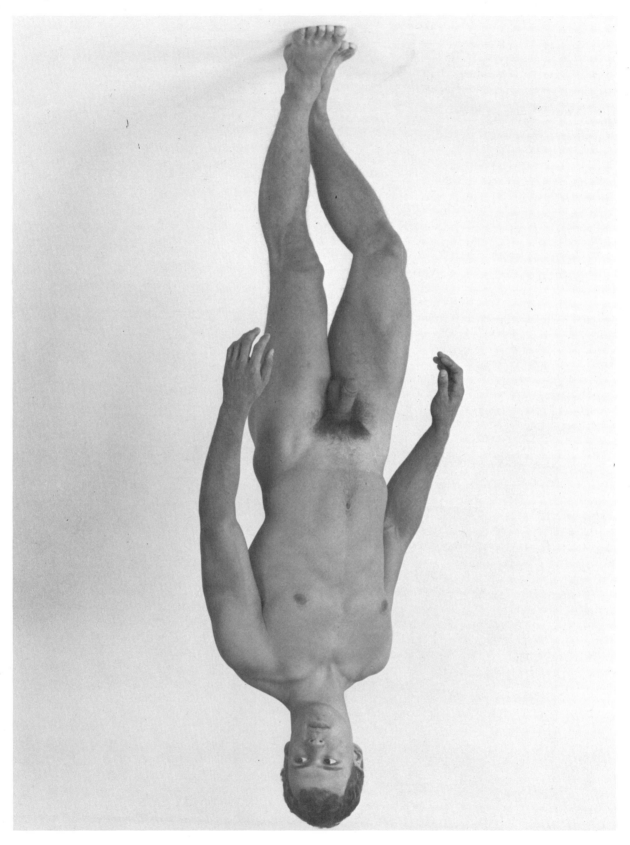

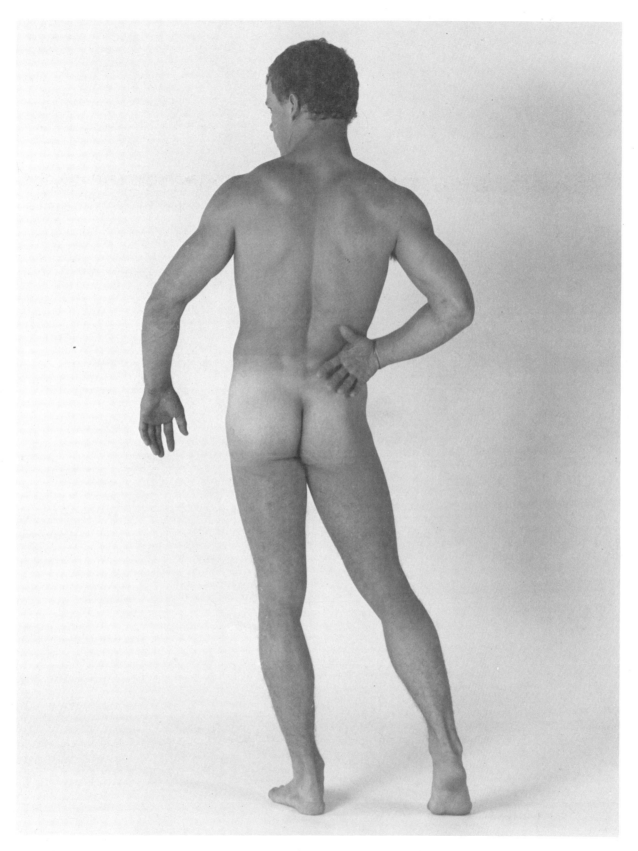

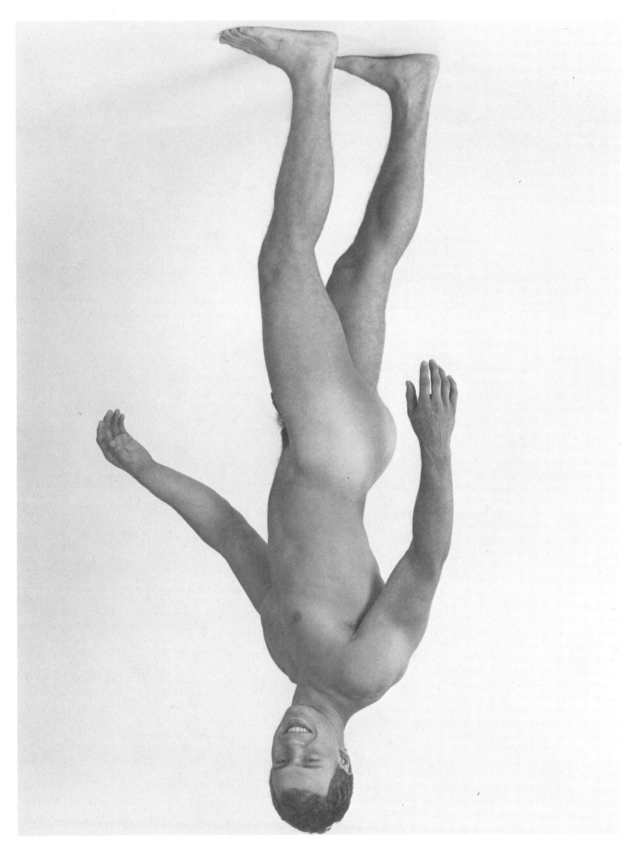

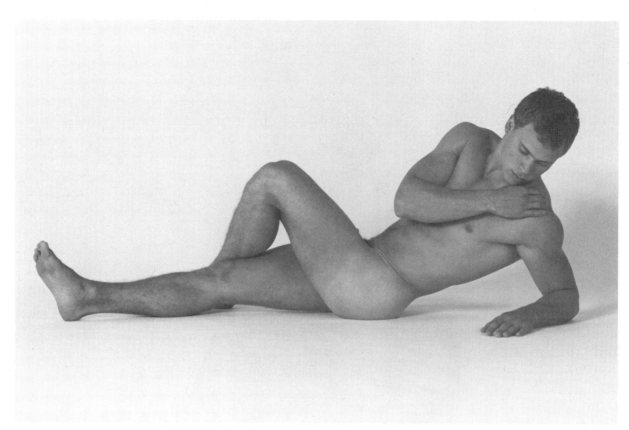

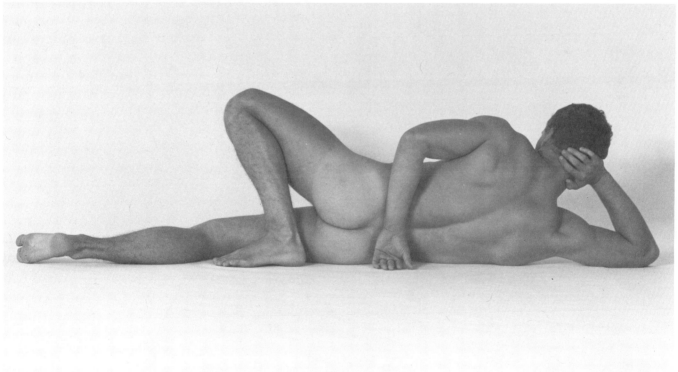

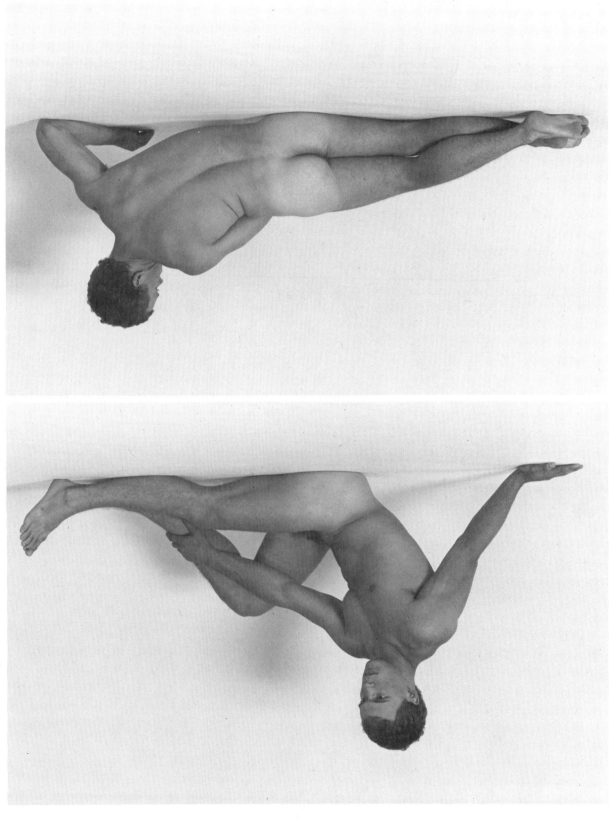

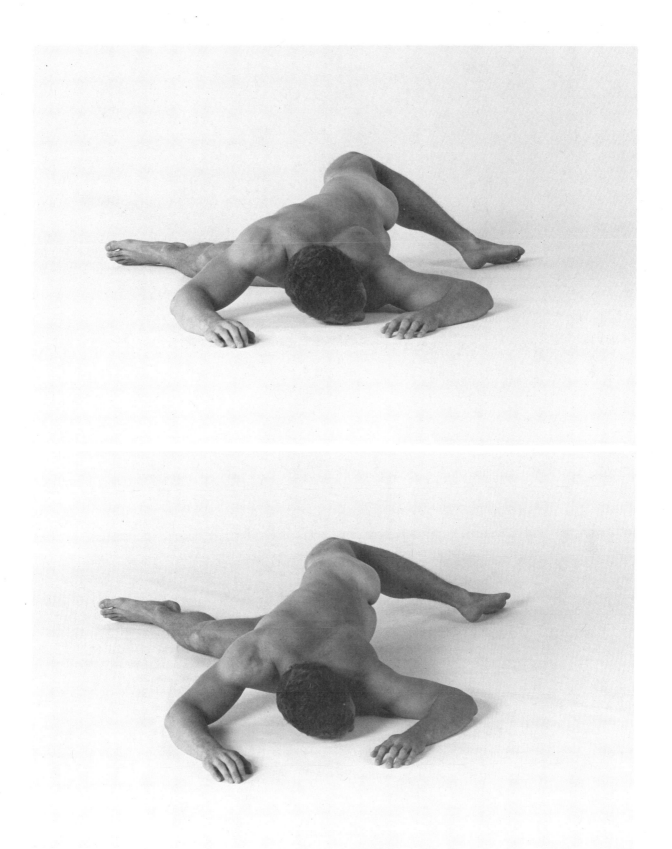

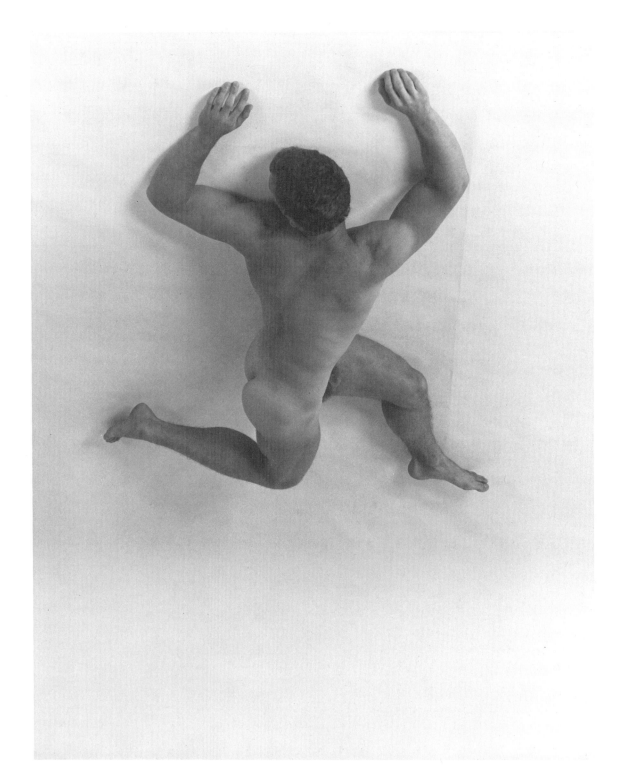

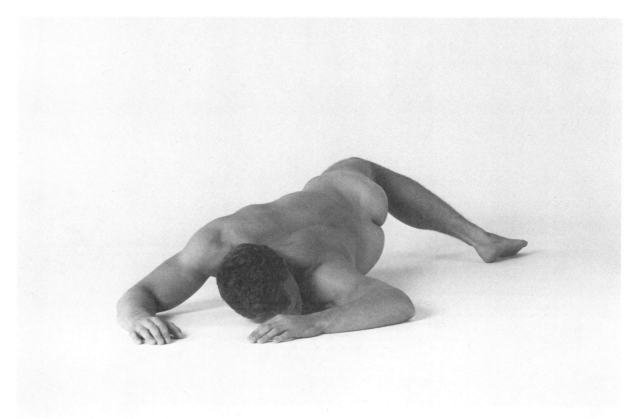

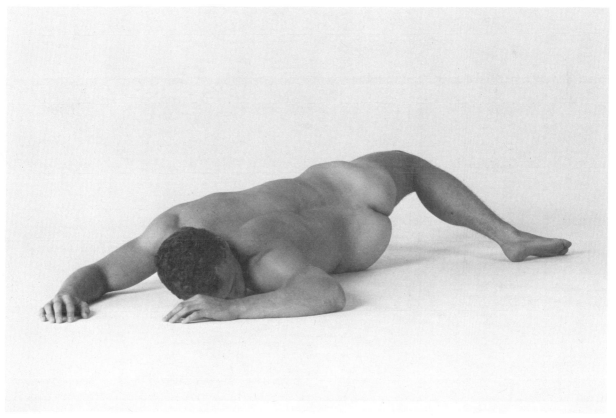

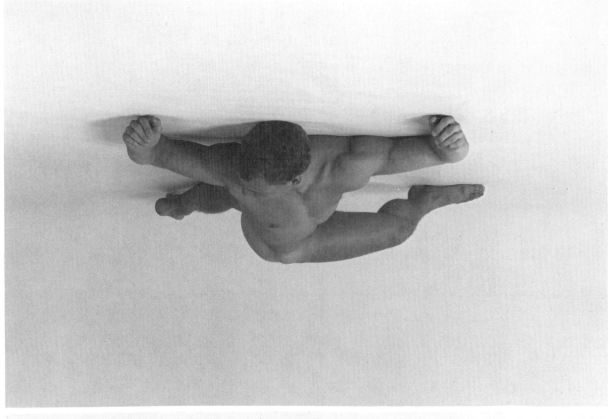

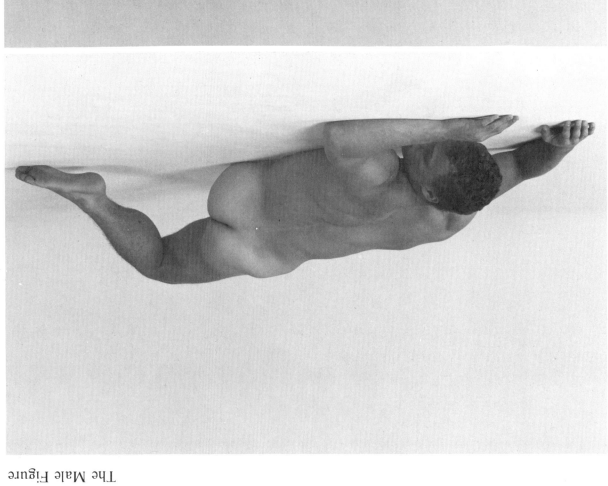

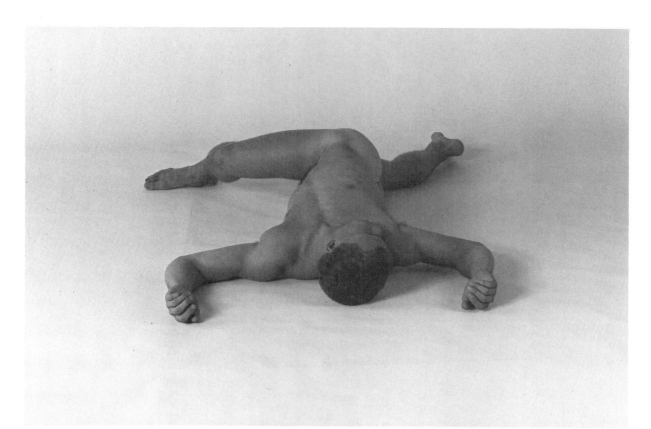

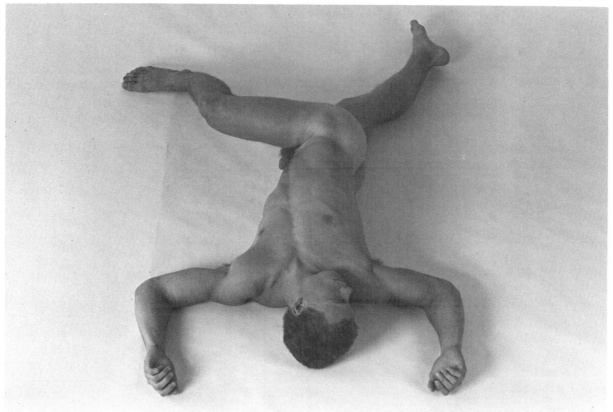

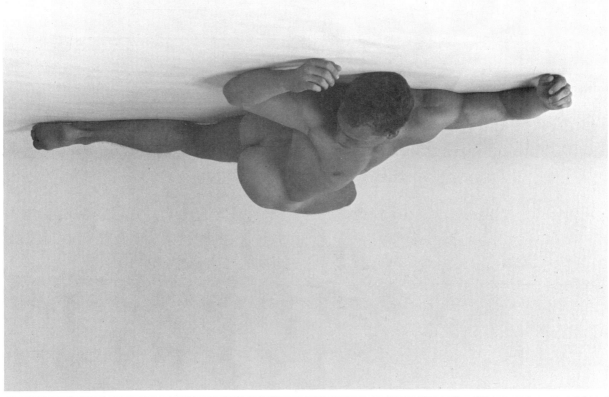

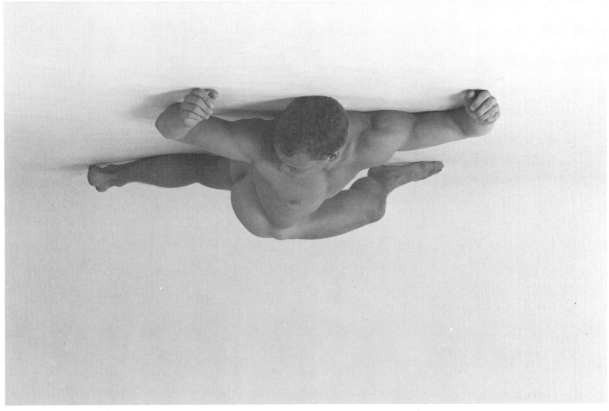

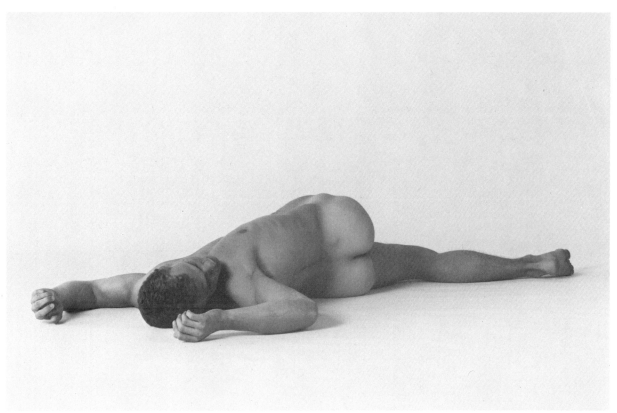

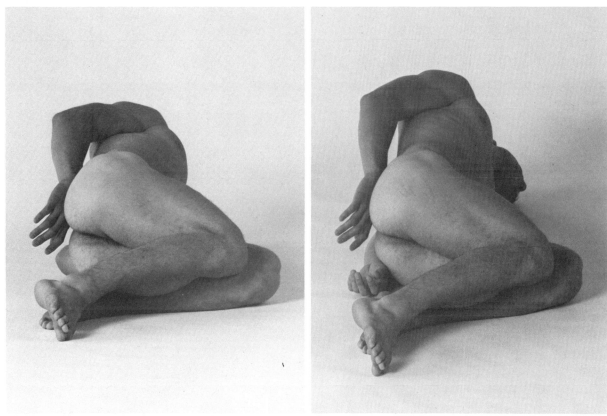

Foreshortened Views: Poses from Multiple Angles 157

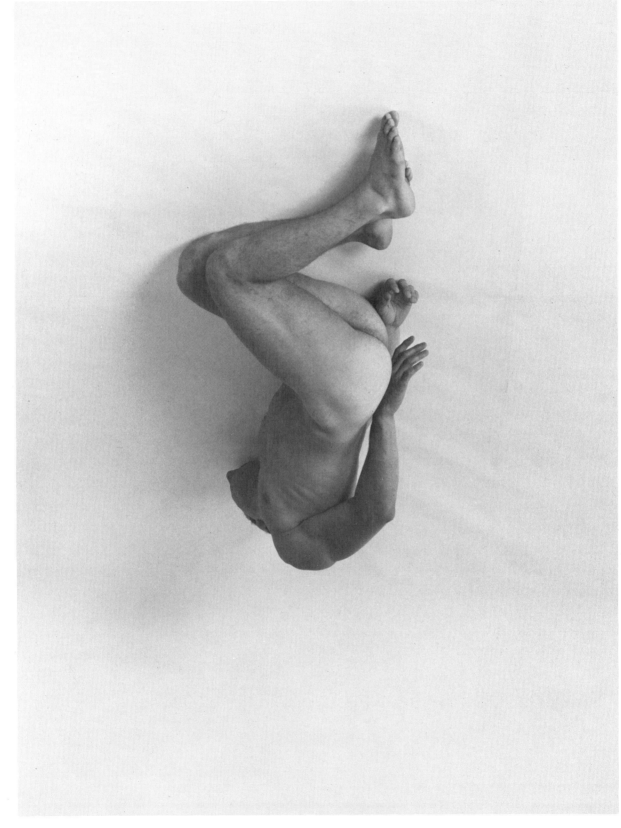

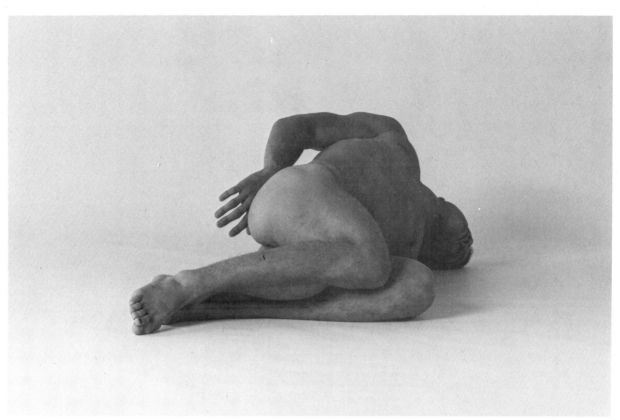

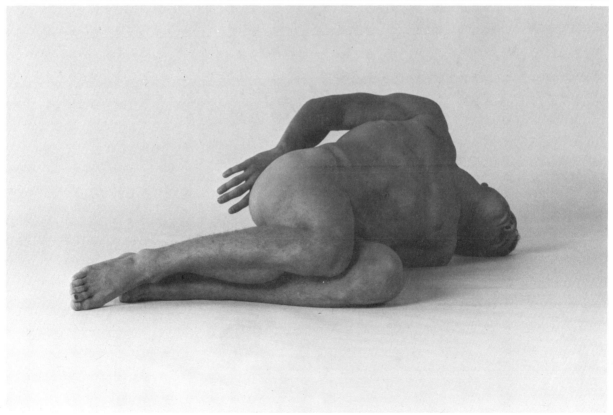

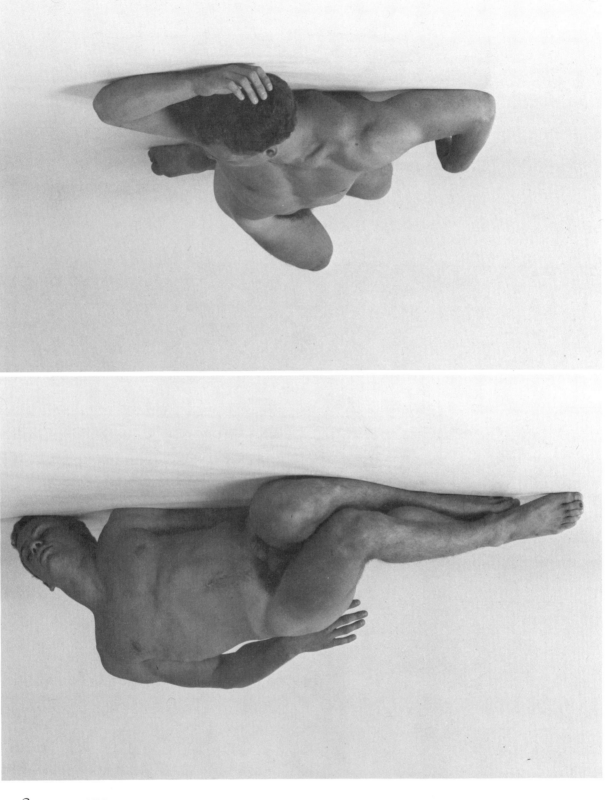

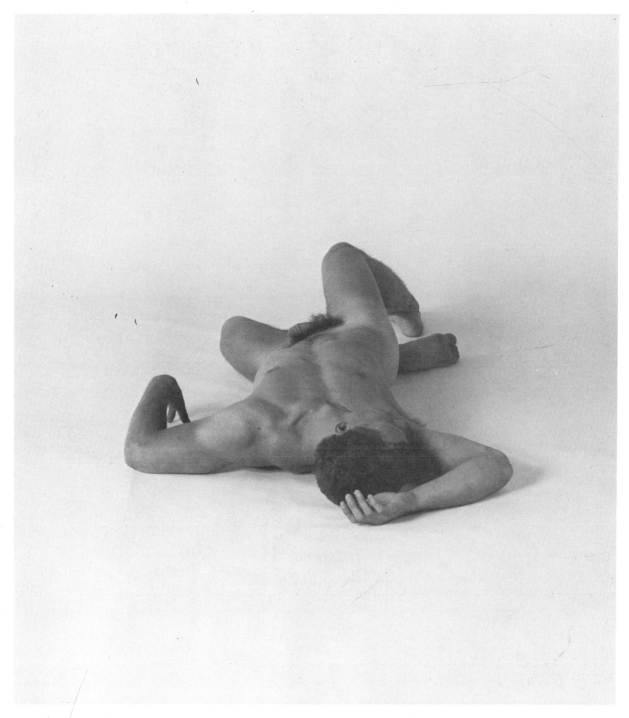

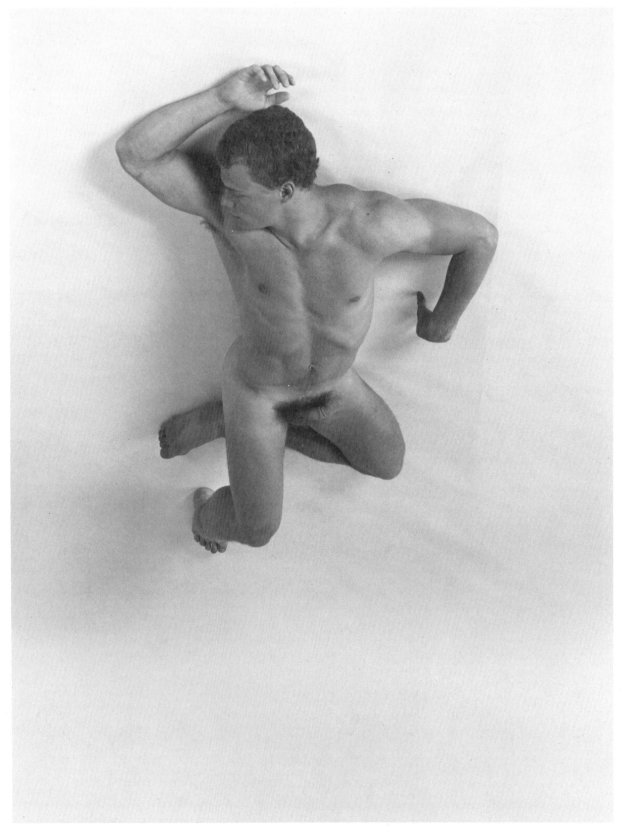

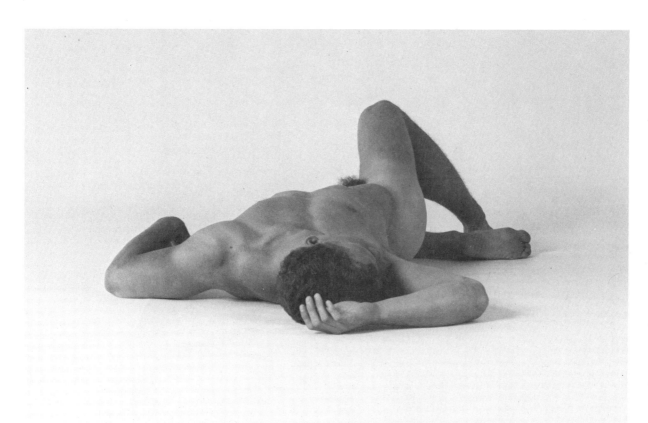

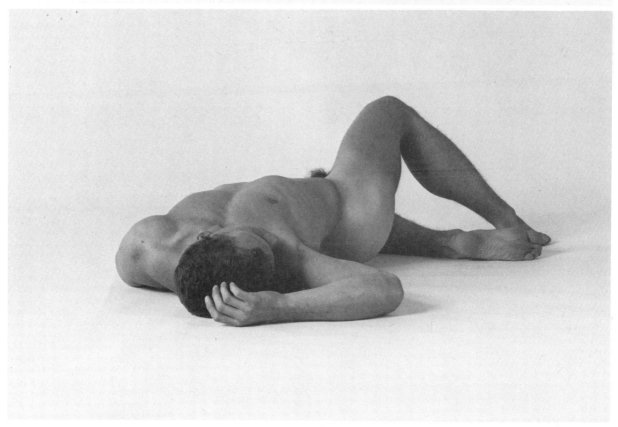

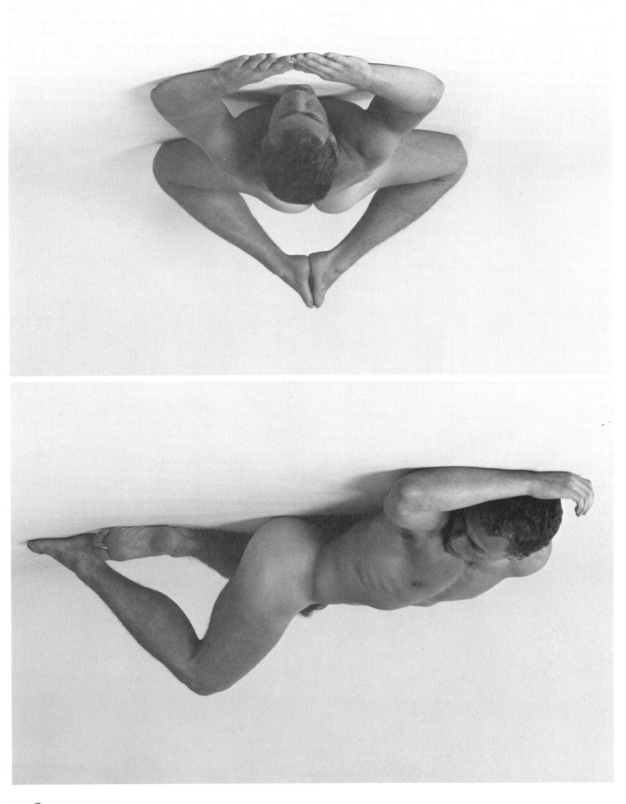

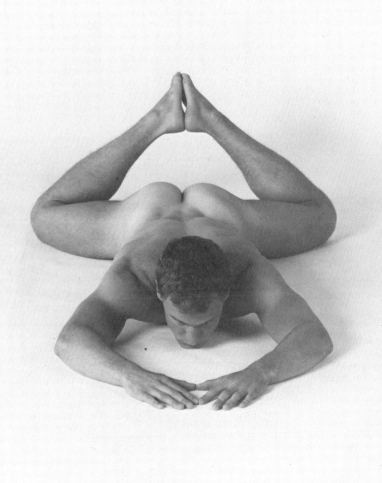

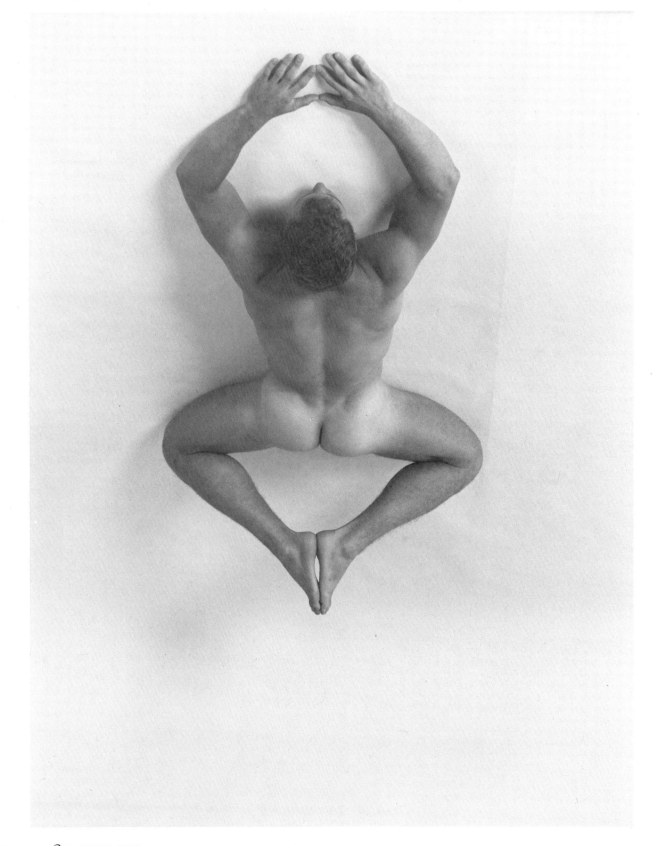

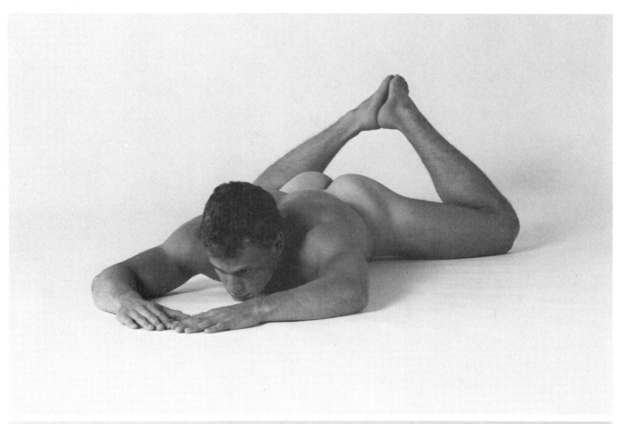

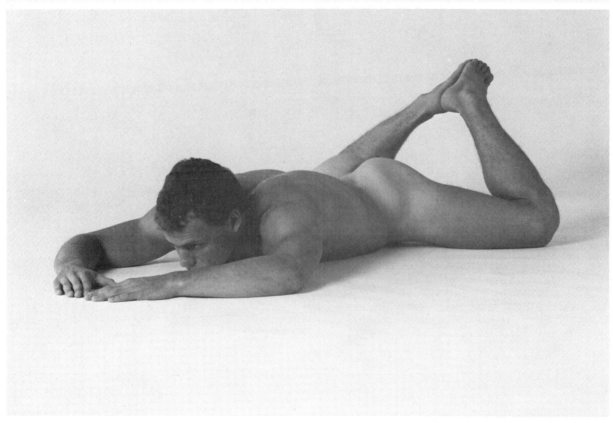

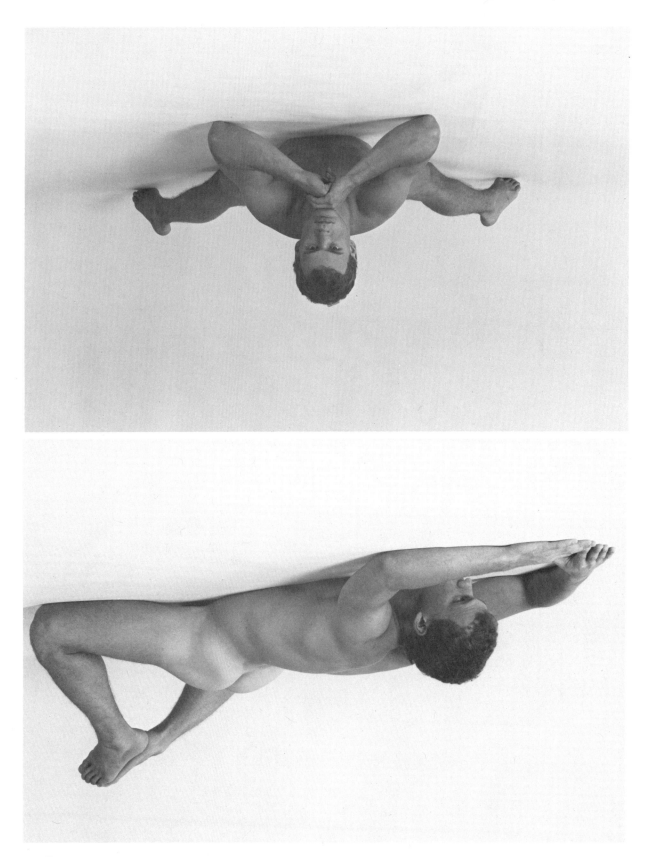

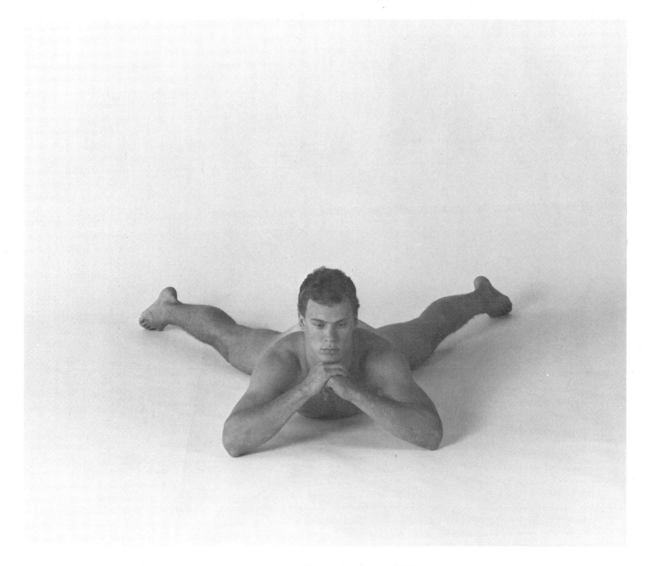

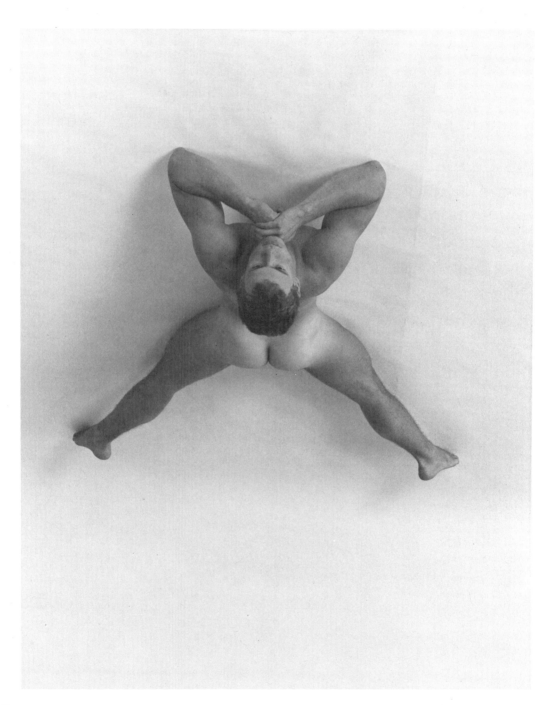

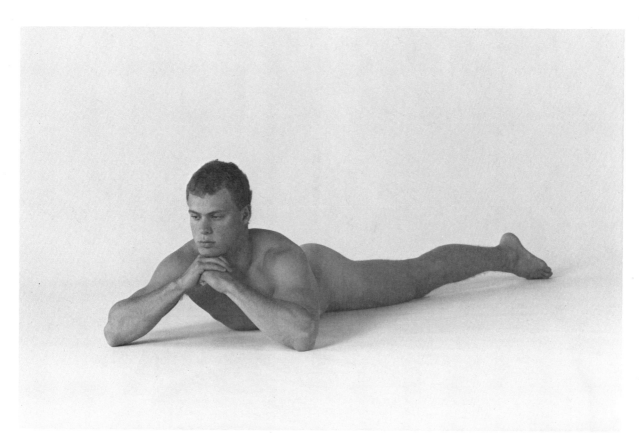

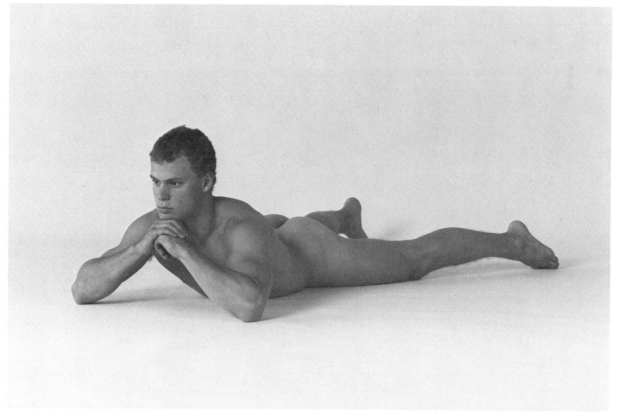

Foreshortened Views: Poses from Multiple Angles 171

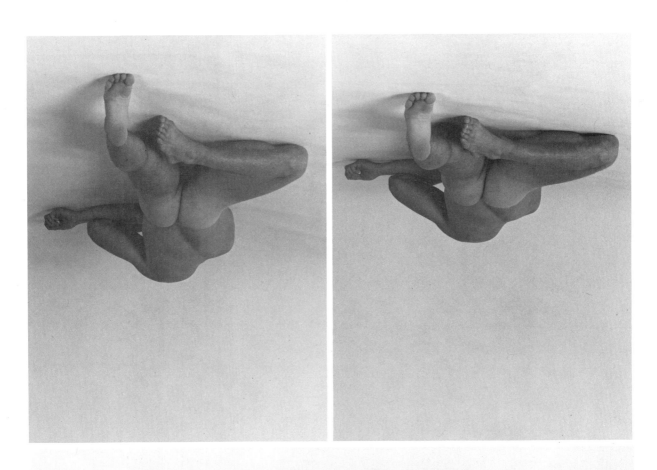

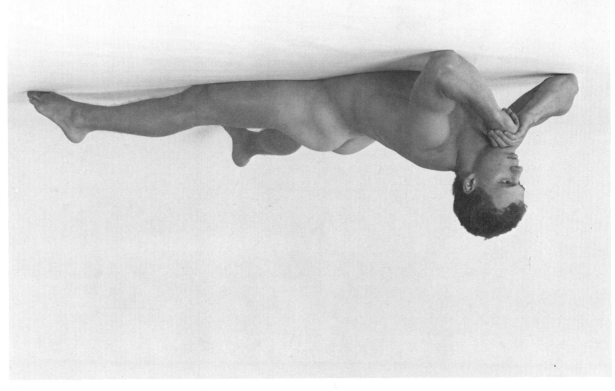

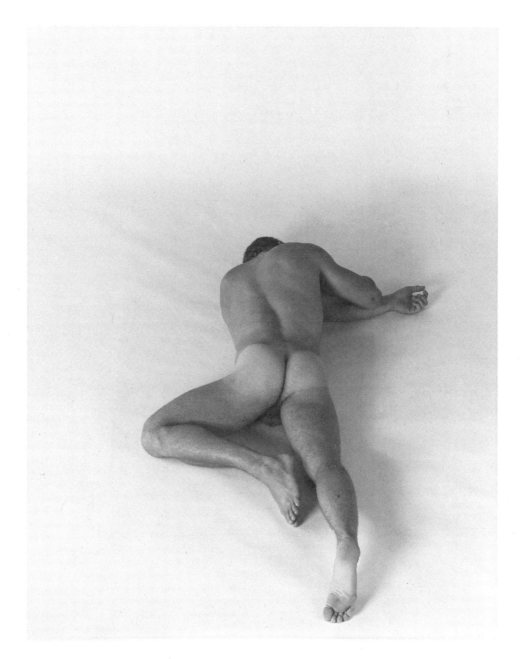

Foreshortened Views: Poses from Multiple Angles

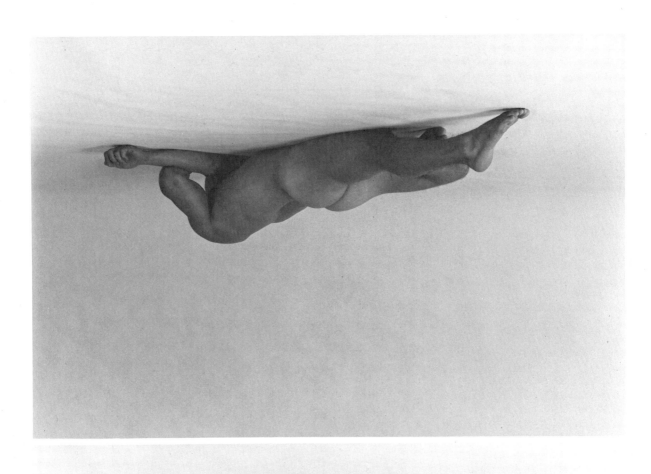

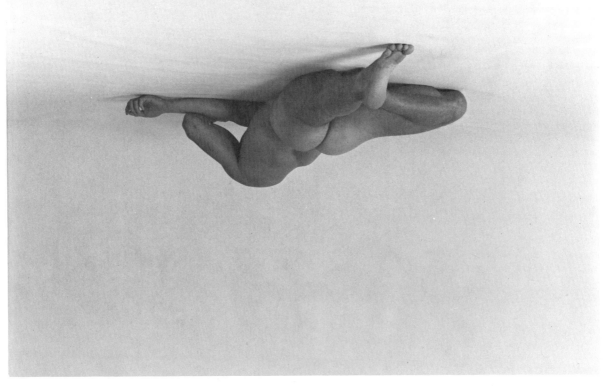

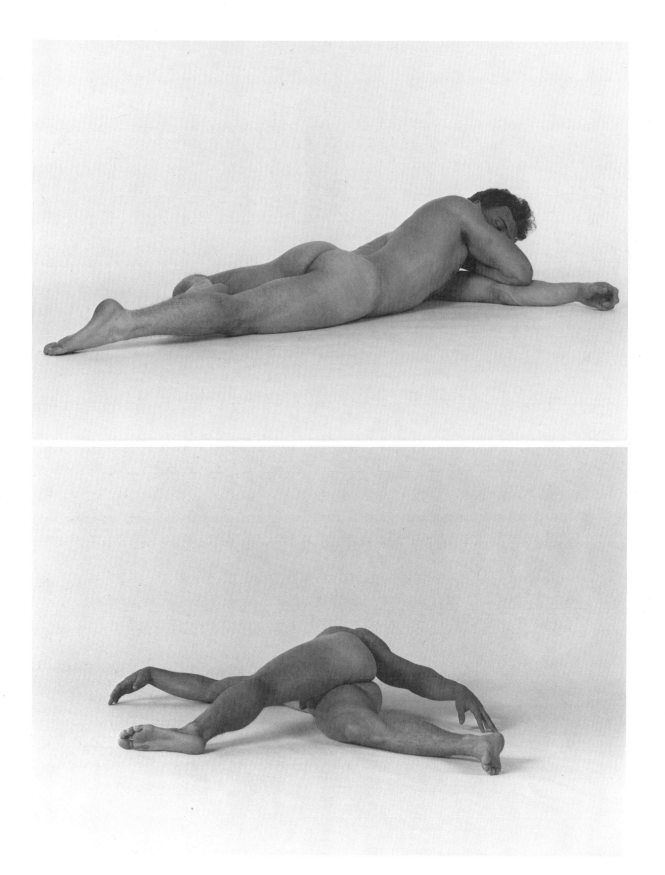

Foreshortened Views: Poses from Multiple Angles

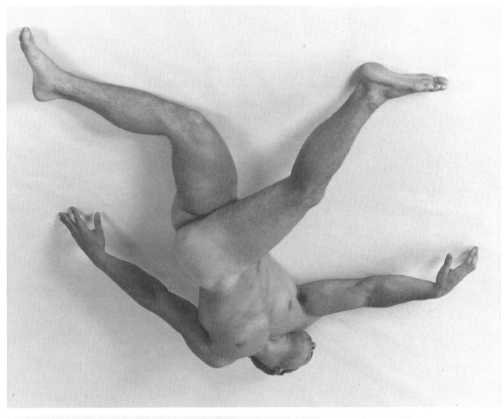

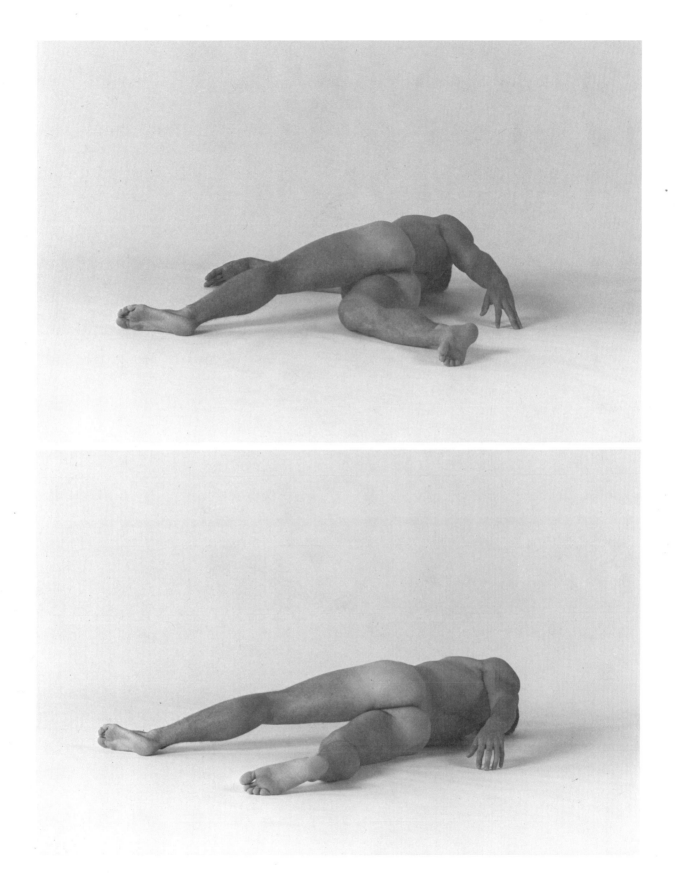

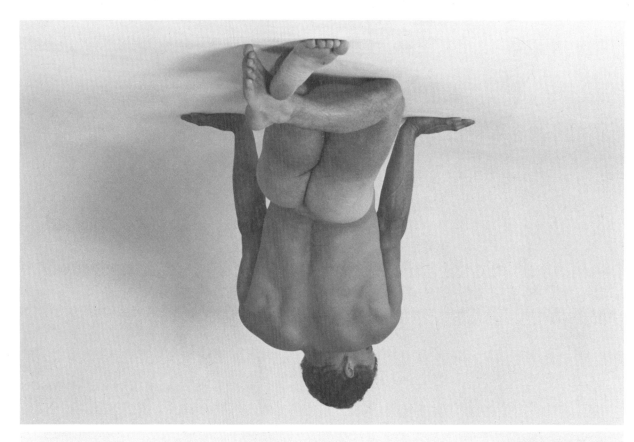

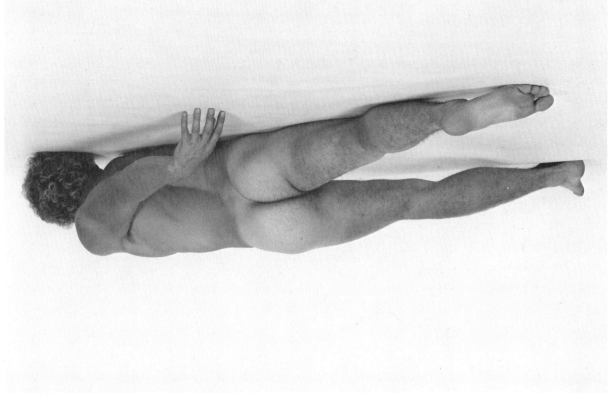

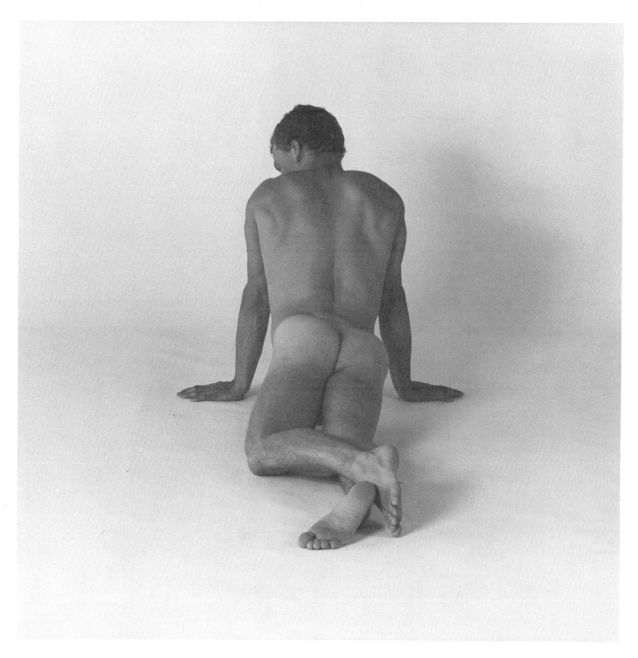

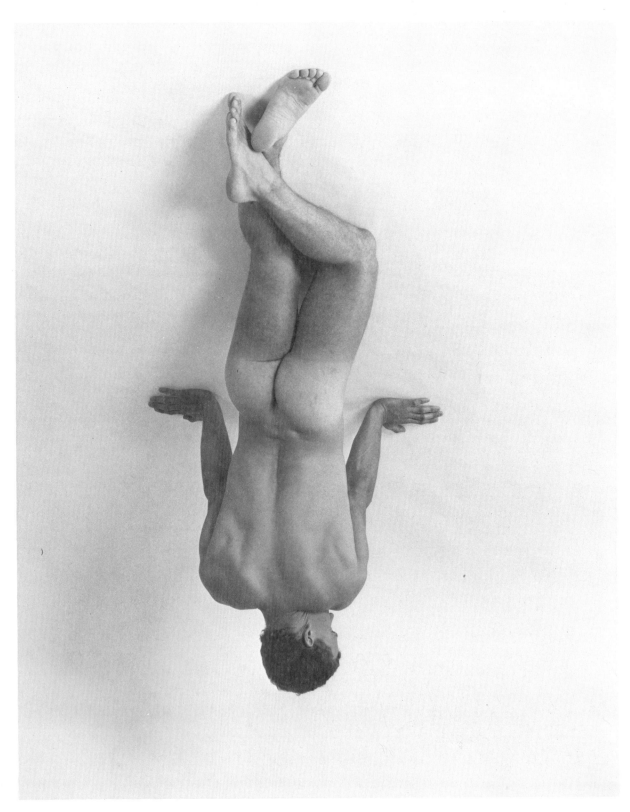

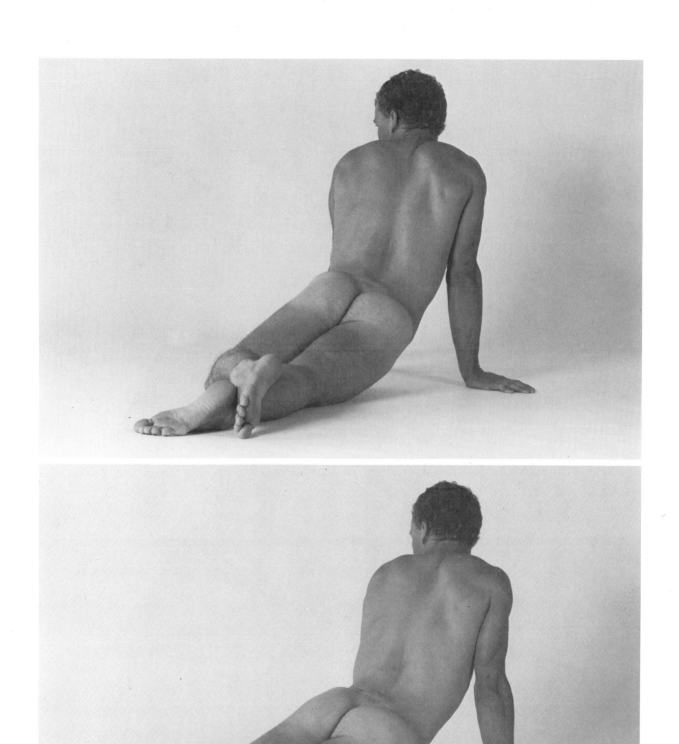

Foreshortened Views: Poses from Multiple Angles 181

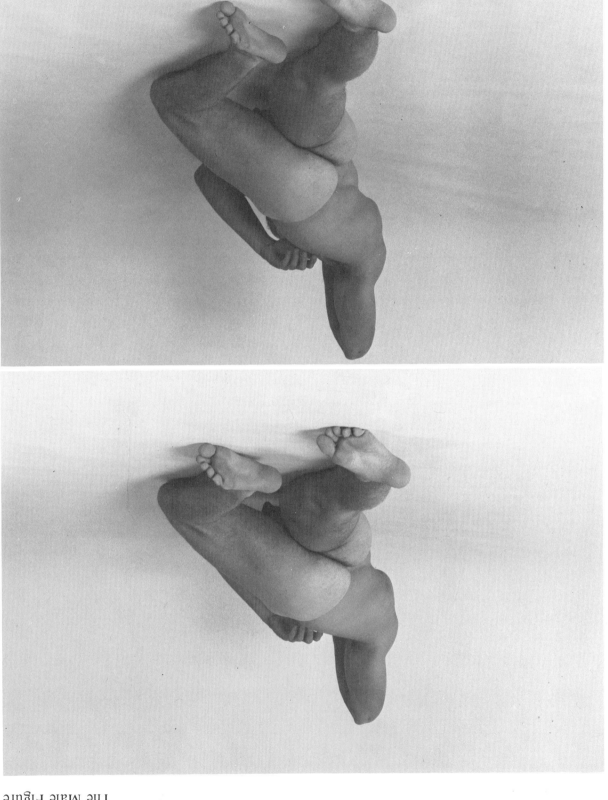

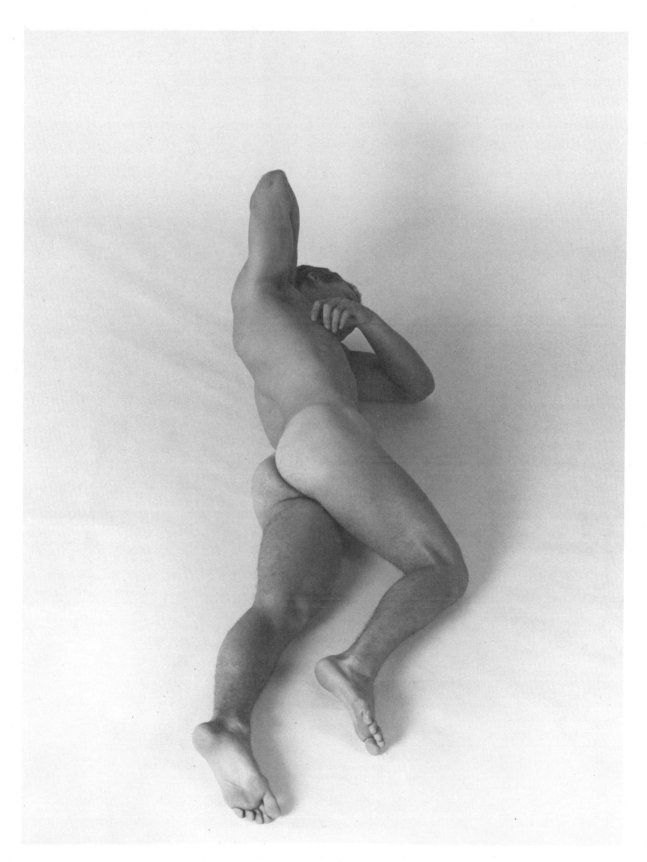

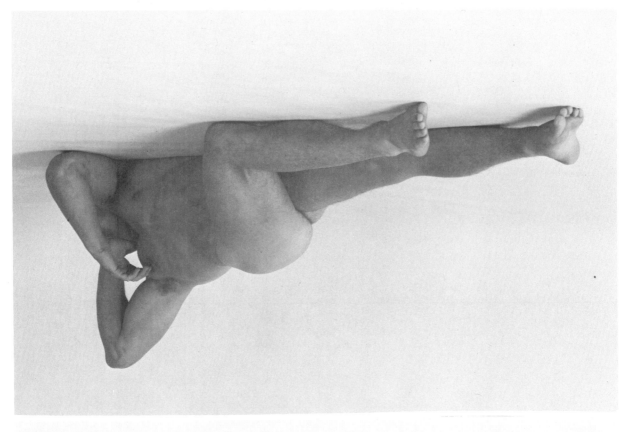

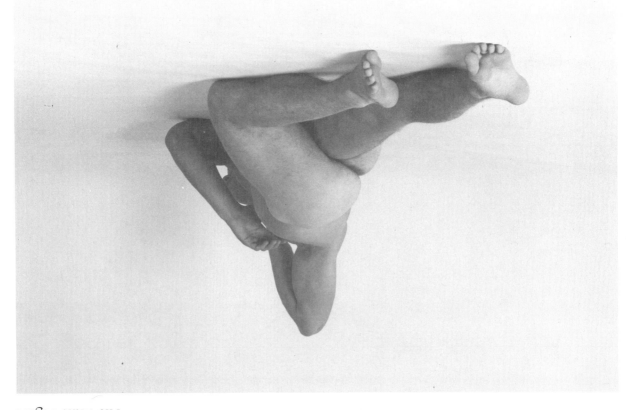

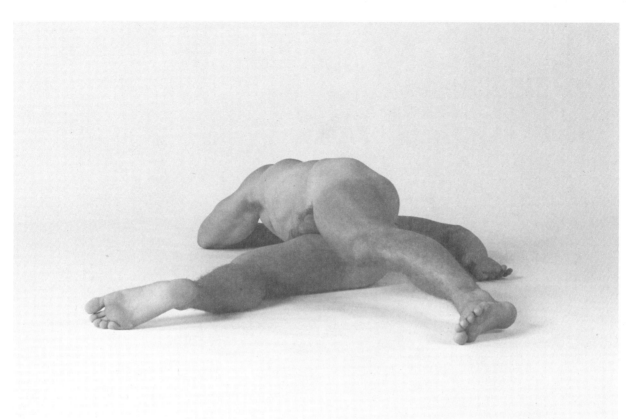

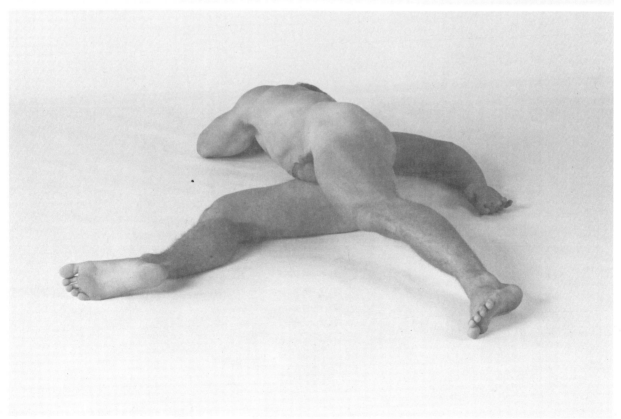

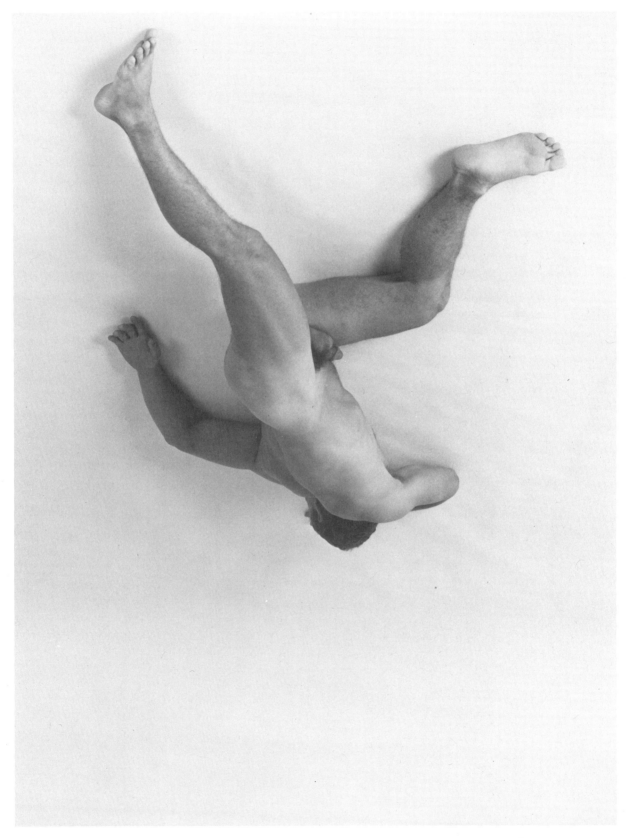

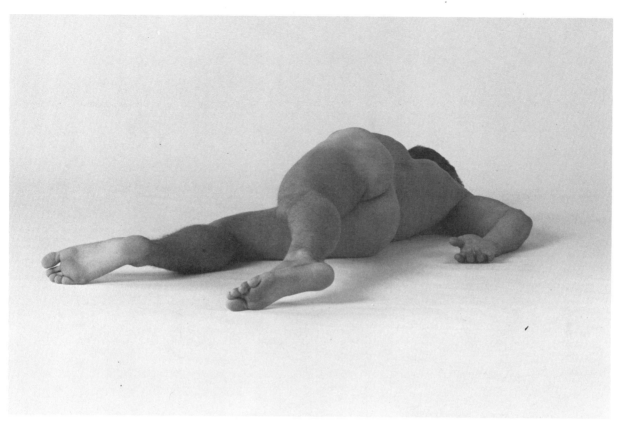

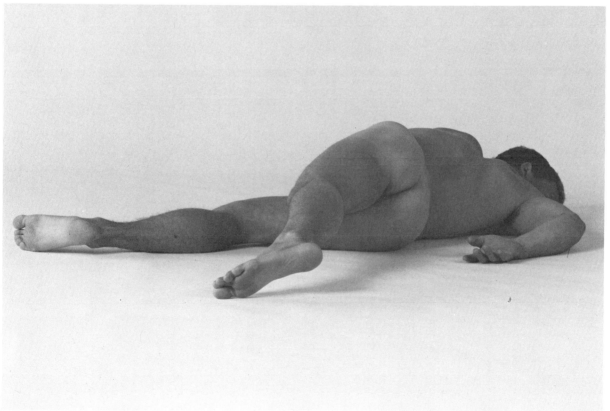

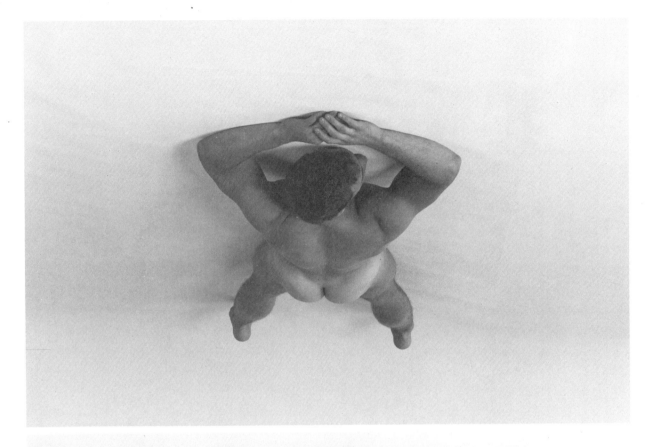

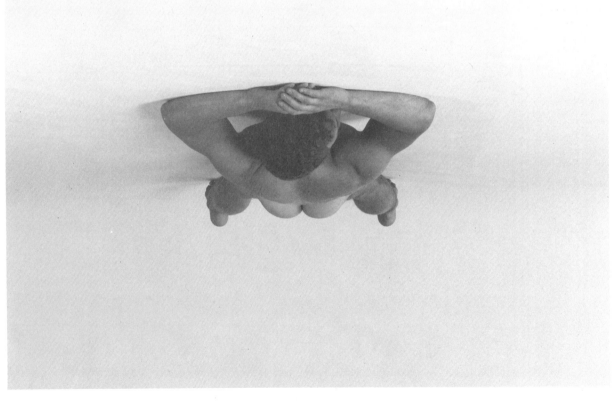

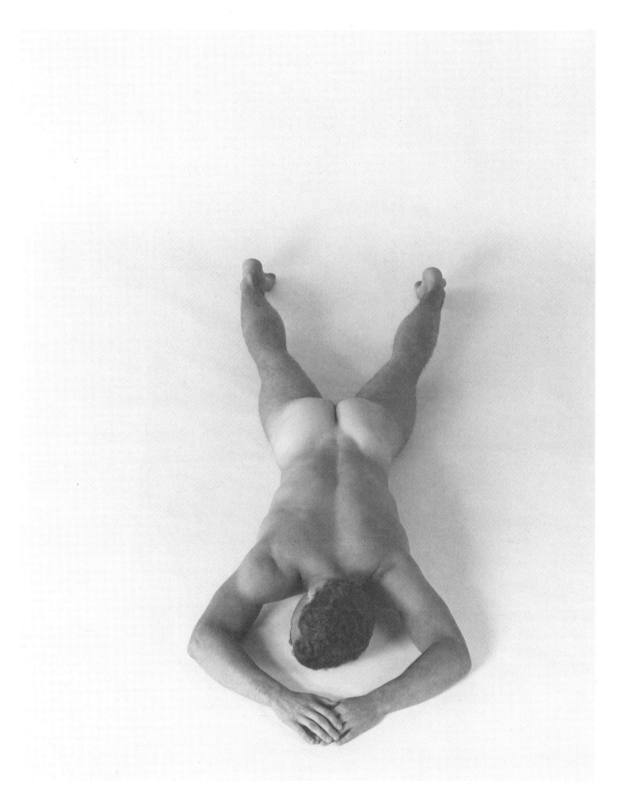

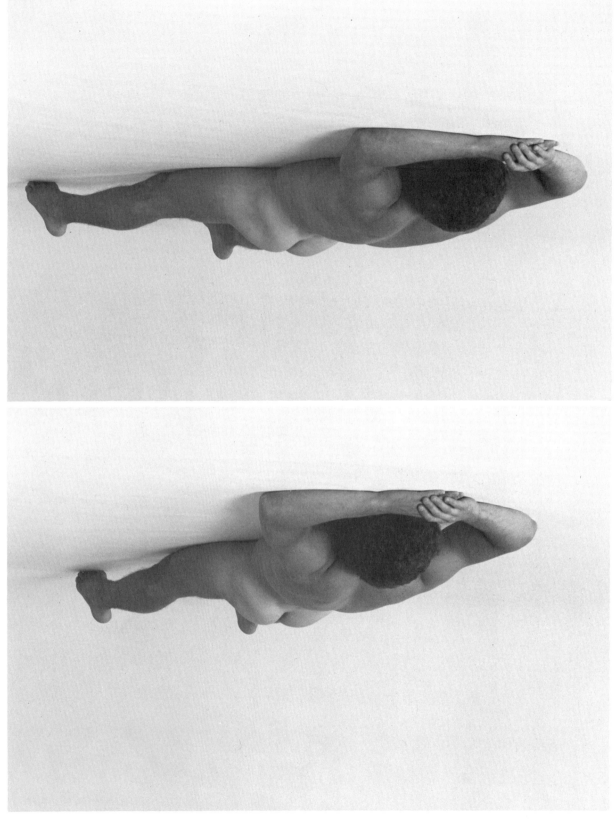

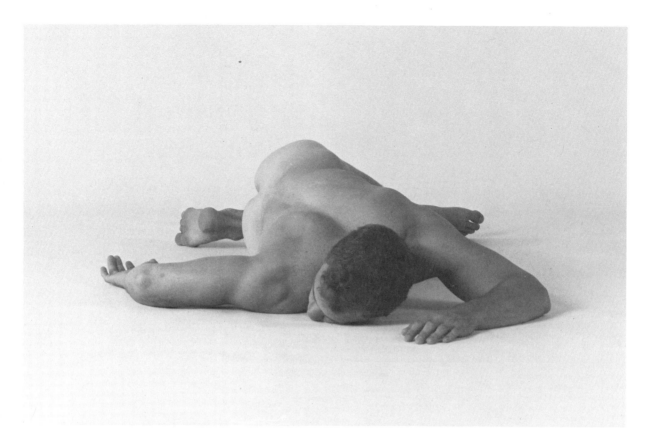

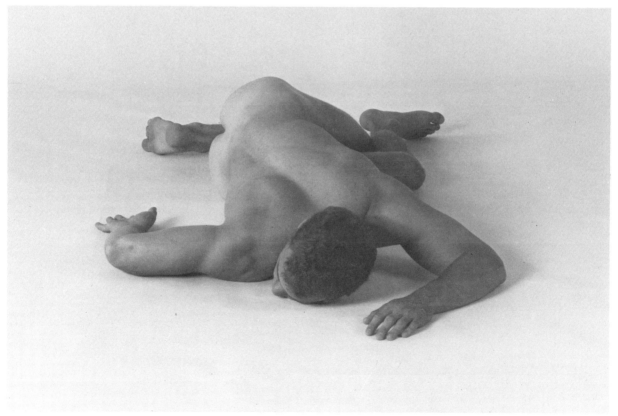

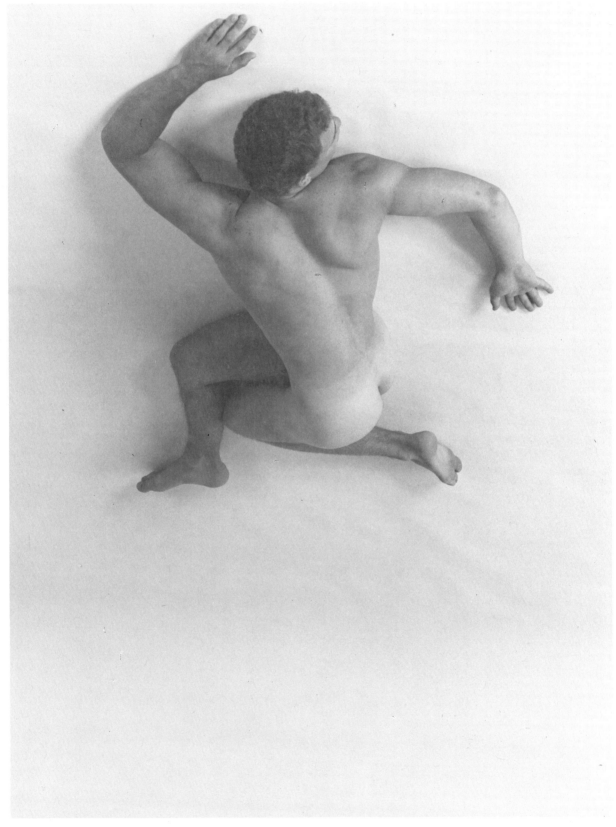

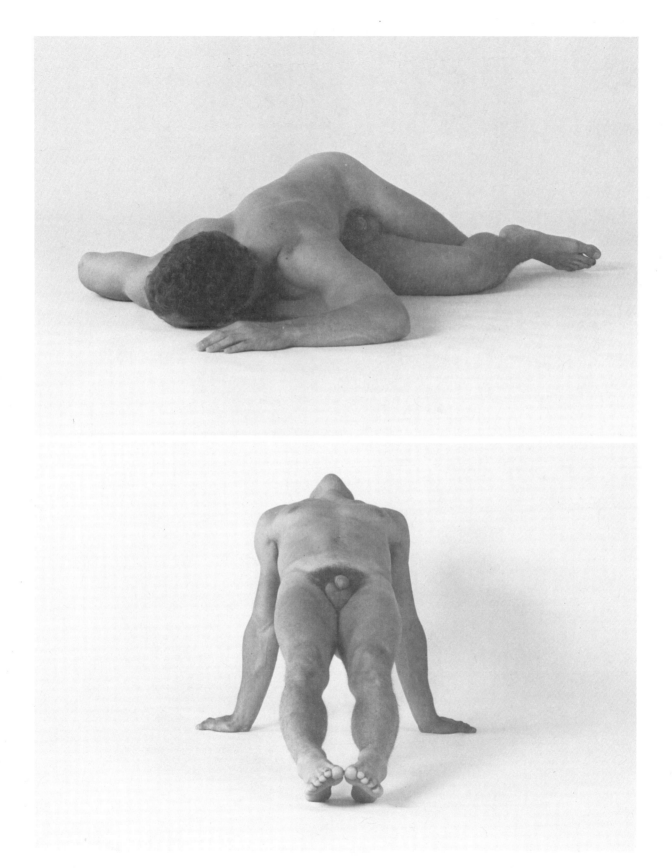

Foreshortened Views: Poses from Multiple Angles 193

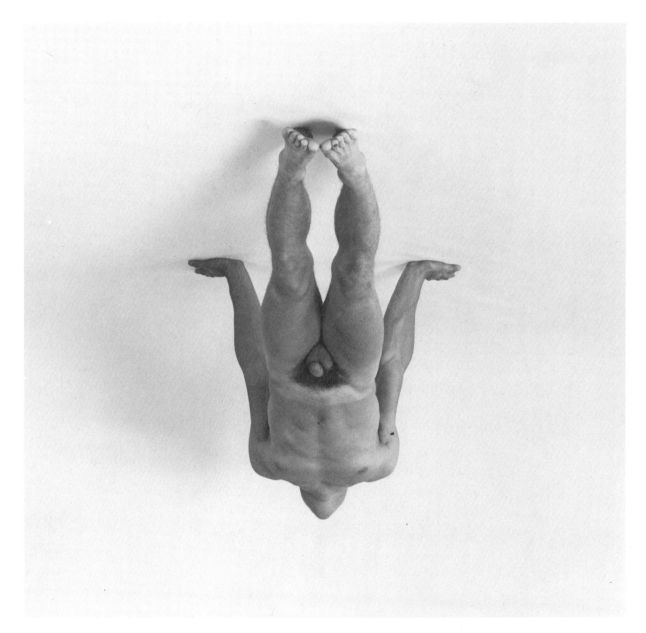

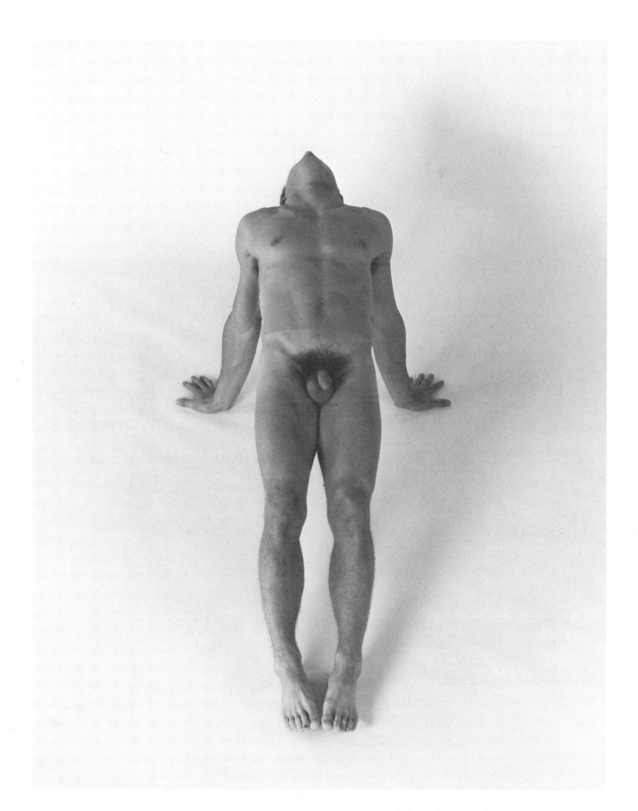

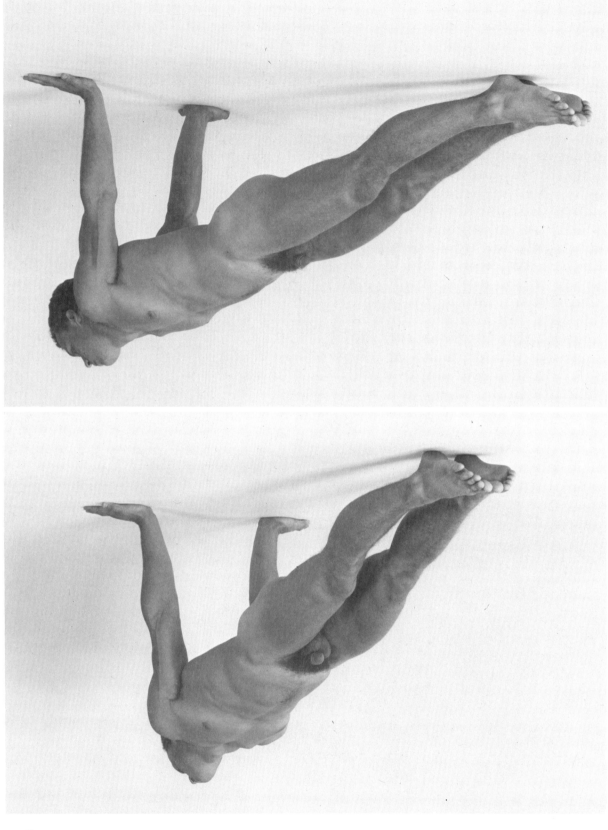

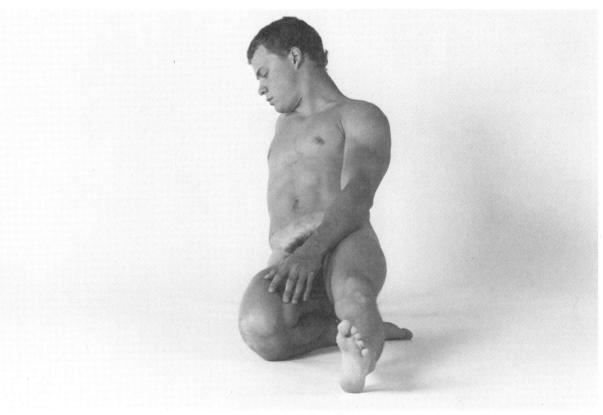

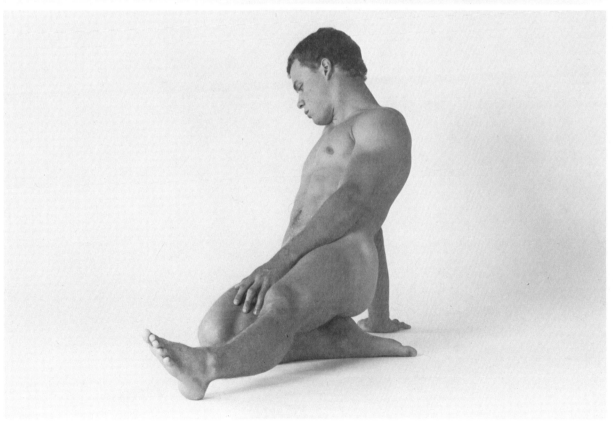

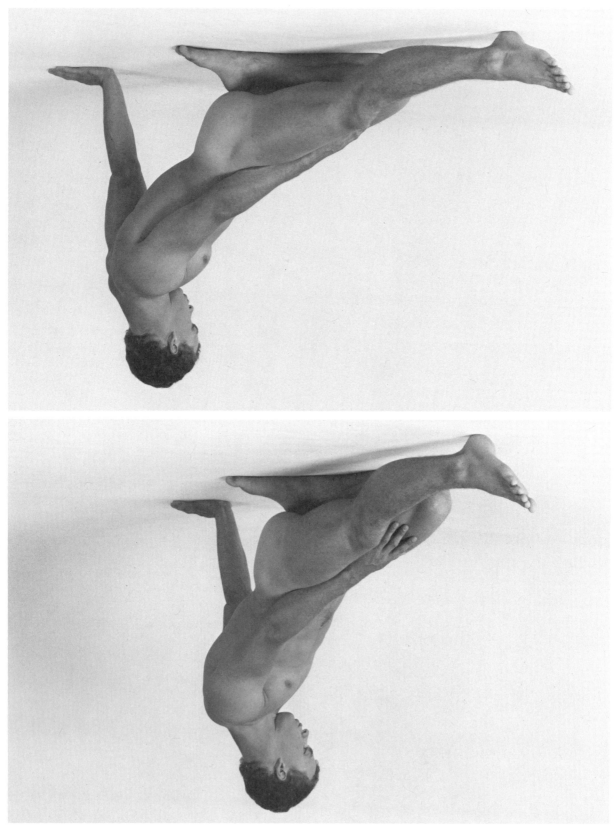

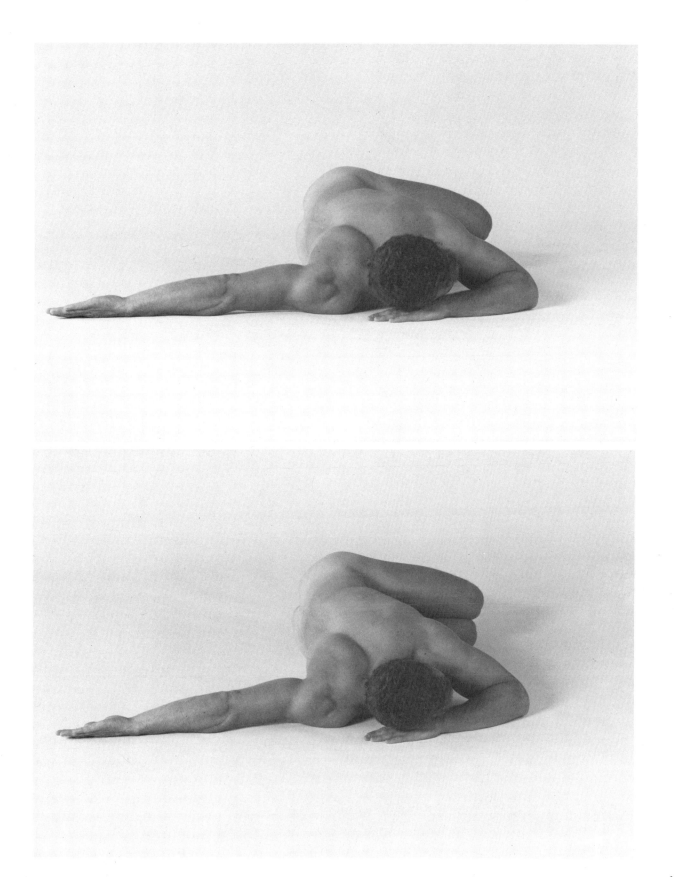

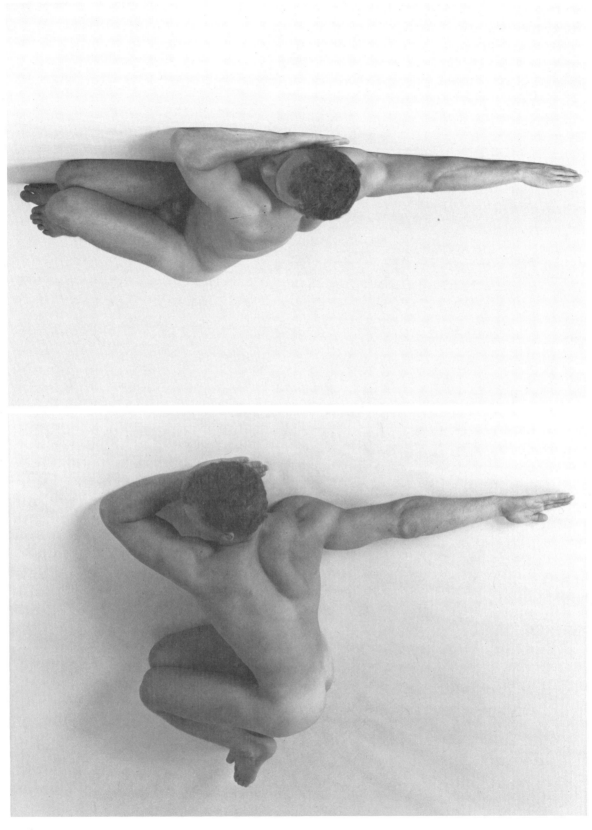

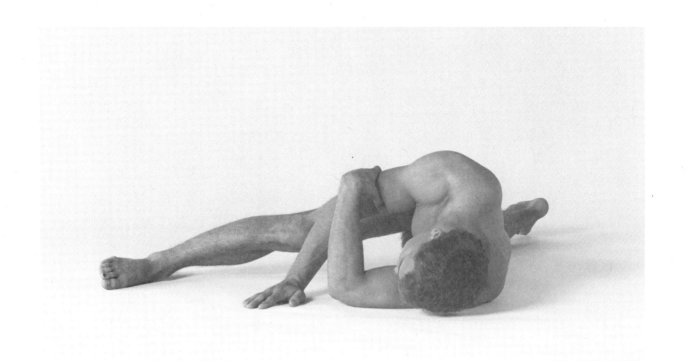

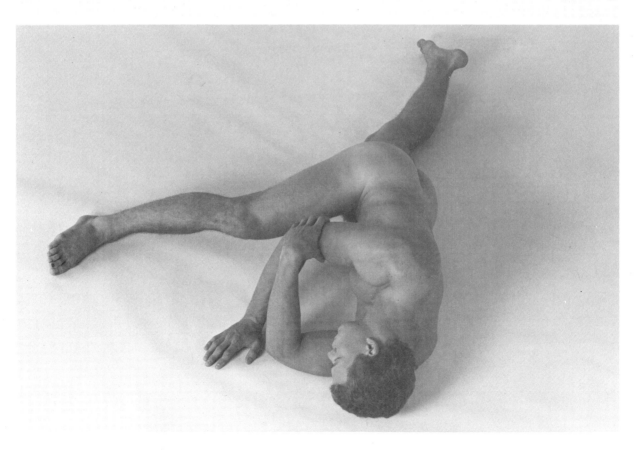

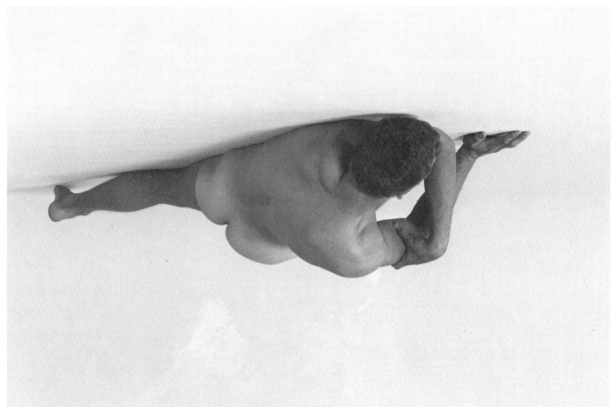

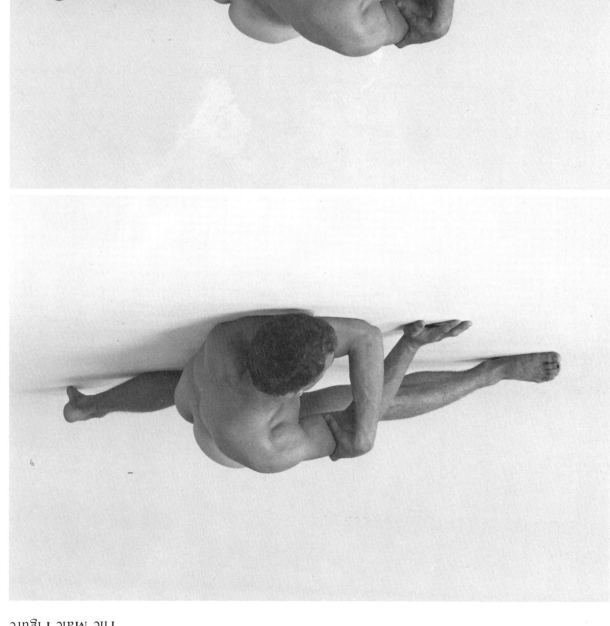

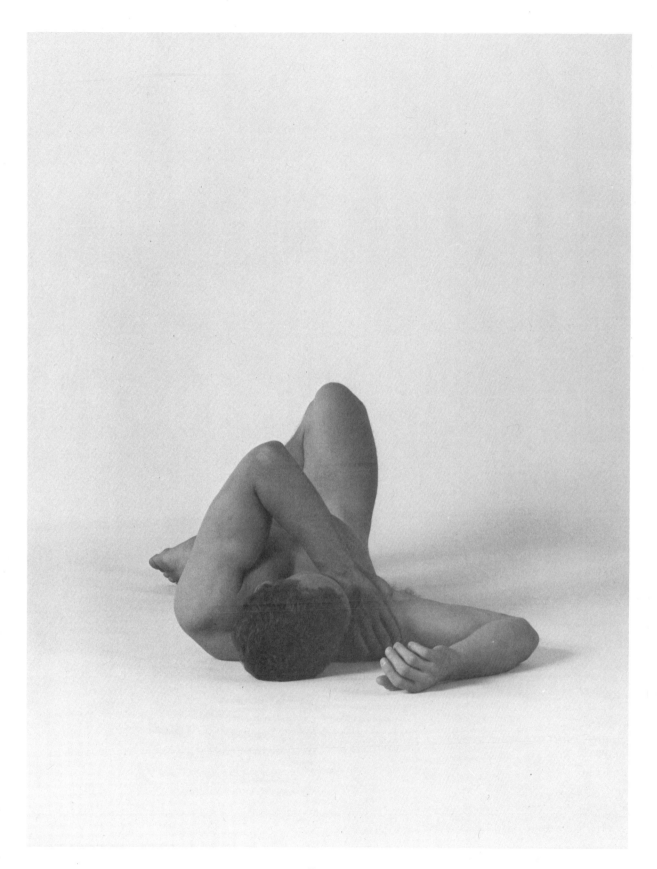

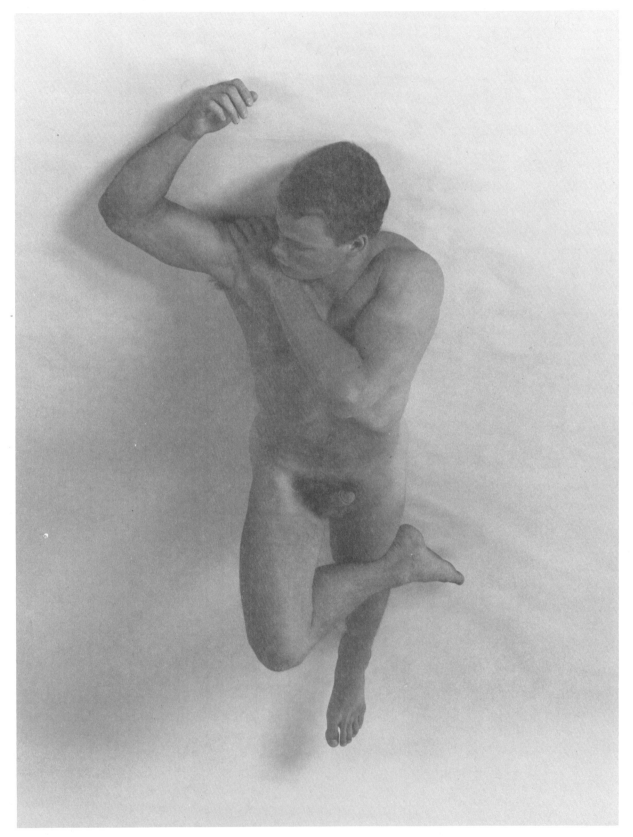

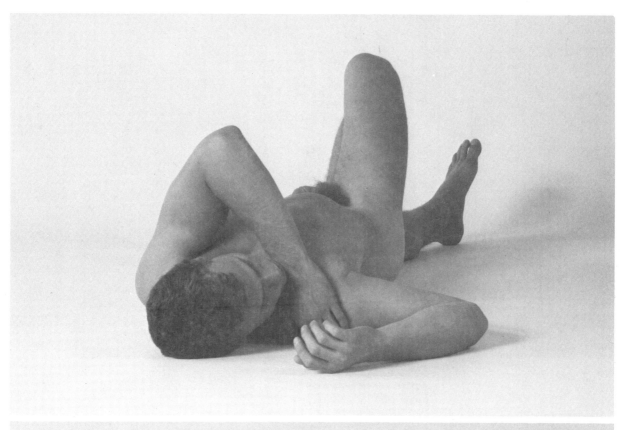

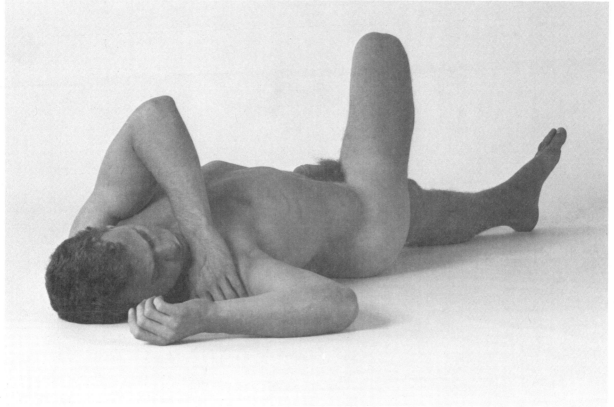

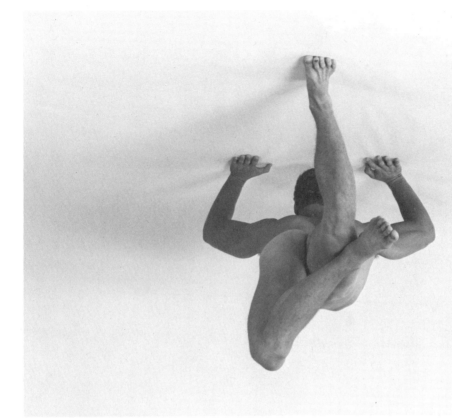

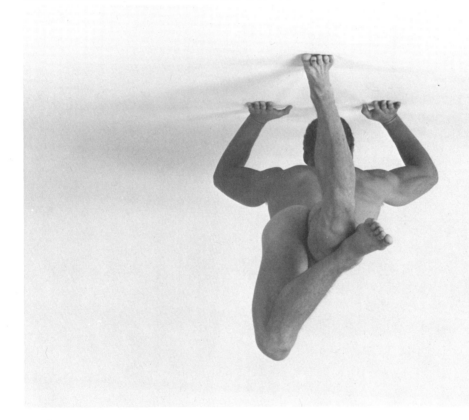

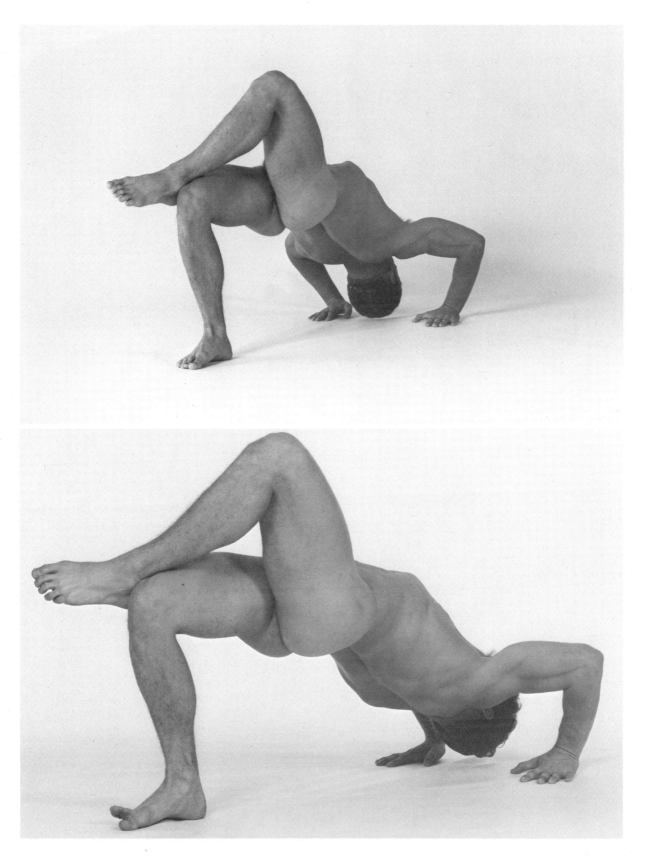

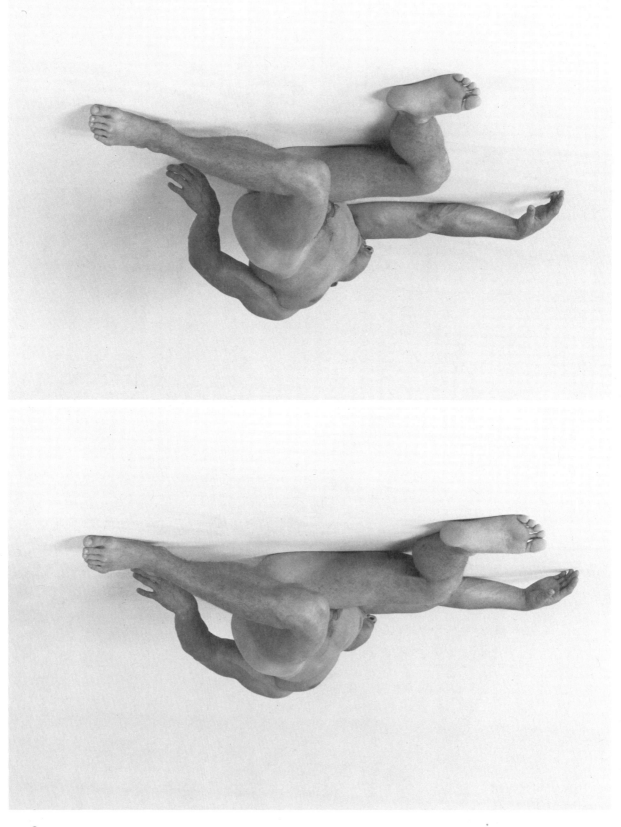

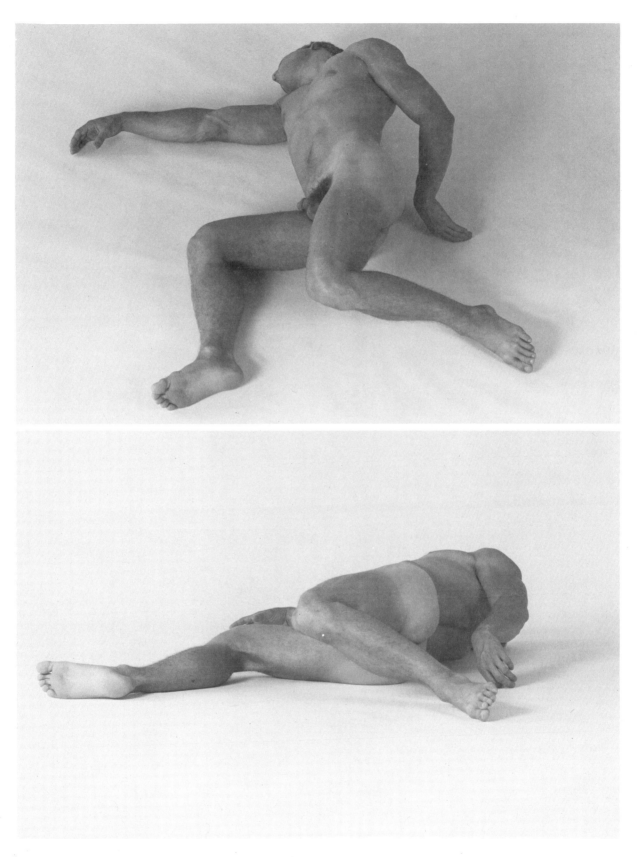

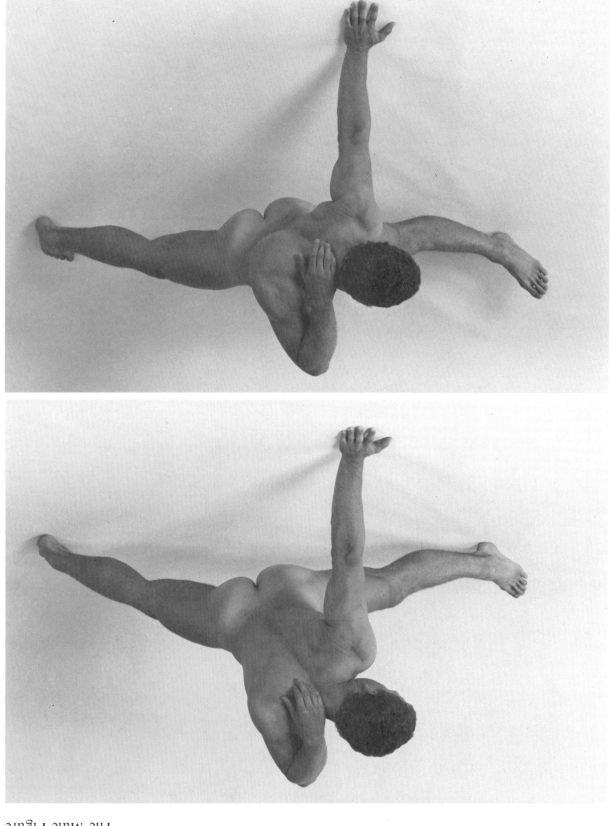

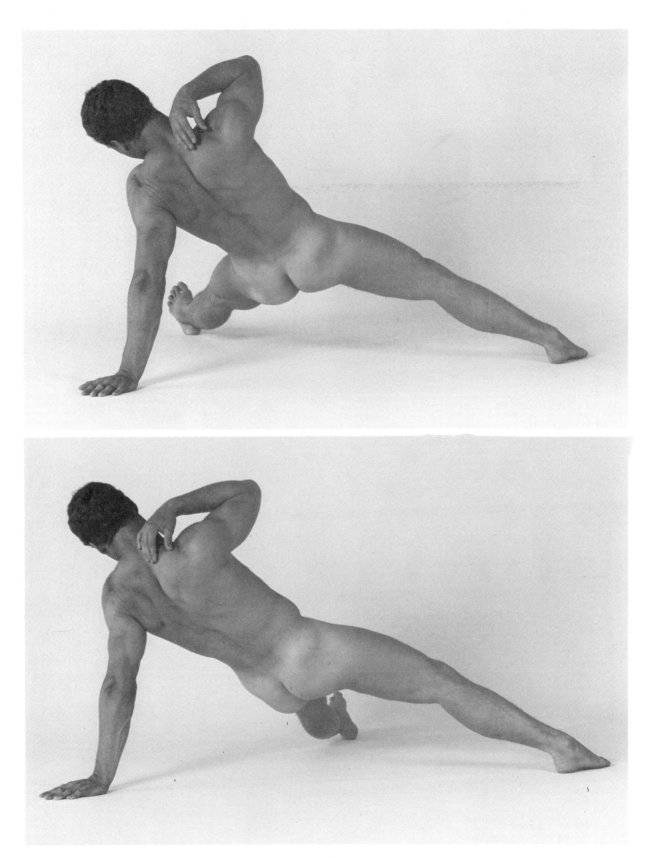

Foreshortened Views: Poses from Multiple Angles

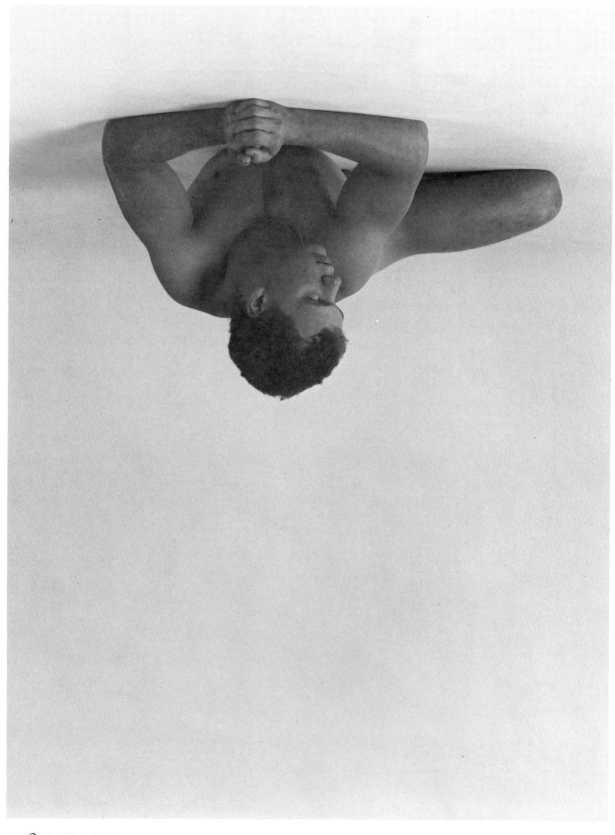

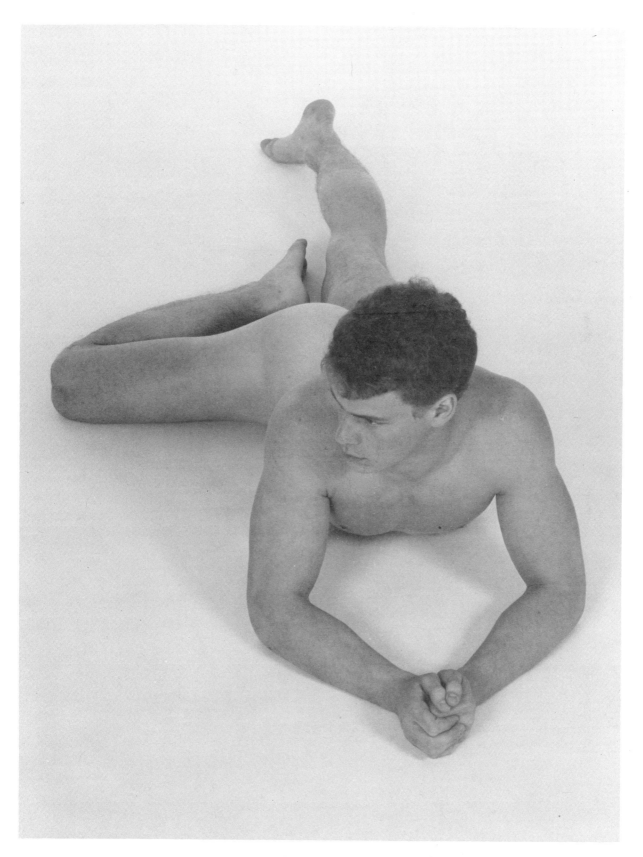

Foreshortened Views: Poses from Multiple Angles 213

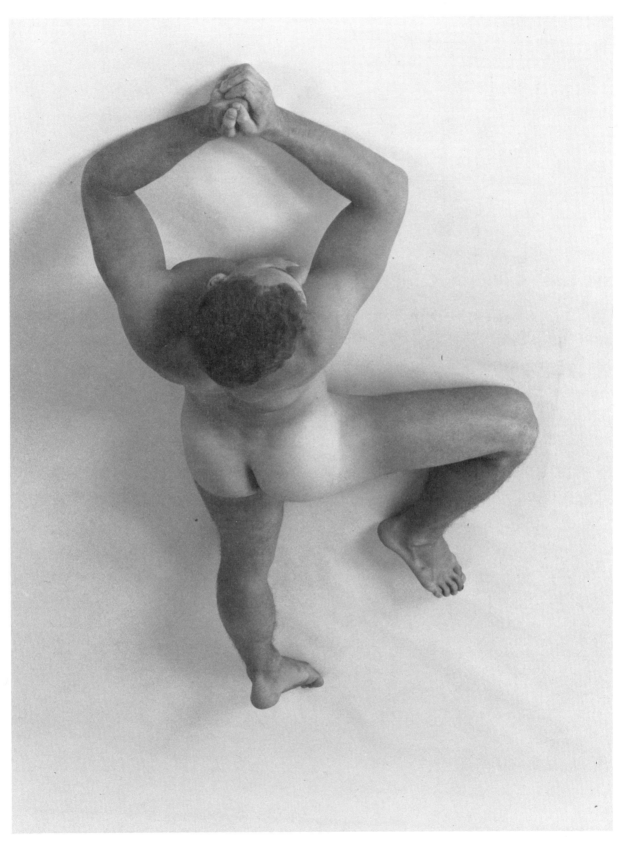

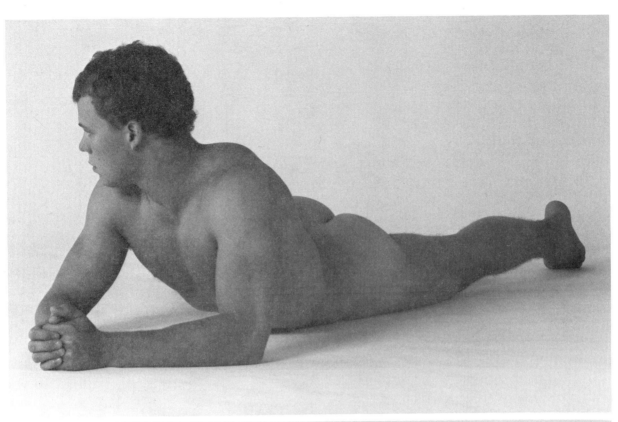

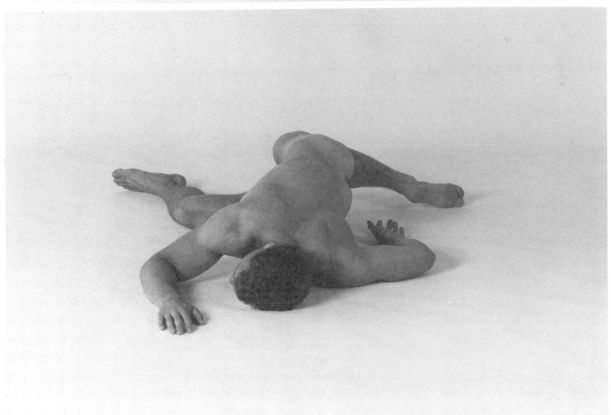

Foreshortened Views: Poses from Multiple Angles 215

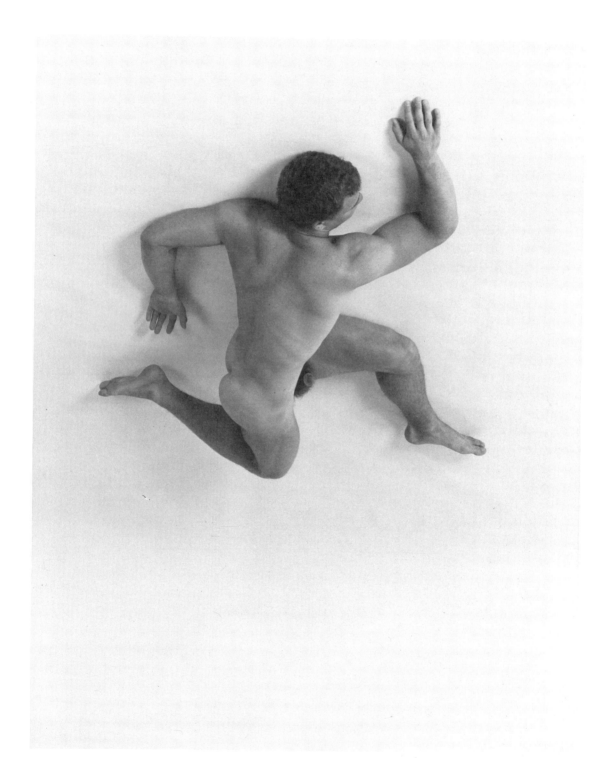

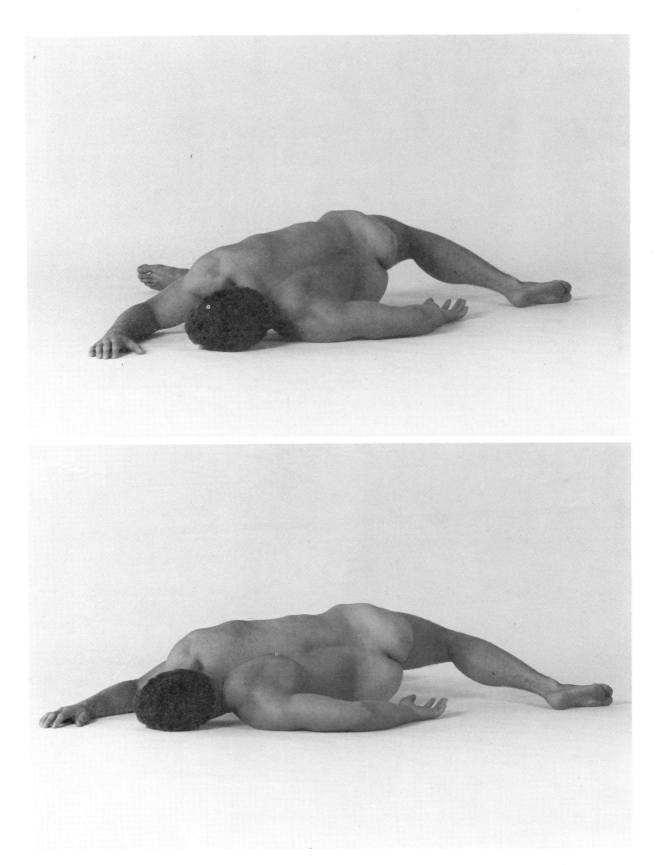

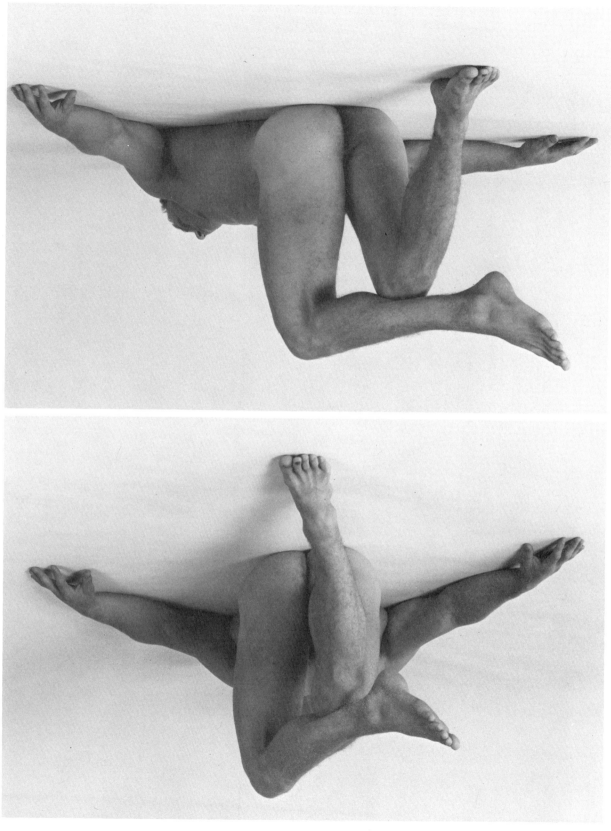

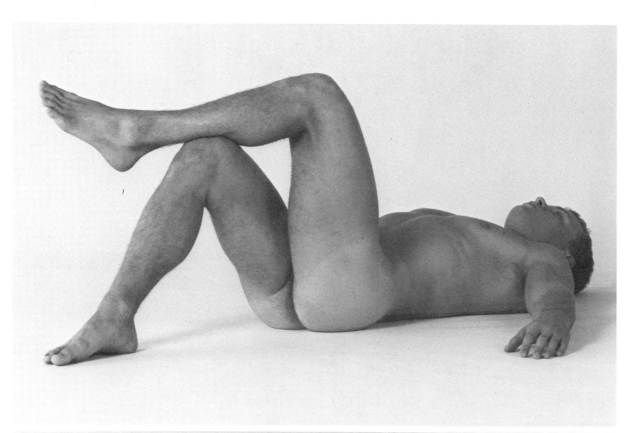

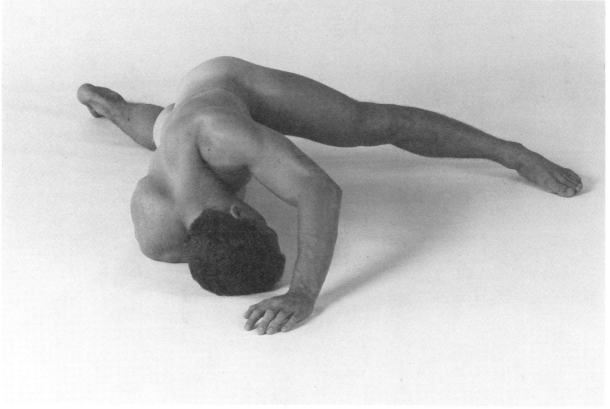

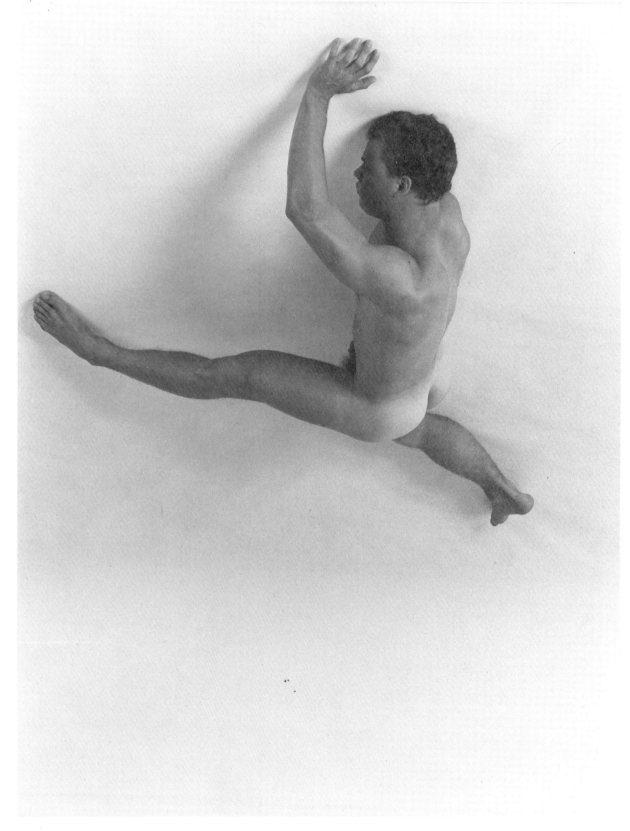

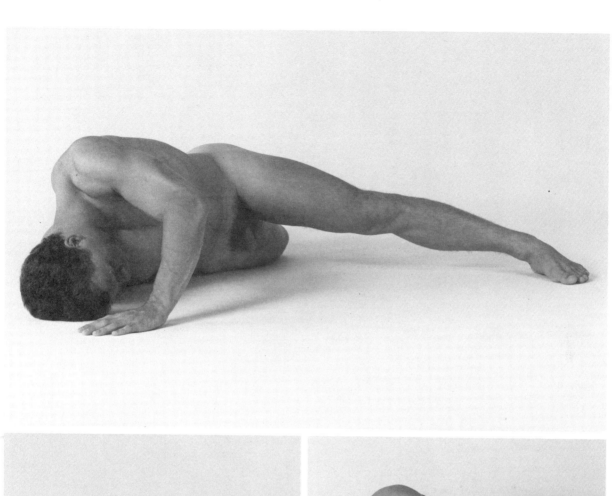

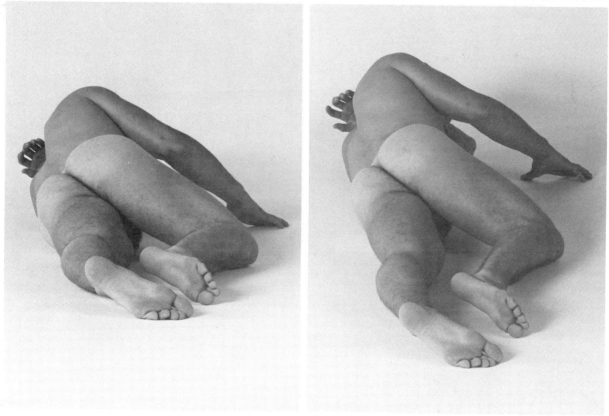

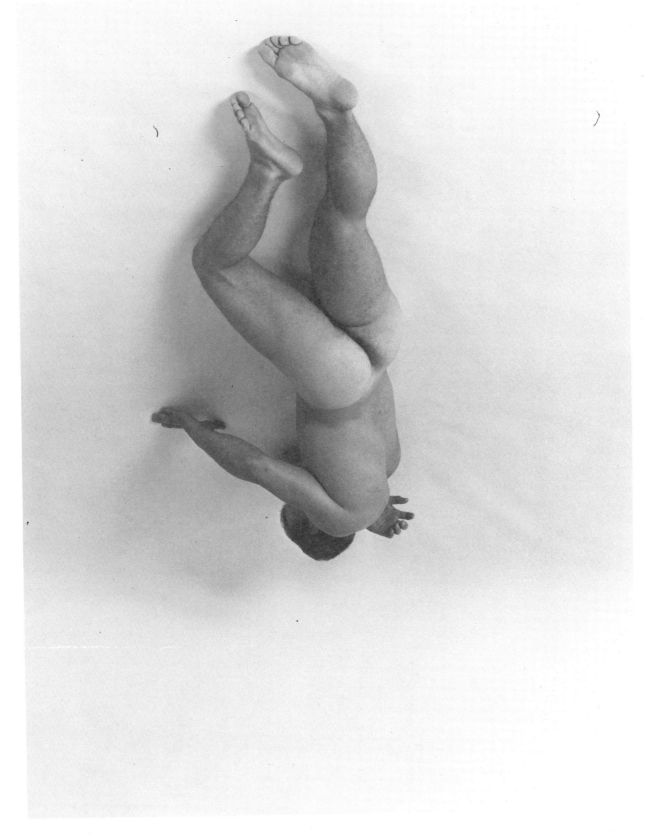

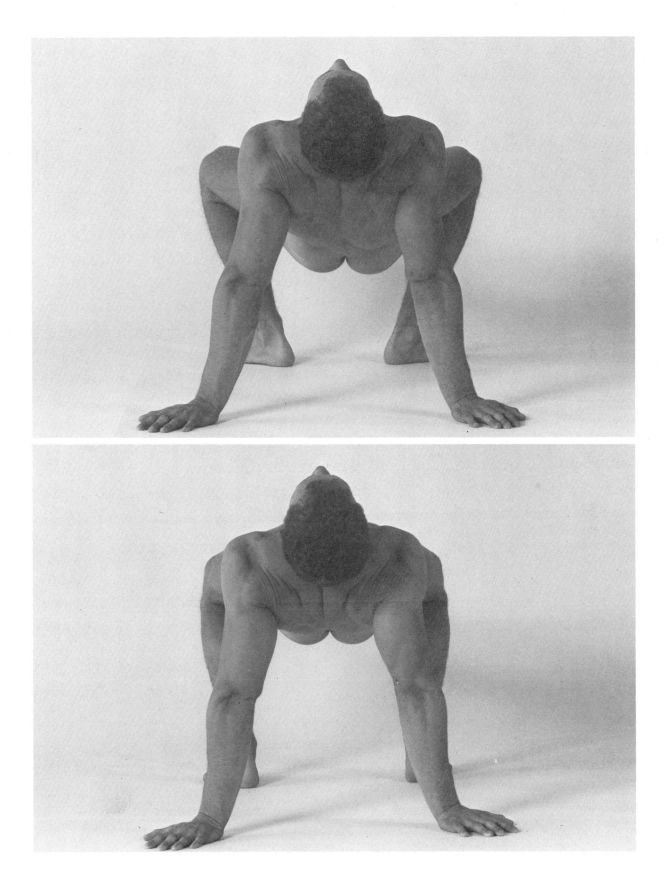

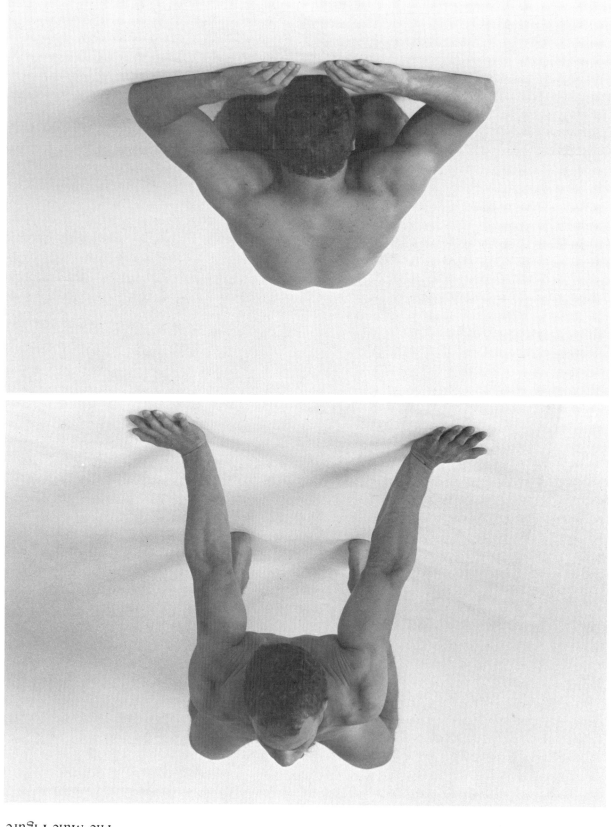

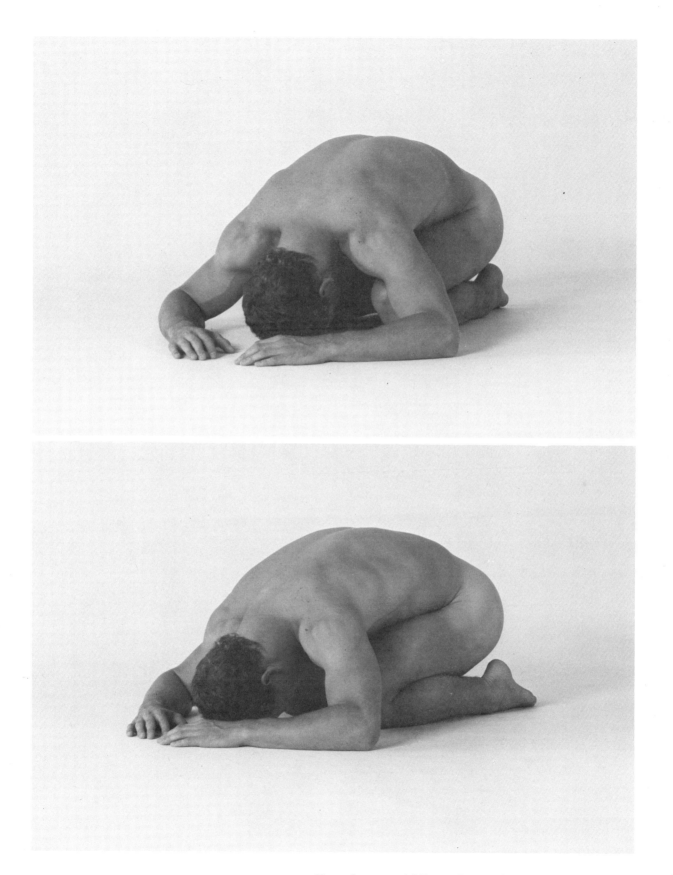

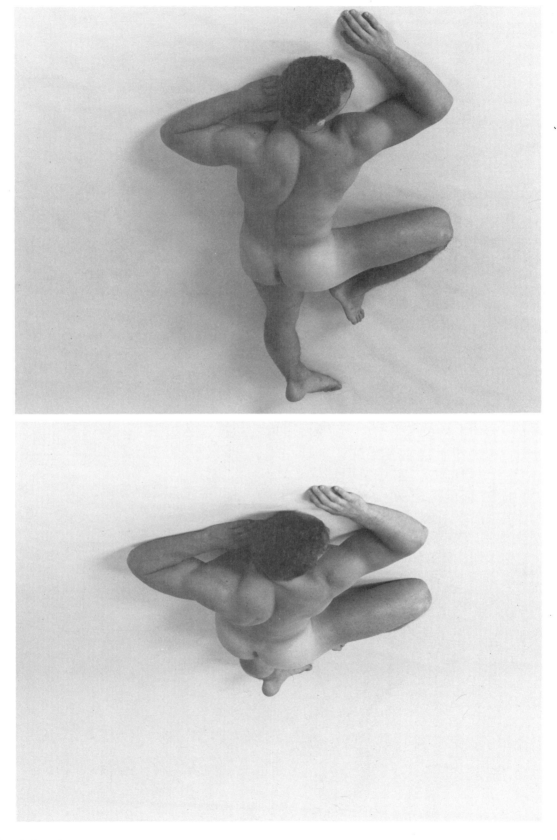

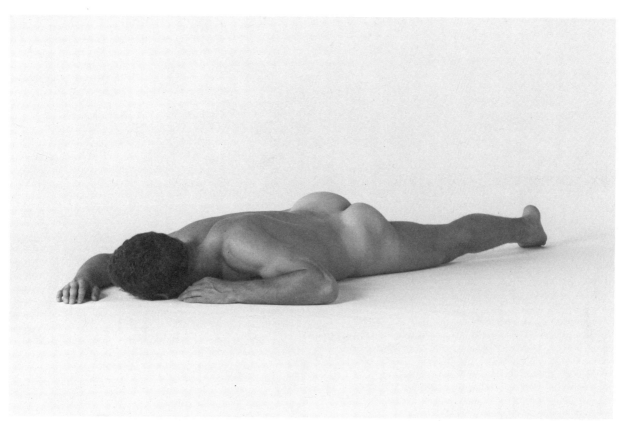

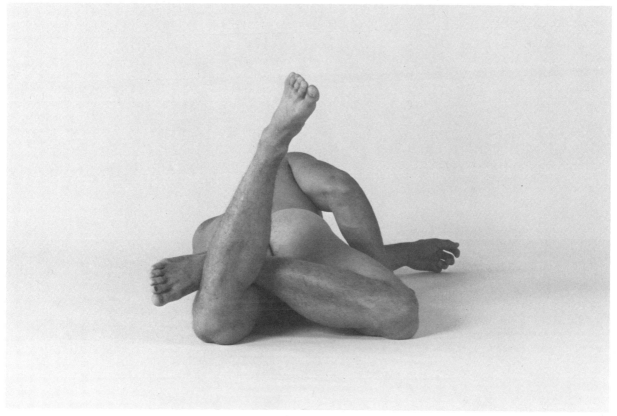

Foreshortened Views: Poses from Multiple Angles 227

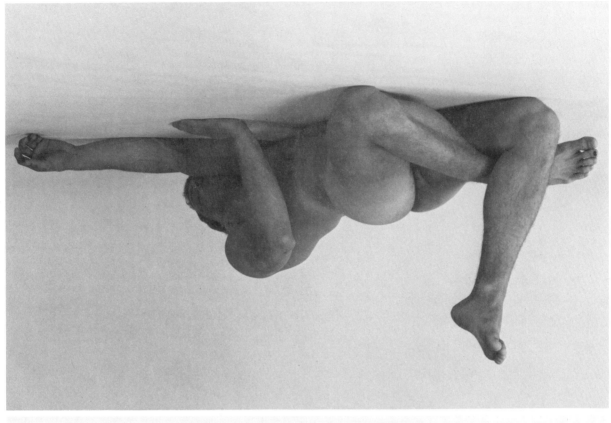

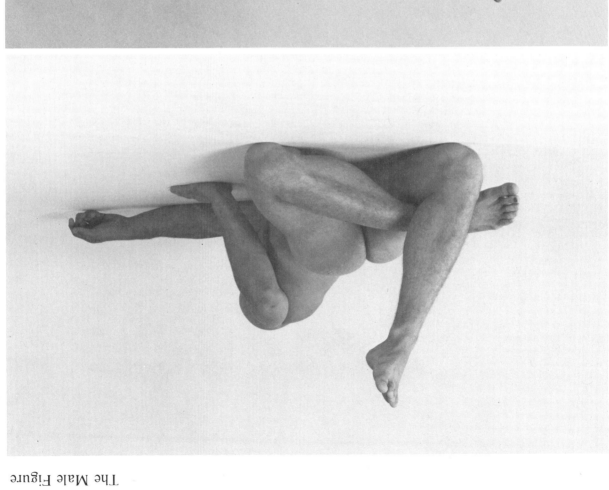

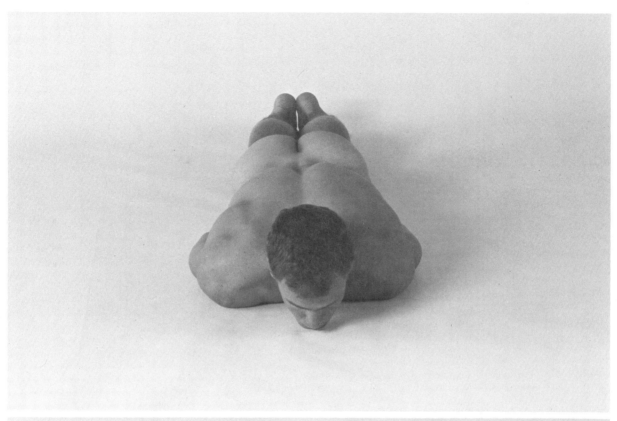

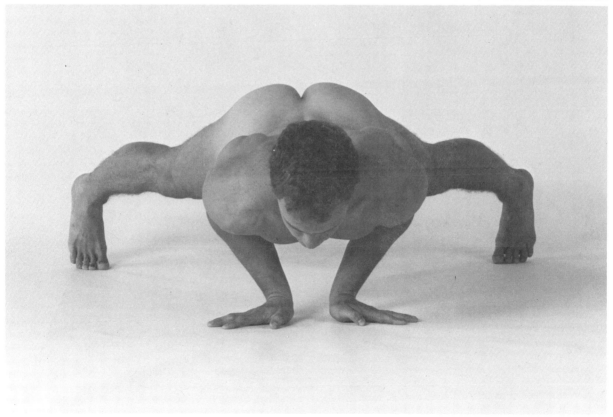

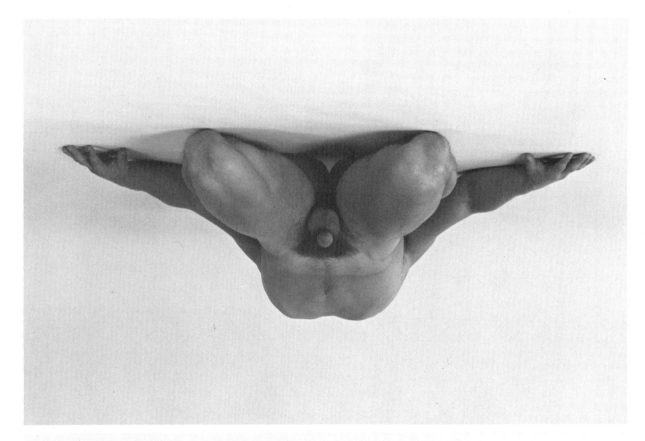

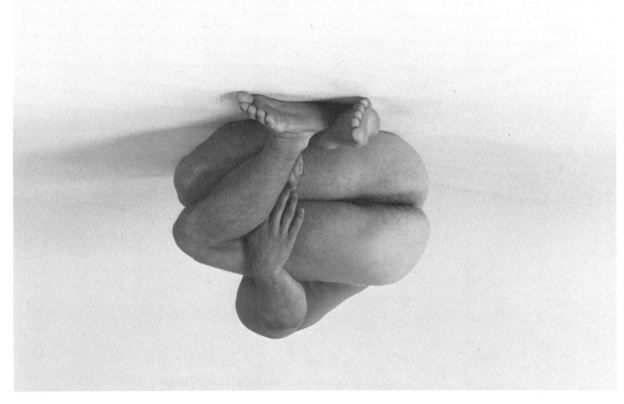

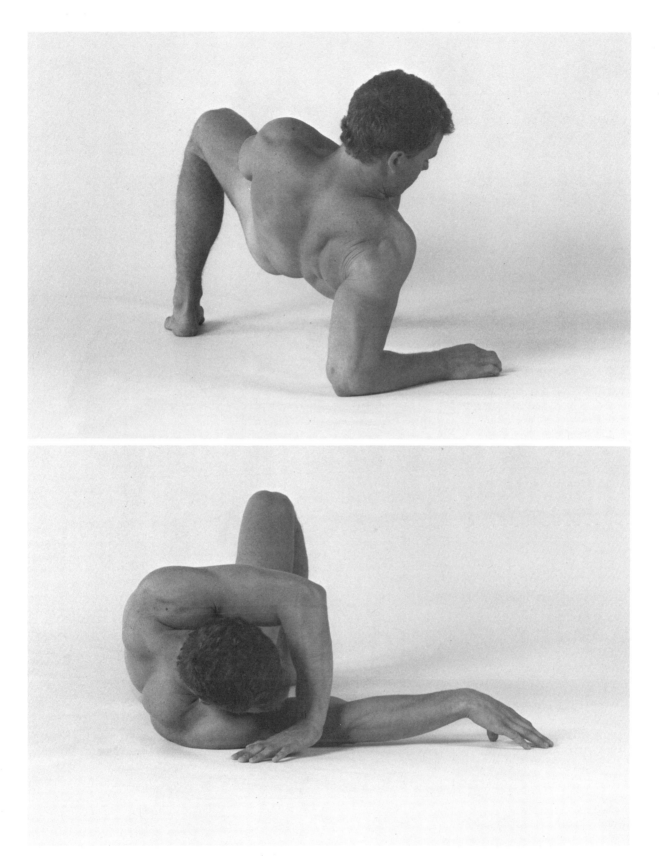

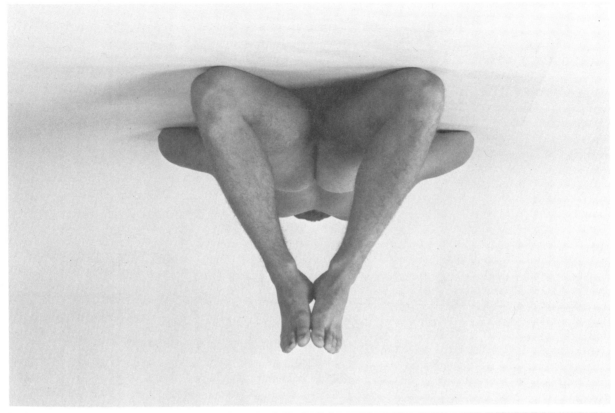

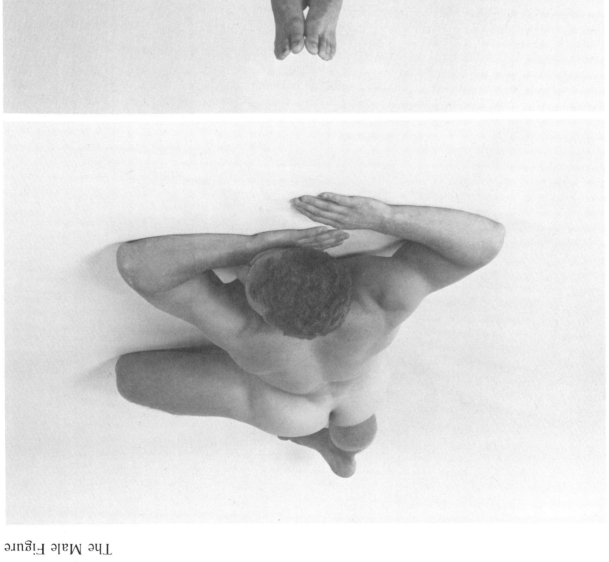

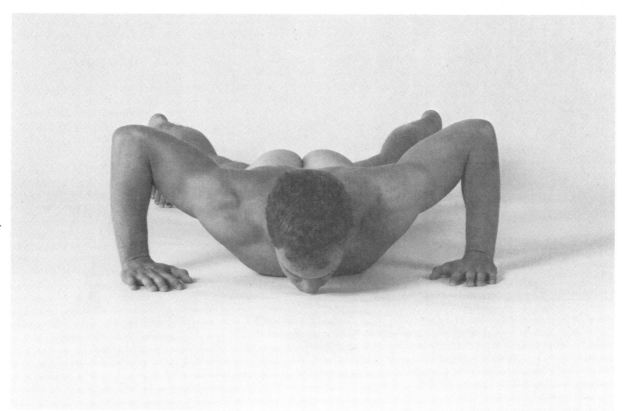

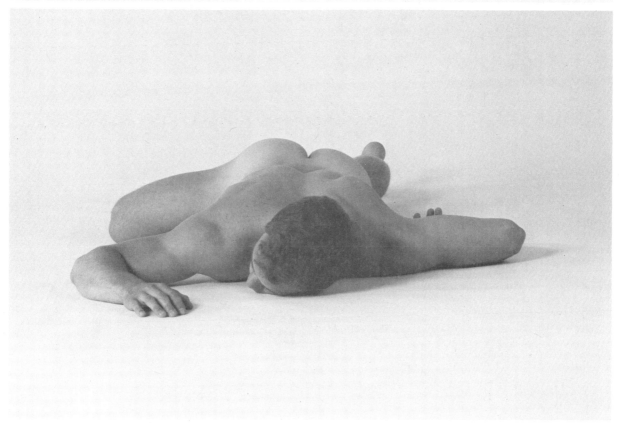

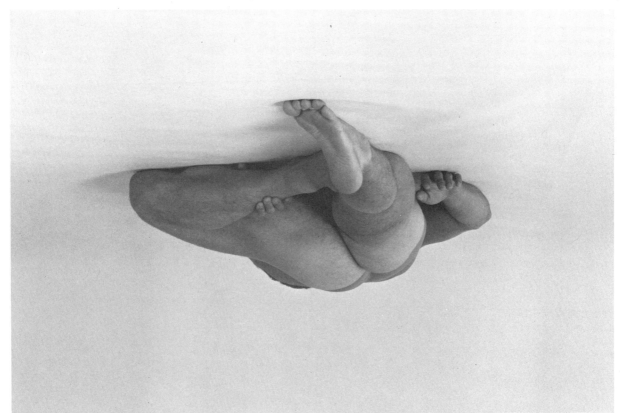

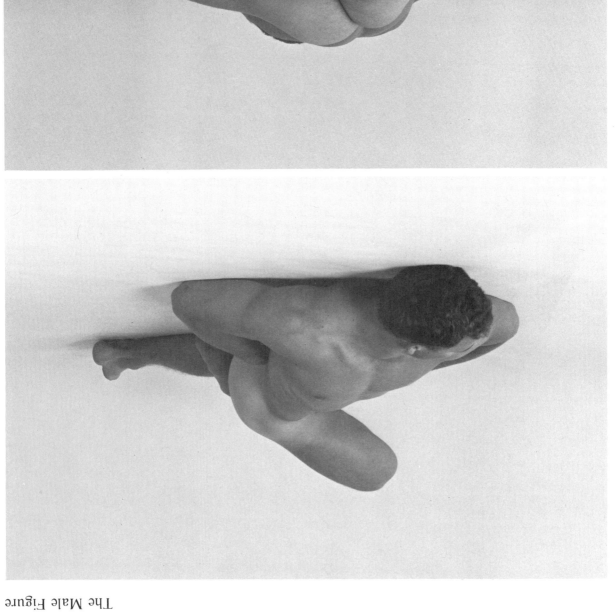

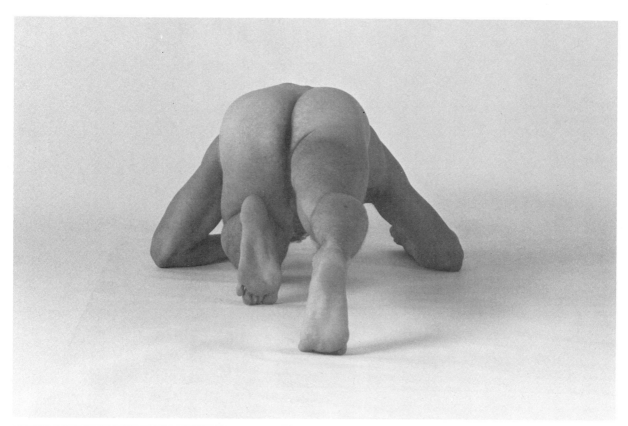

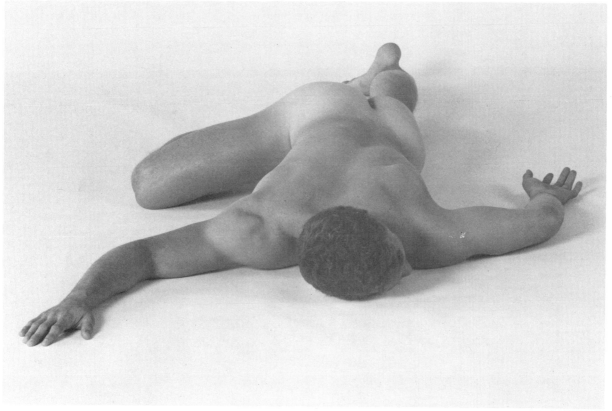

Foreshortened Views: Poses with Marked Foreshortening 235

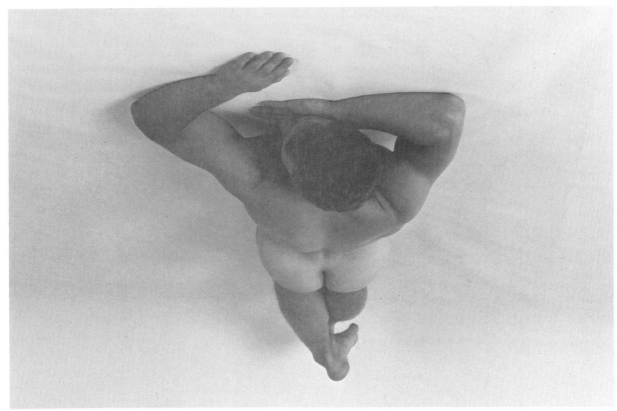

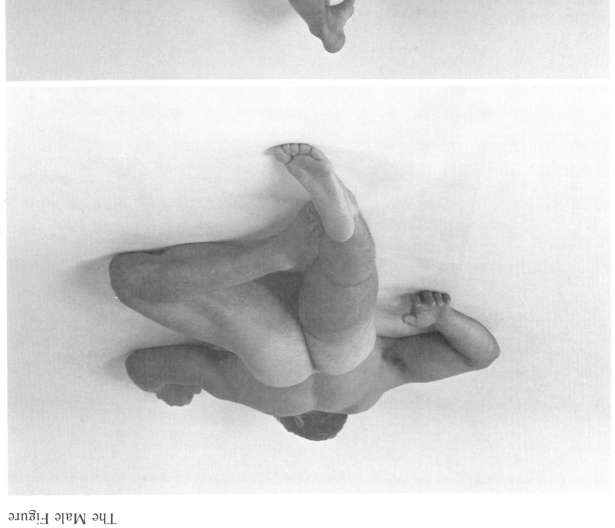

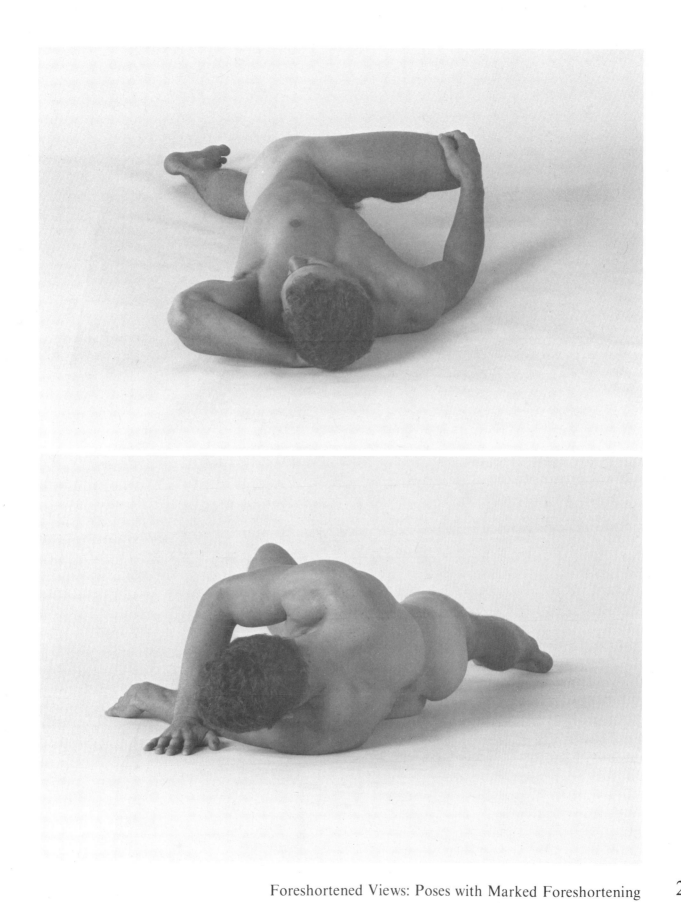

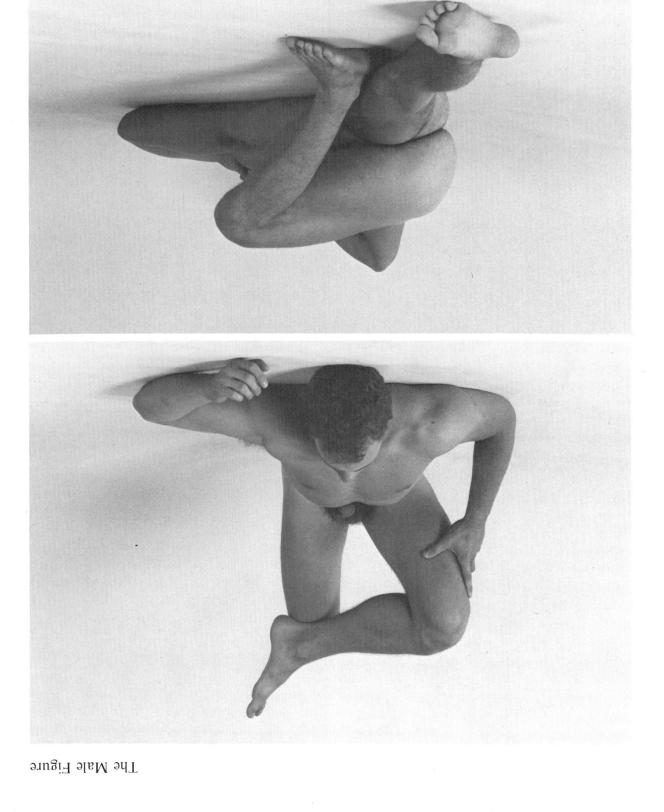

238 The Male Figure

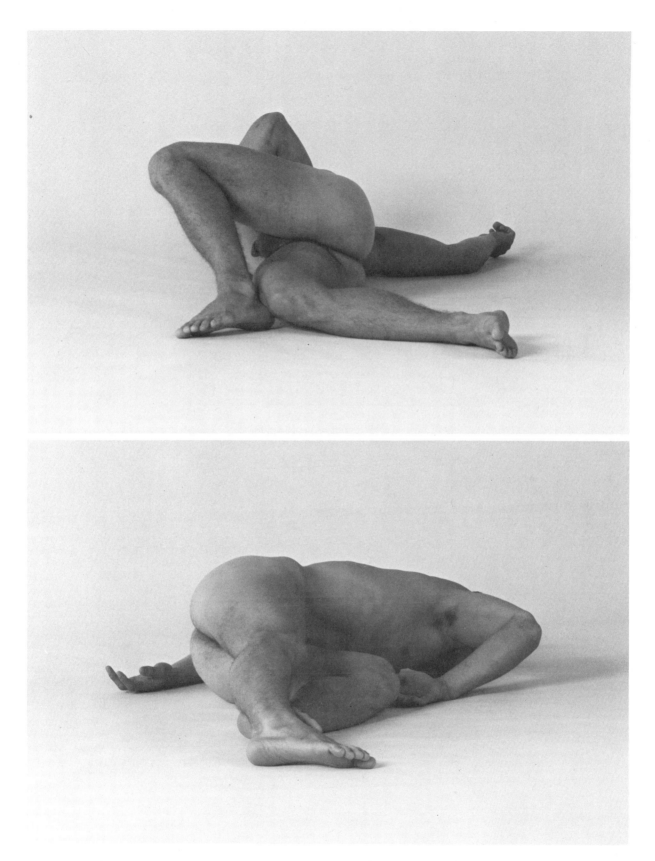

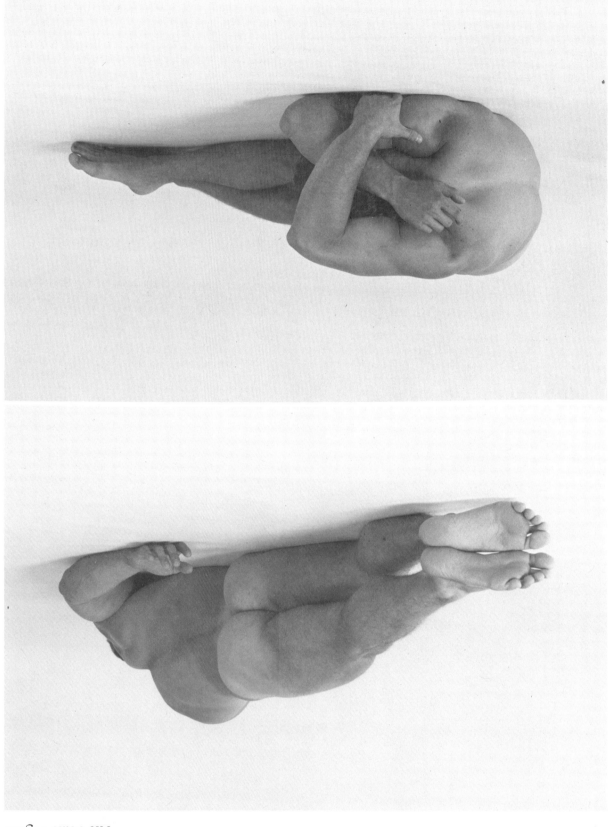

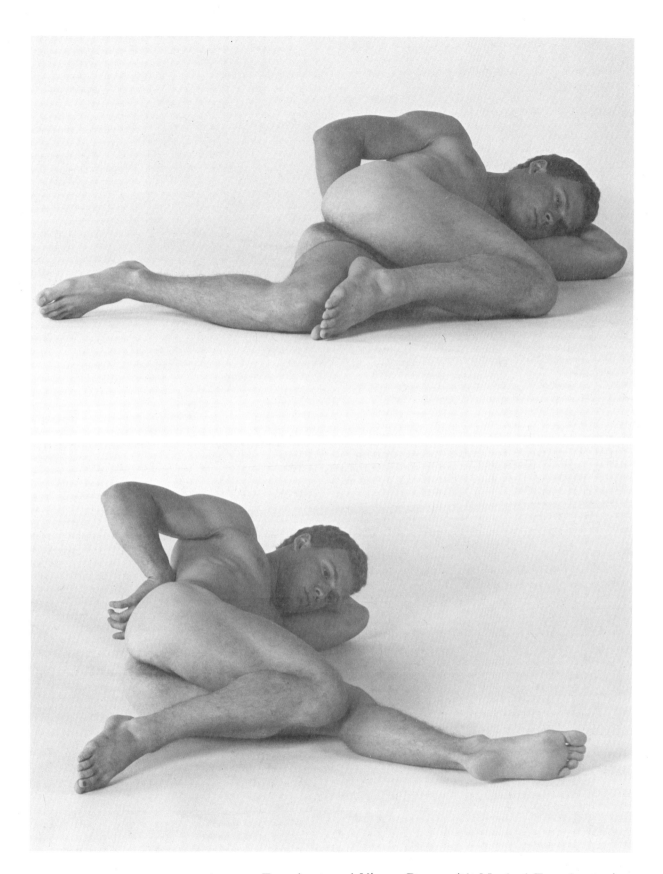

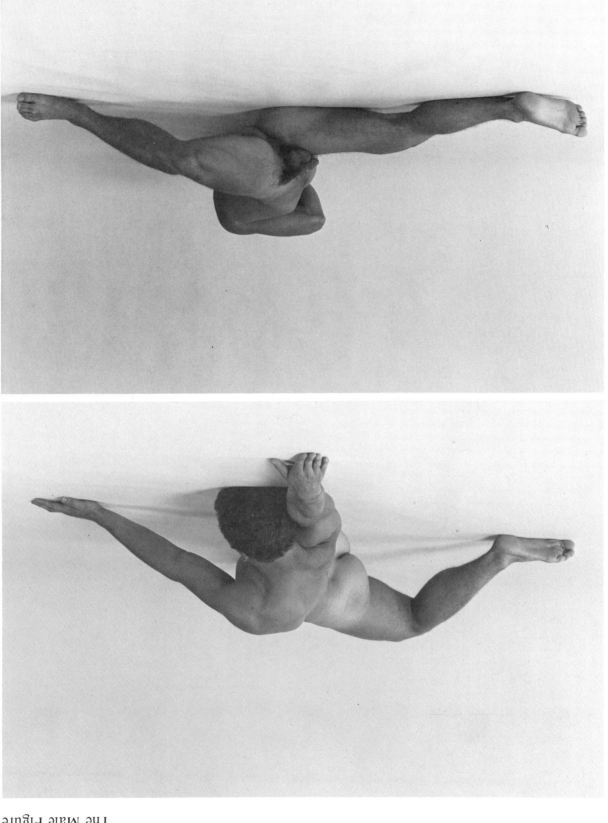

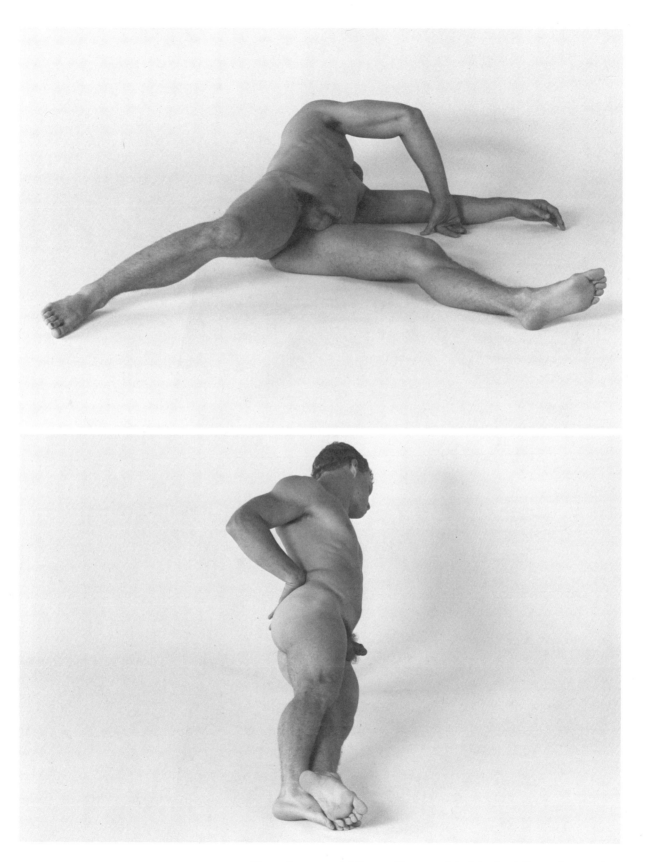

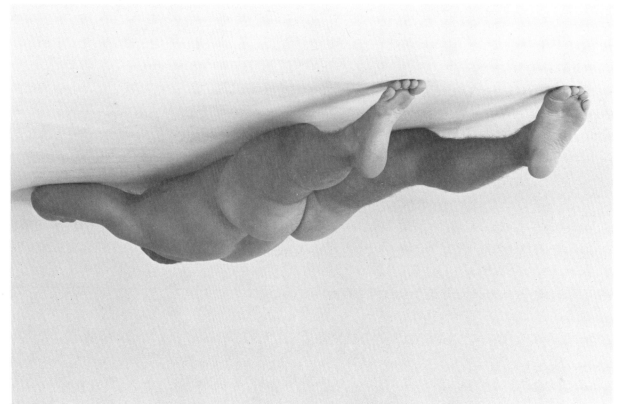

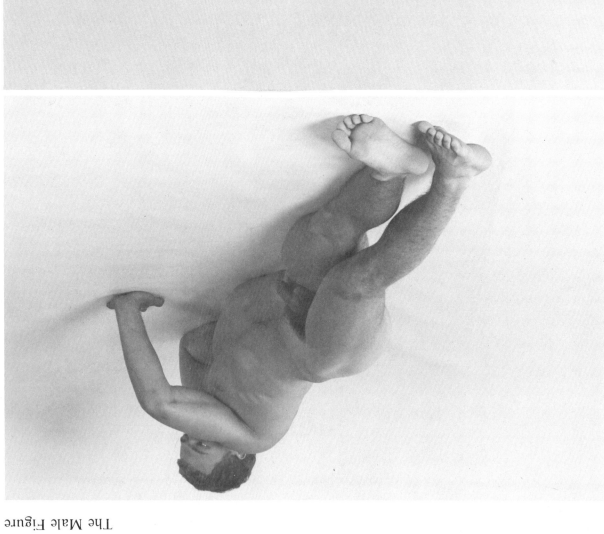

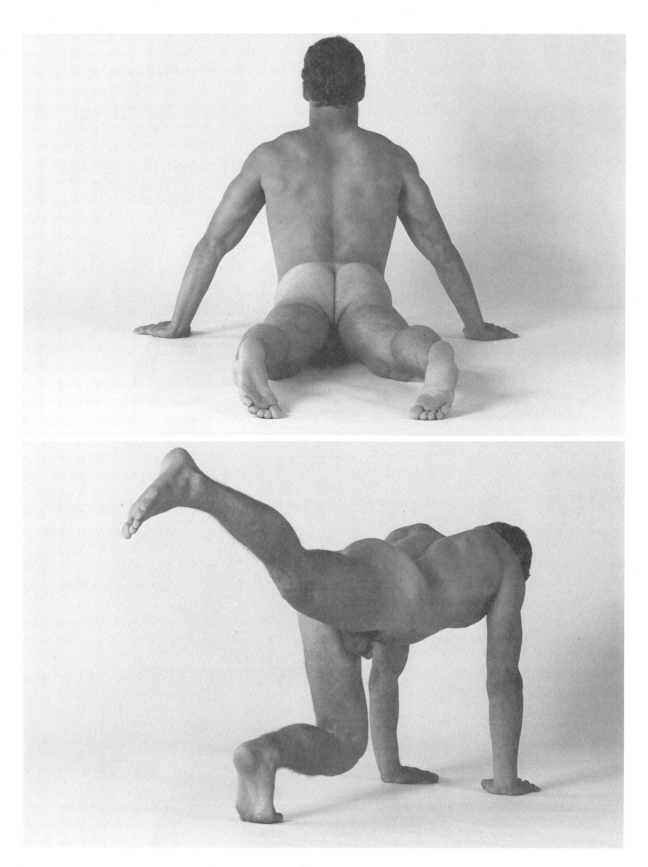

Foreshortened Views: Poses with Marked Foreshortening 245

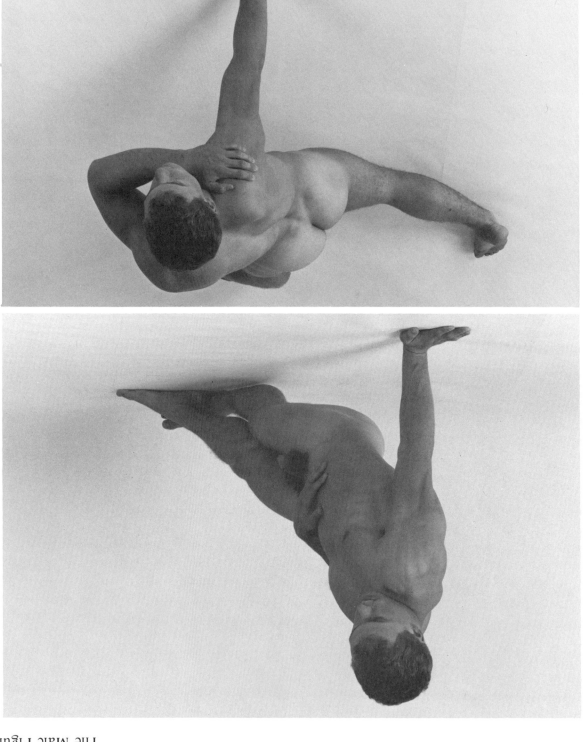

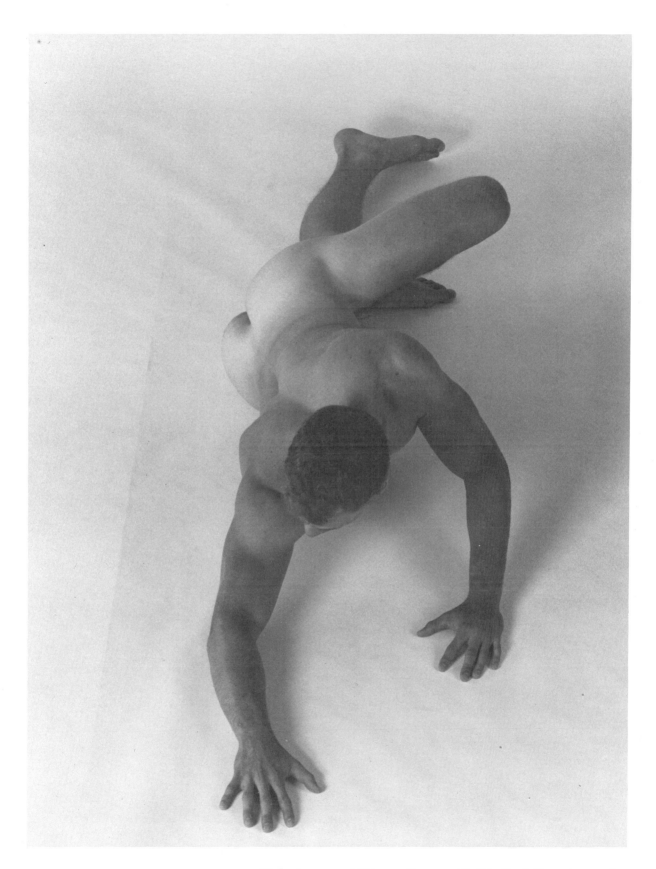

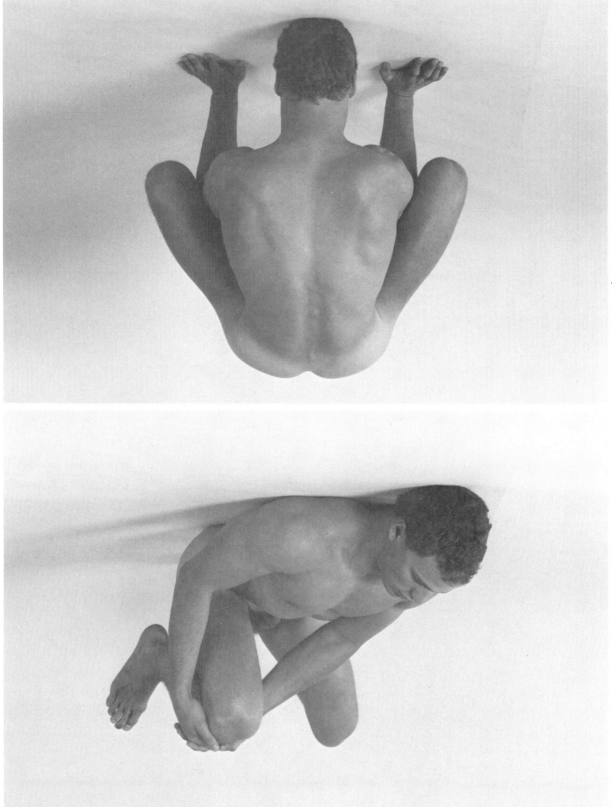

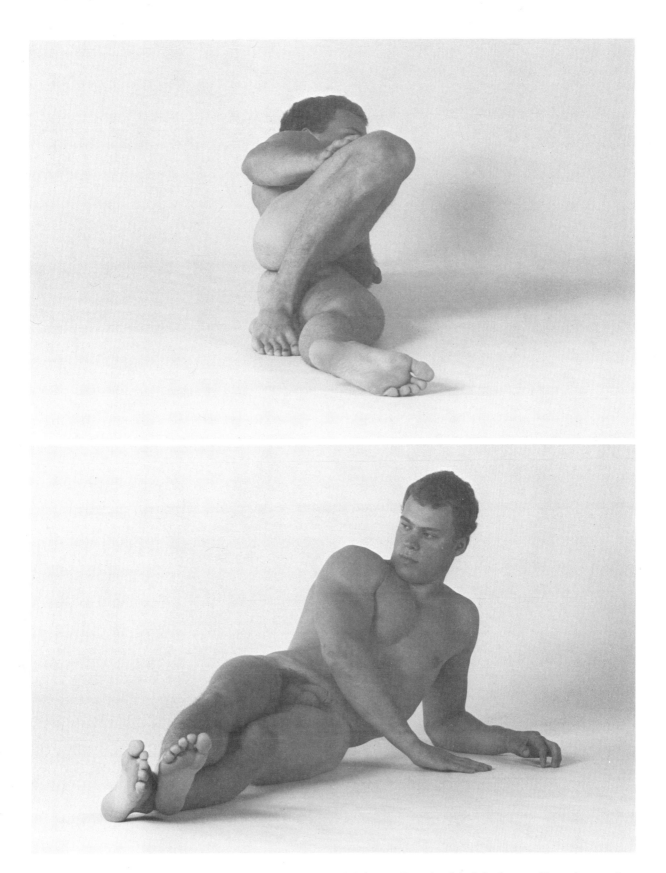

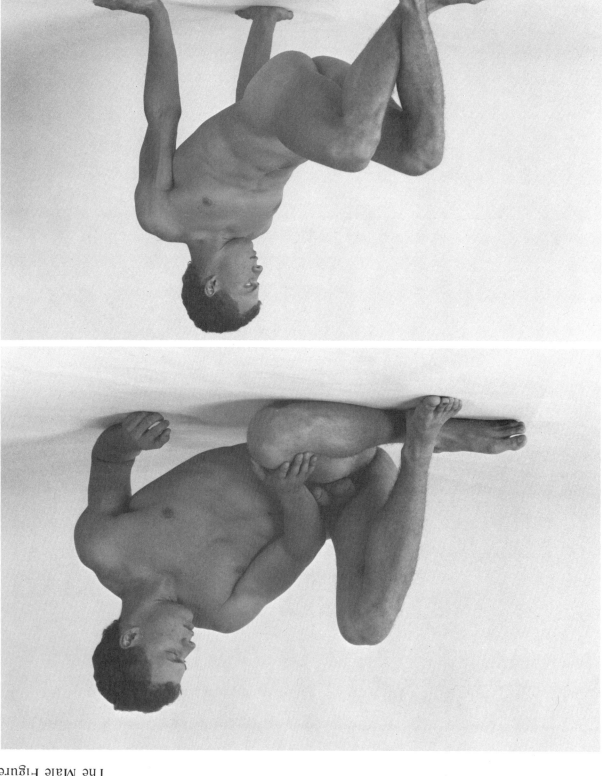

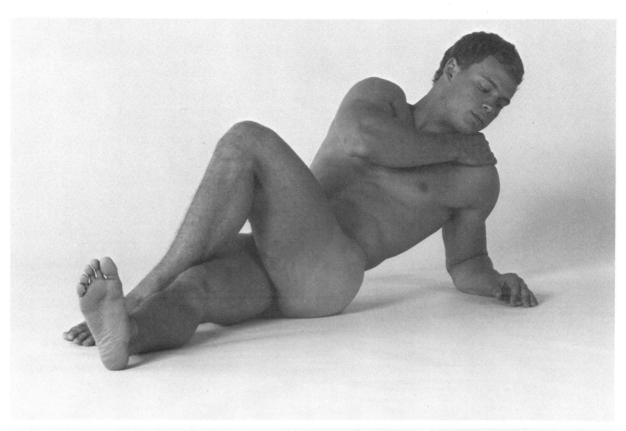

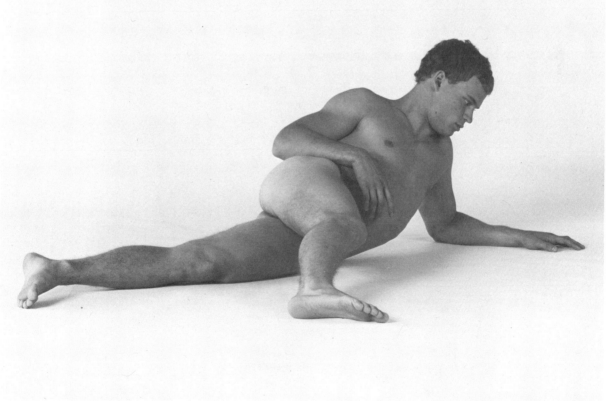

Foreshortened Views: Poses with Moderate Foreshortening 251

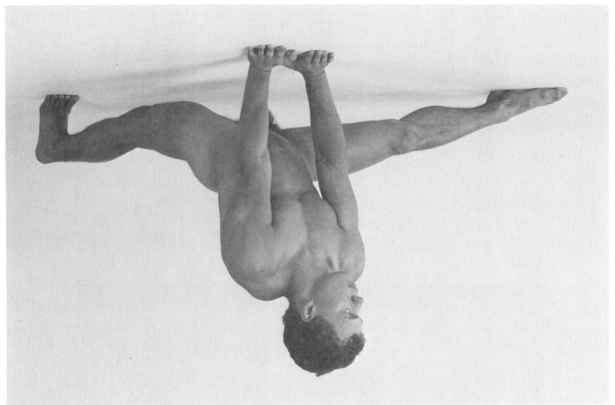

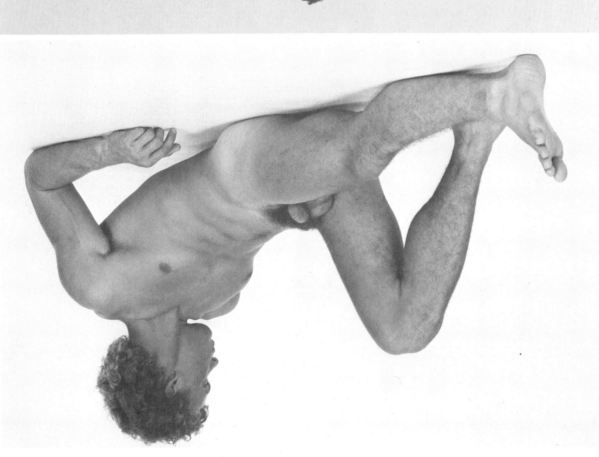

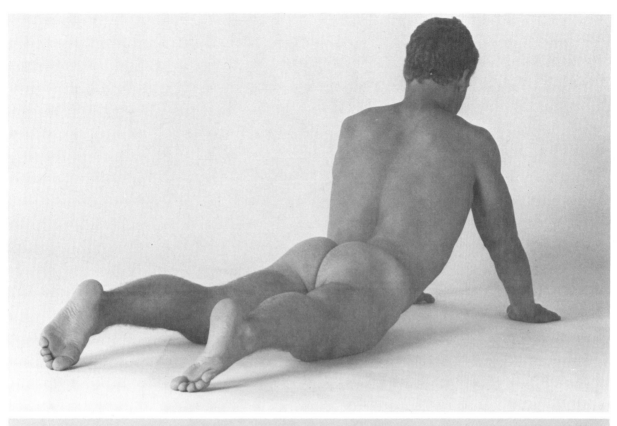

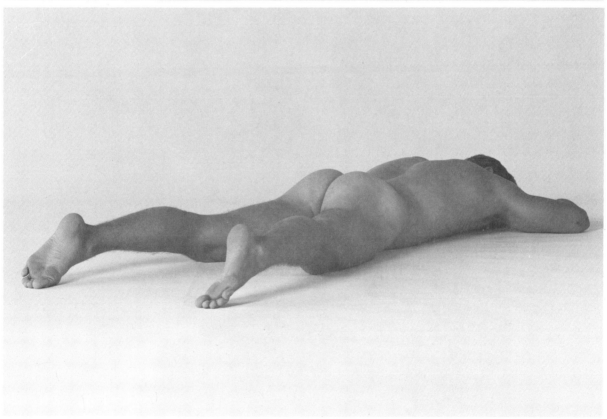

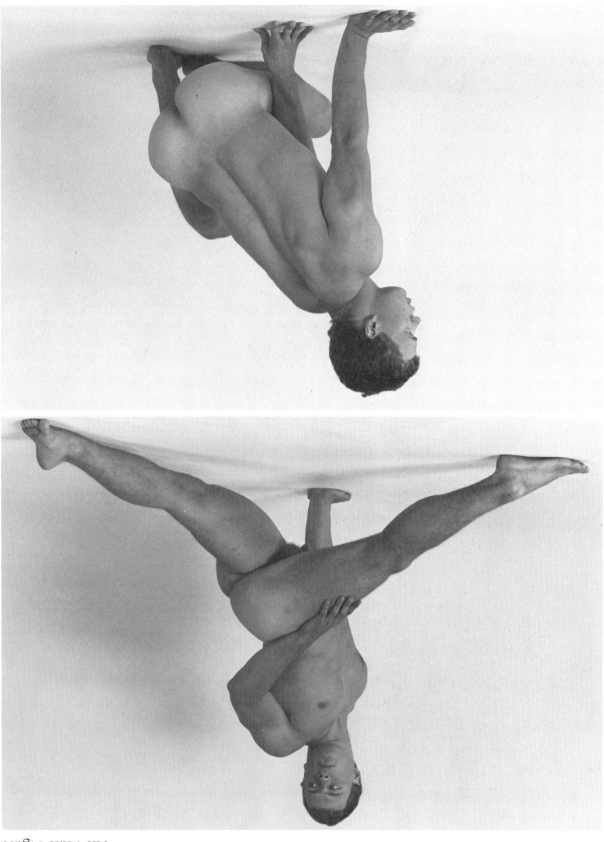

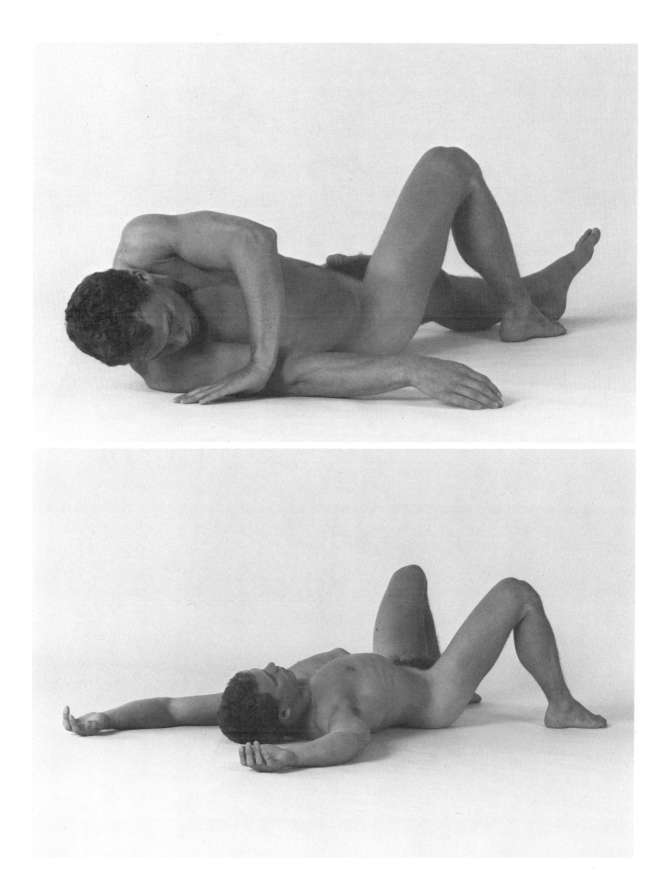

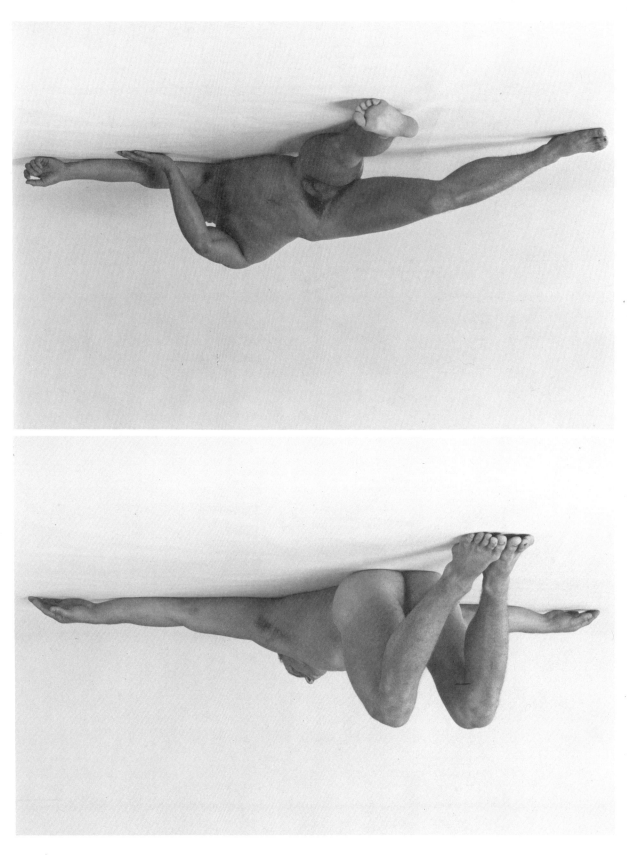

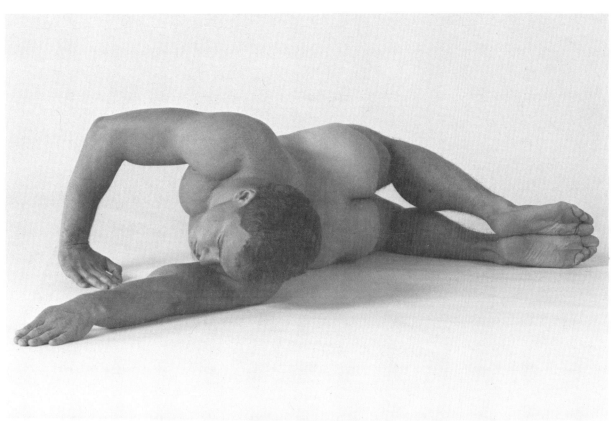

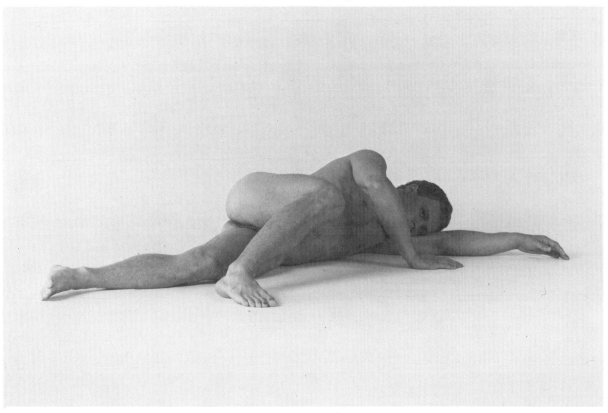

Foreshortened Views: Poses with Moderate Foreshortening 257

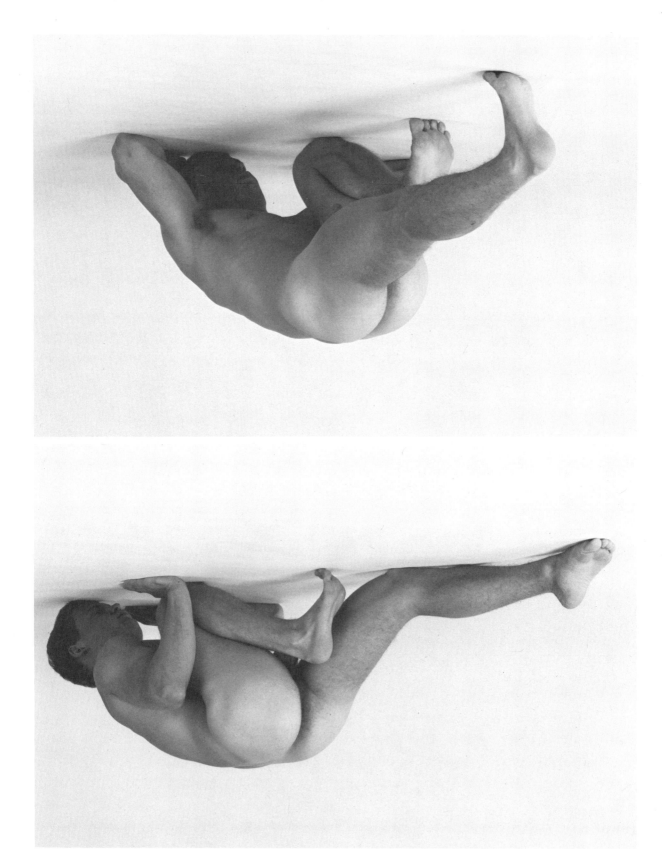

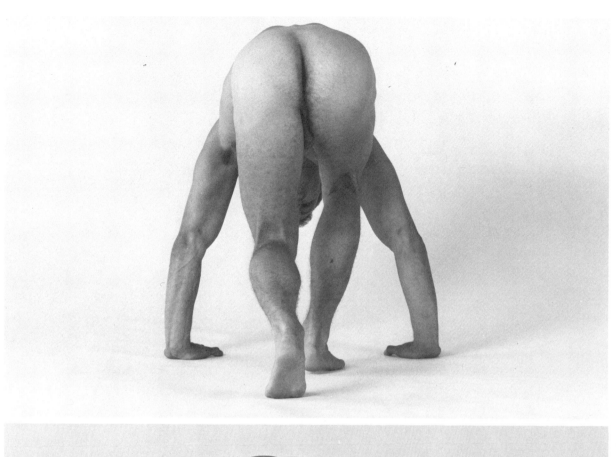

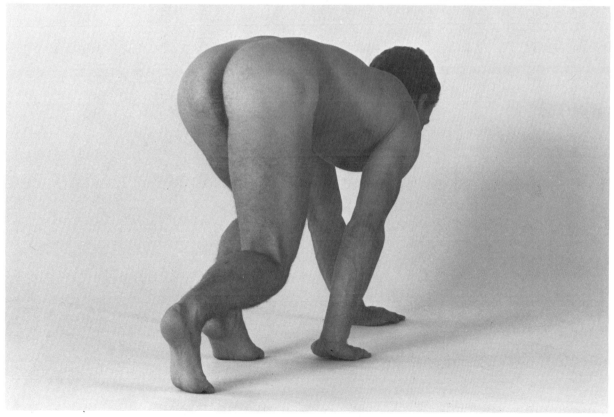

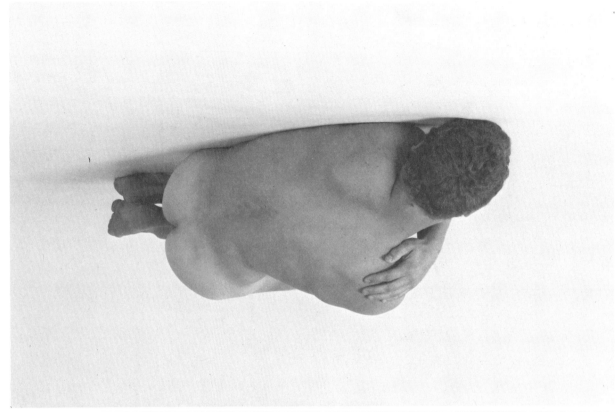

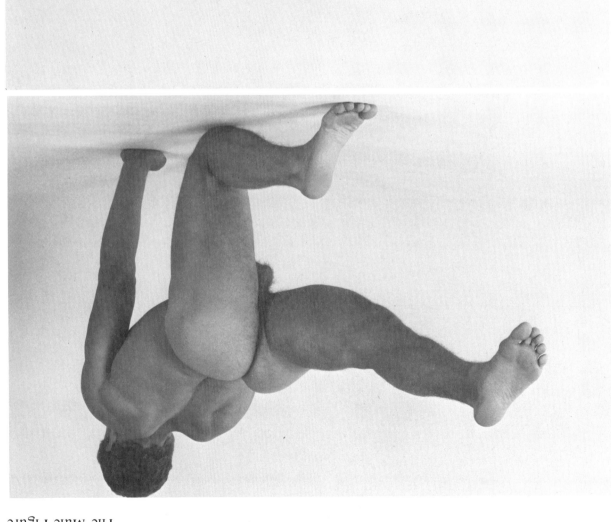

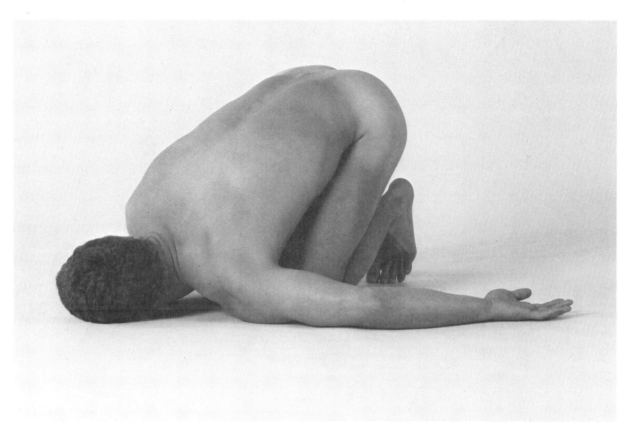

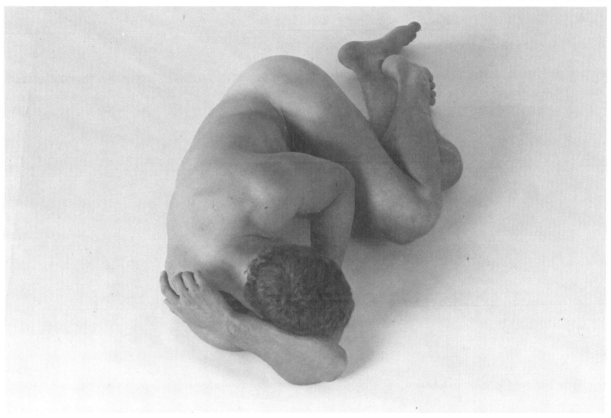

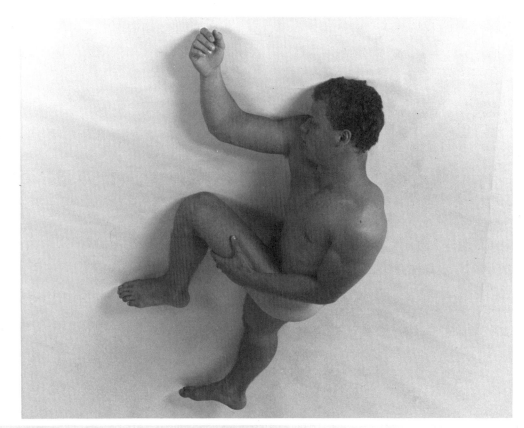

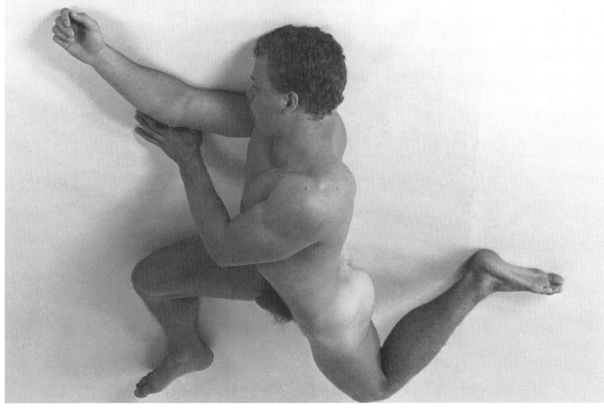

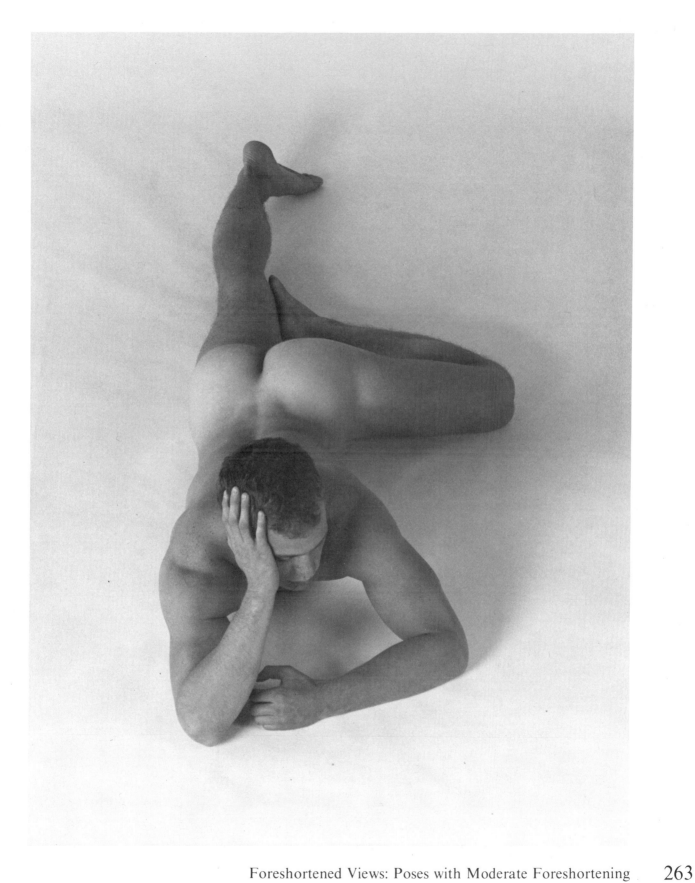

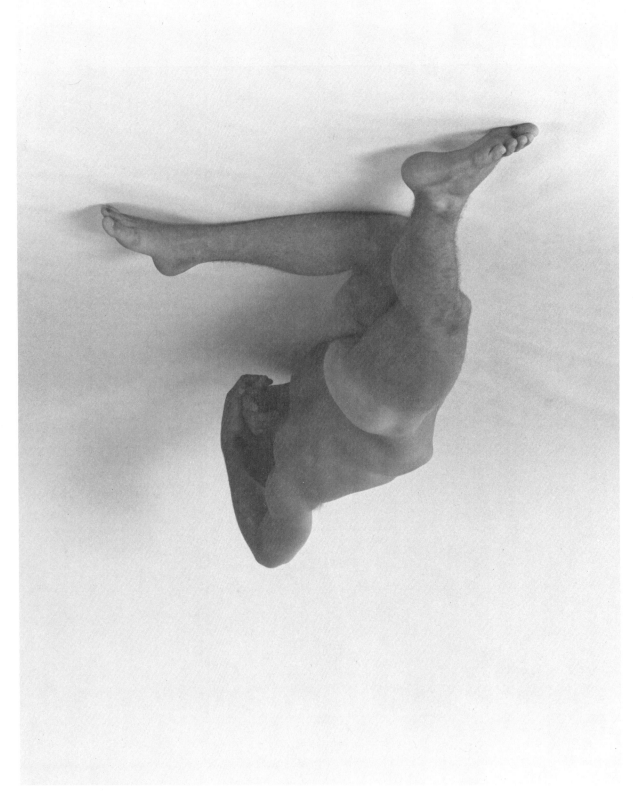

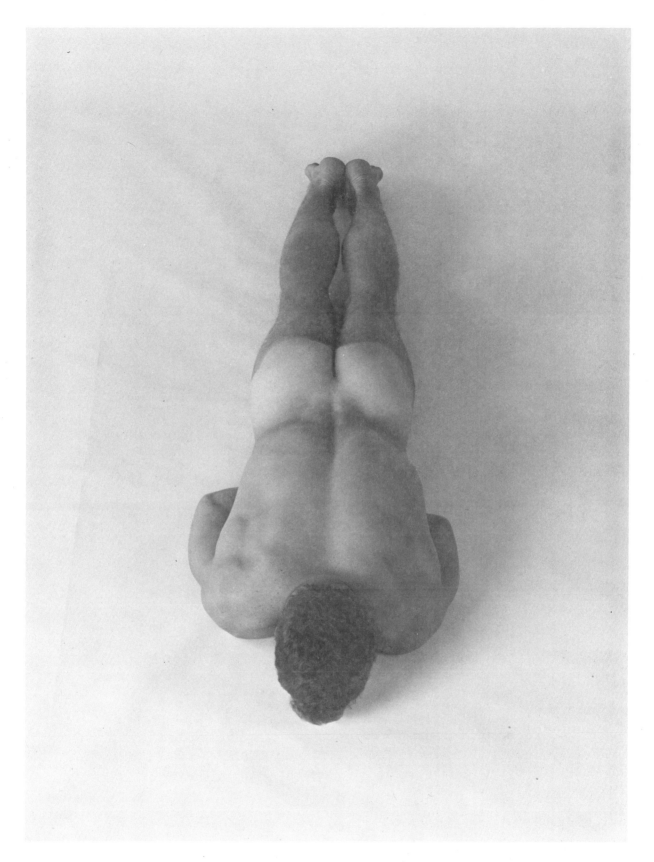

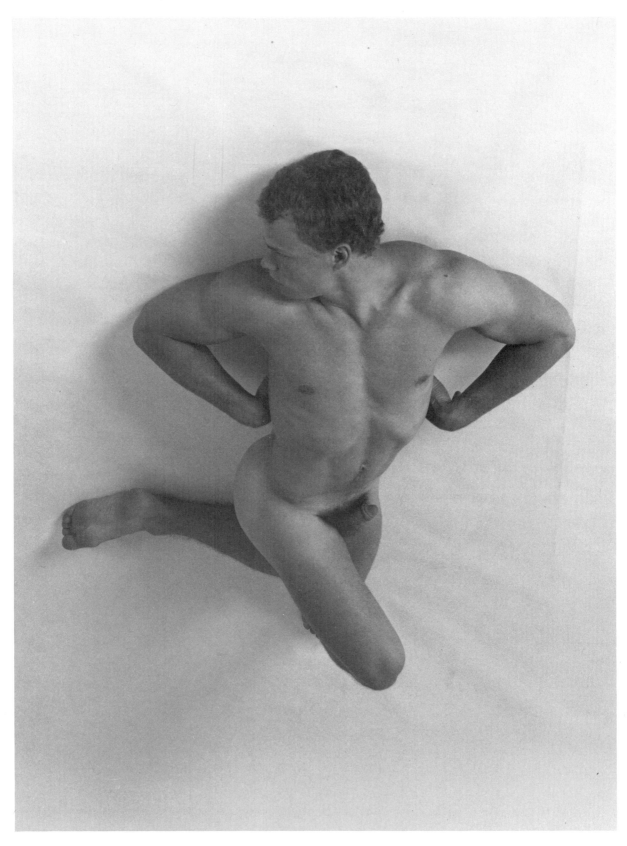

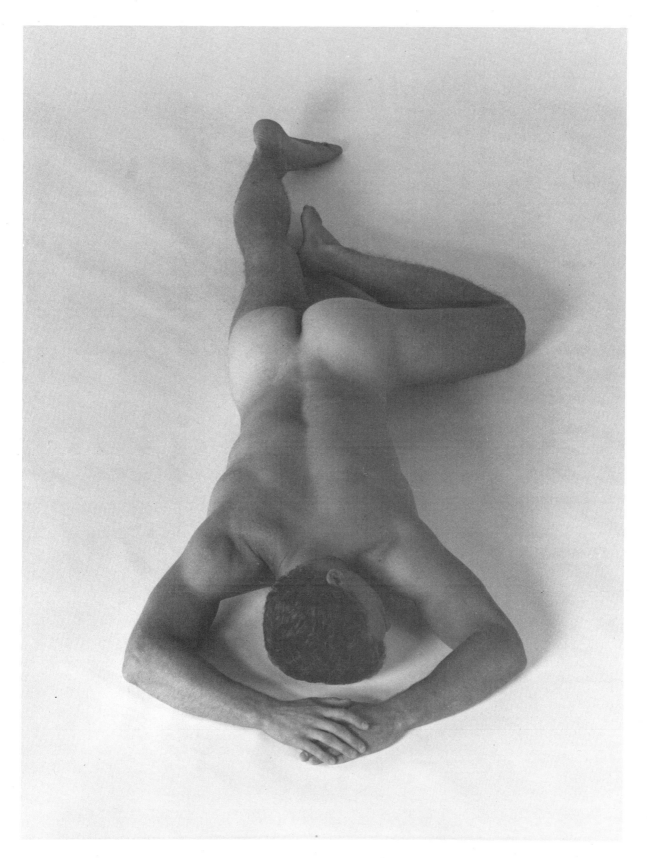

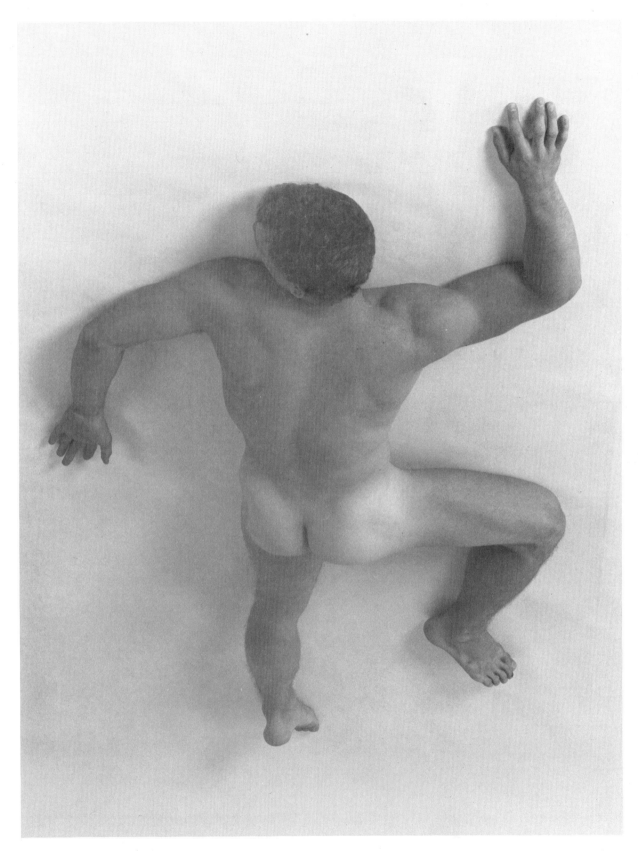

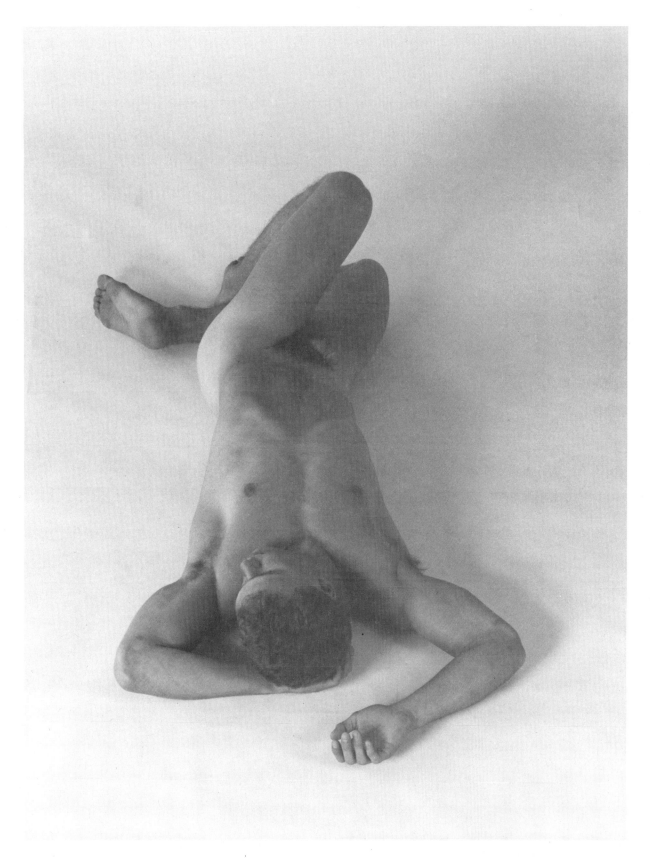

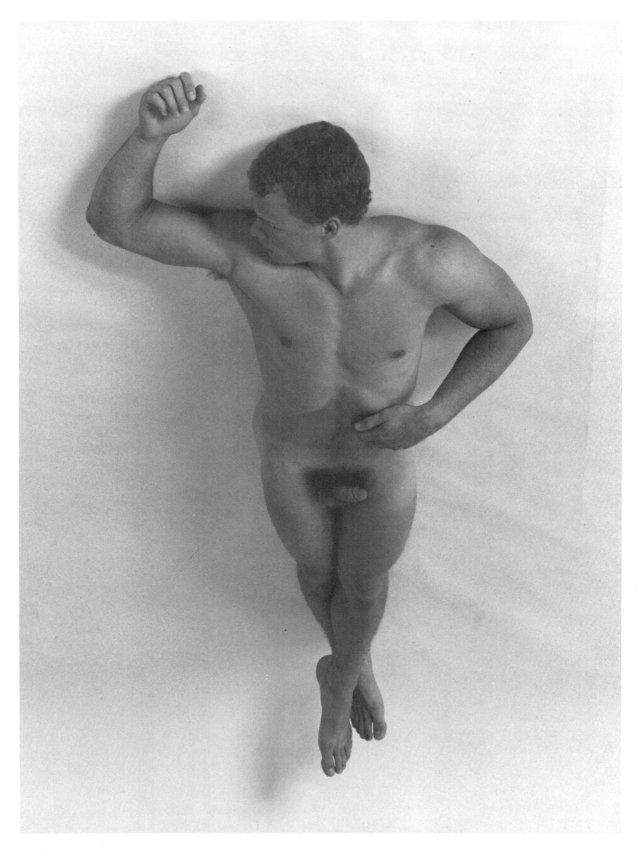

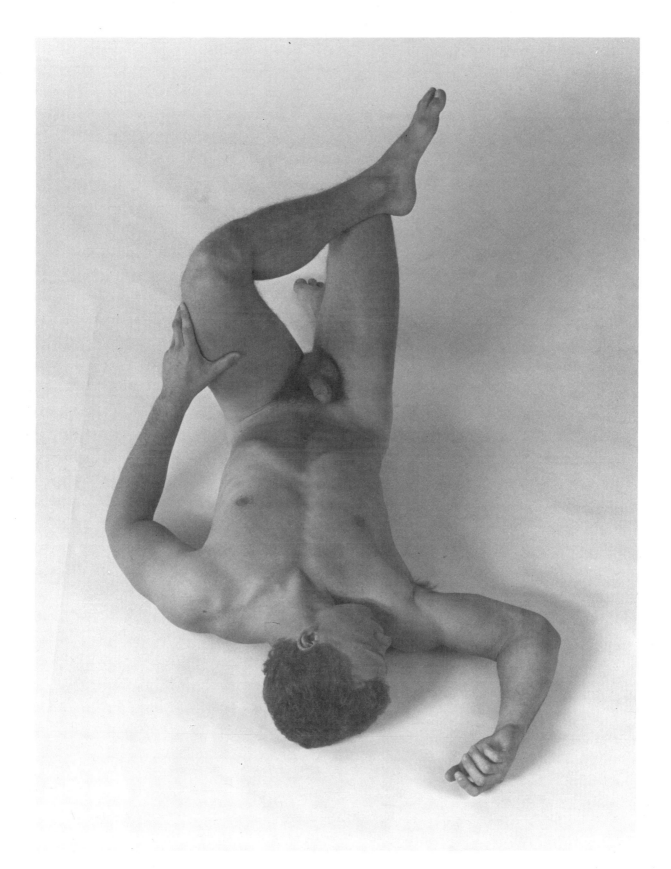

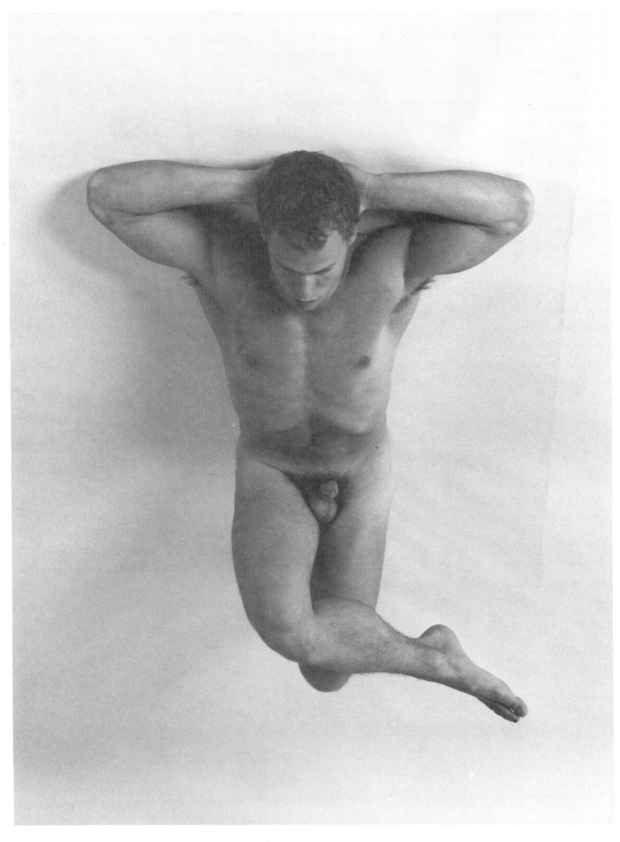

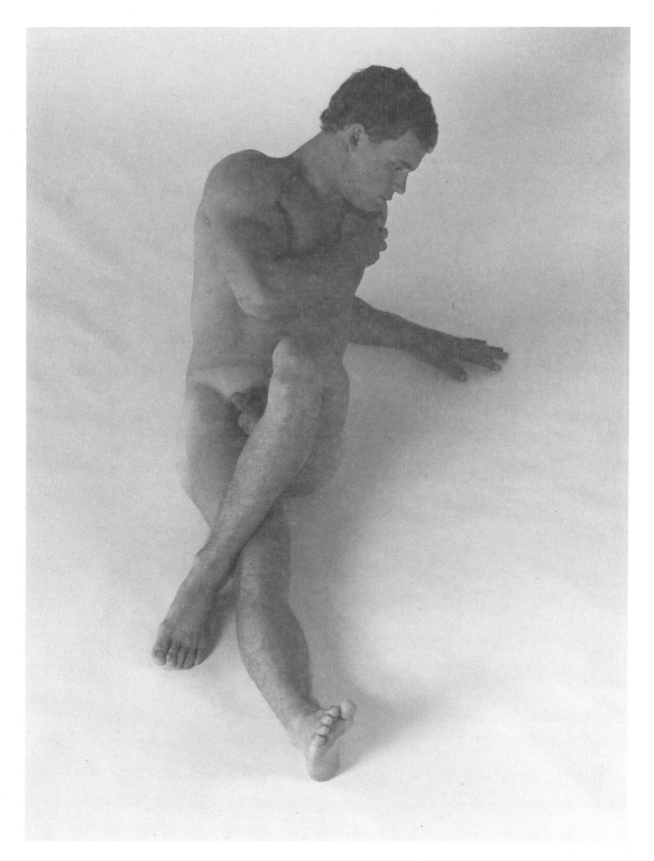

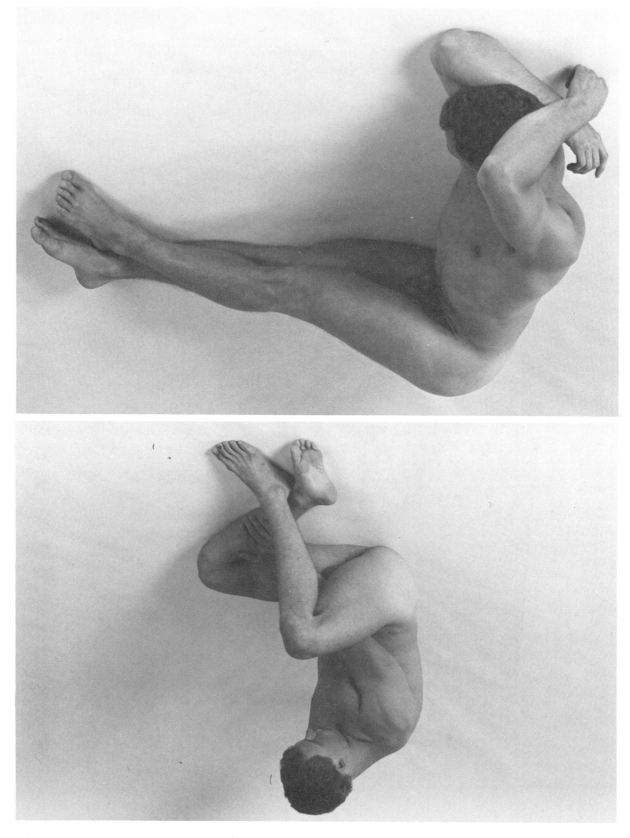

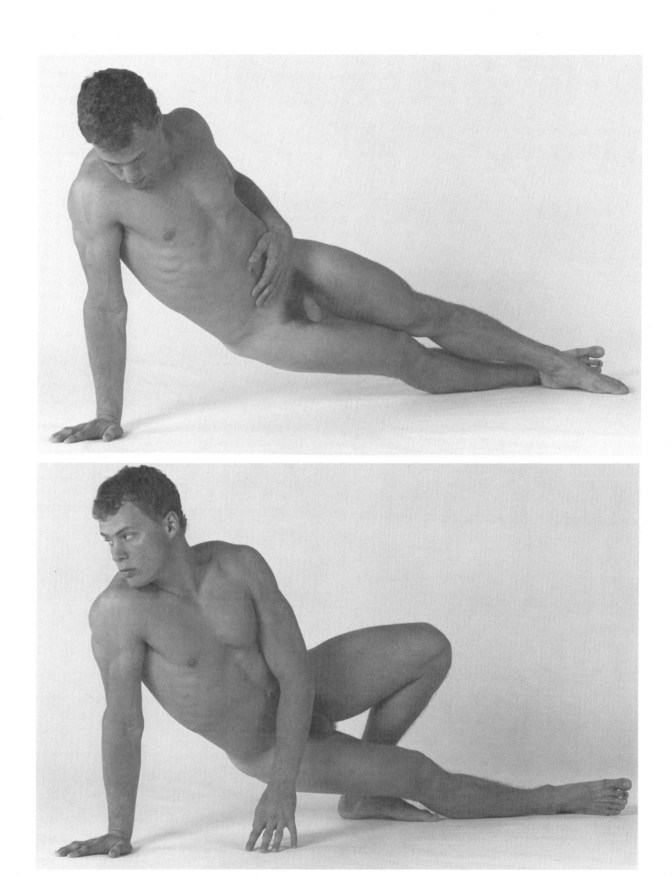

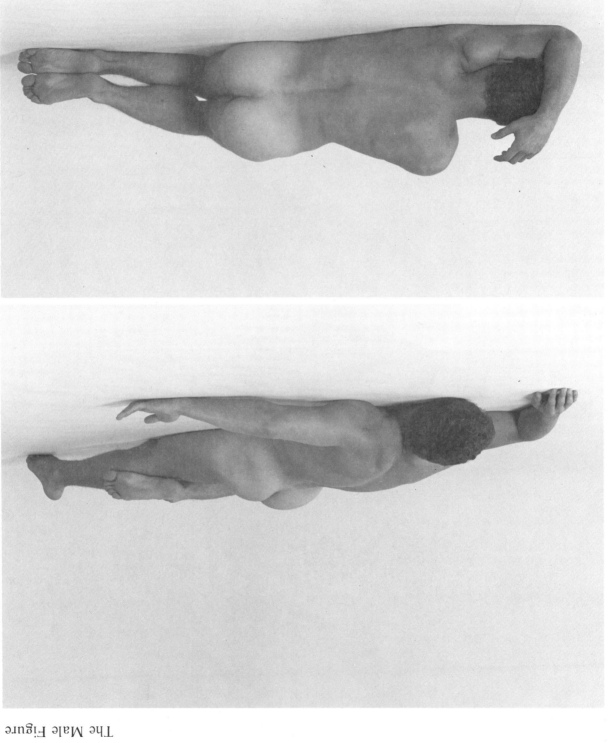

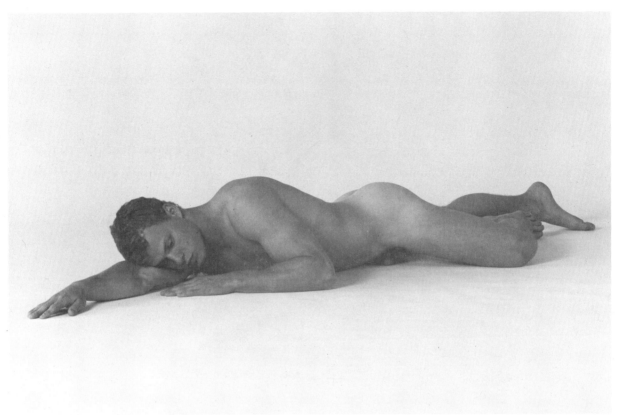

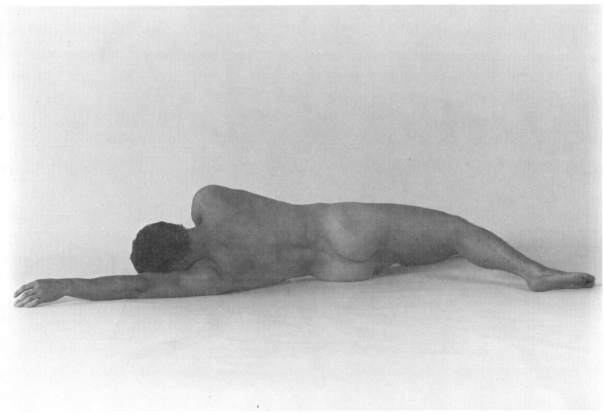

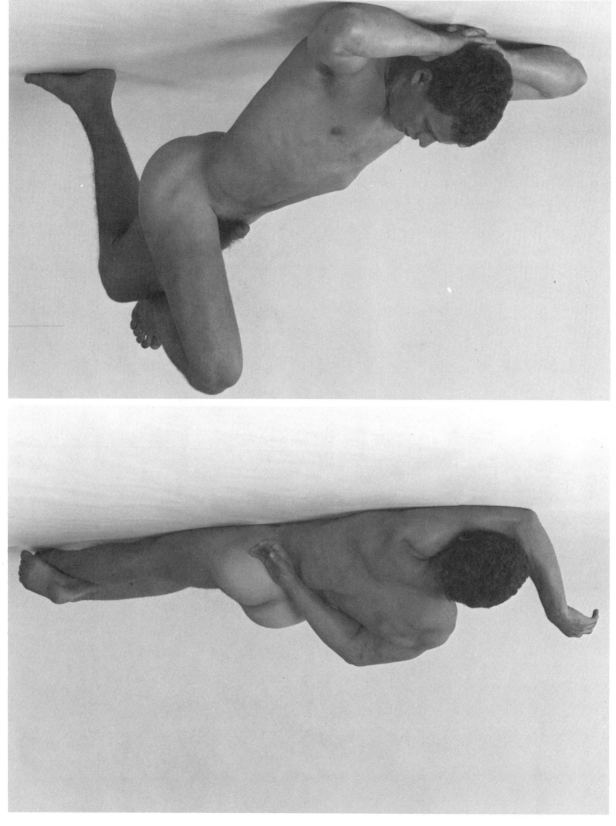

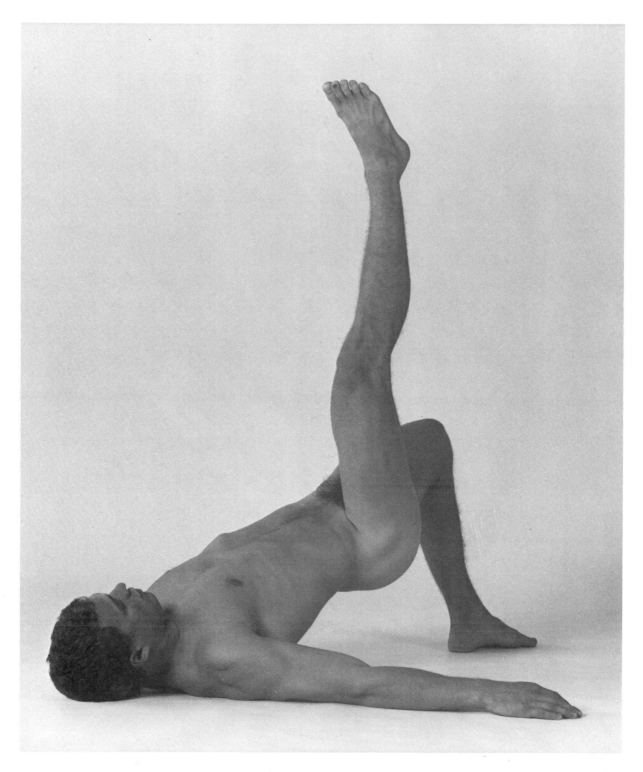

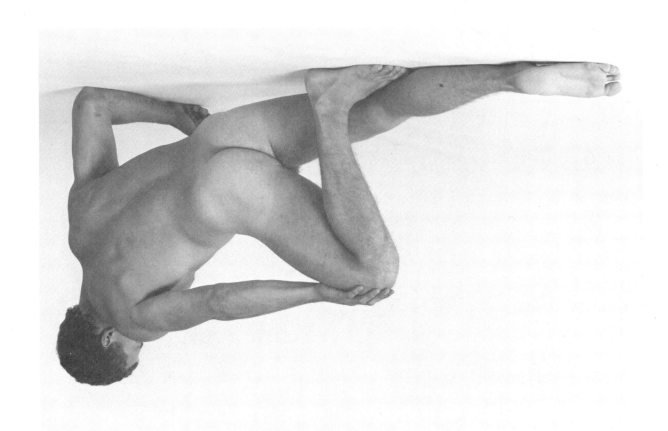

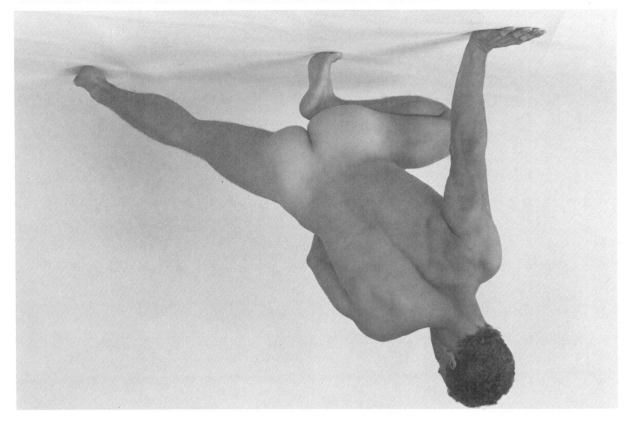

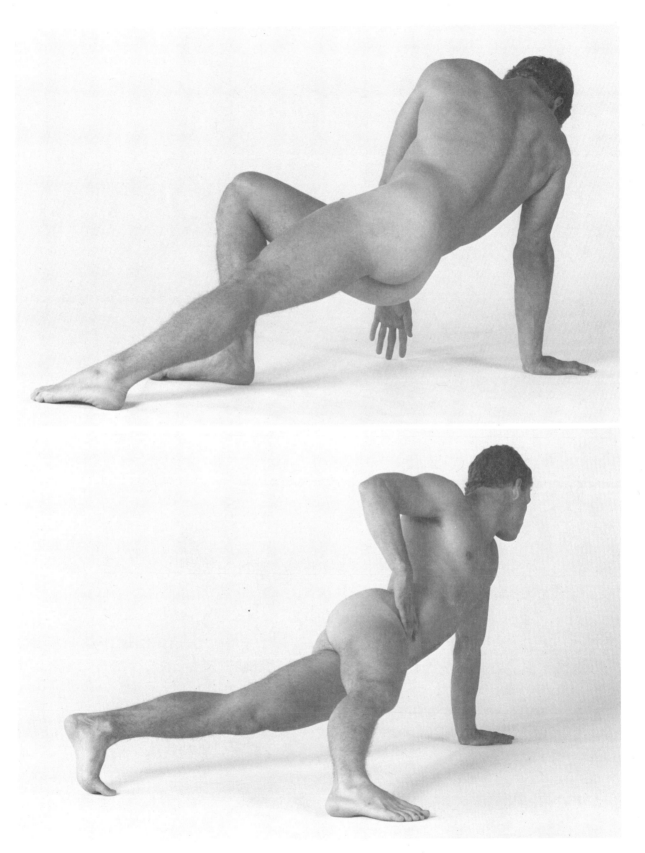

Foreshortened Views: Poses with Slight Foreshortening 281

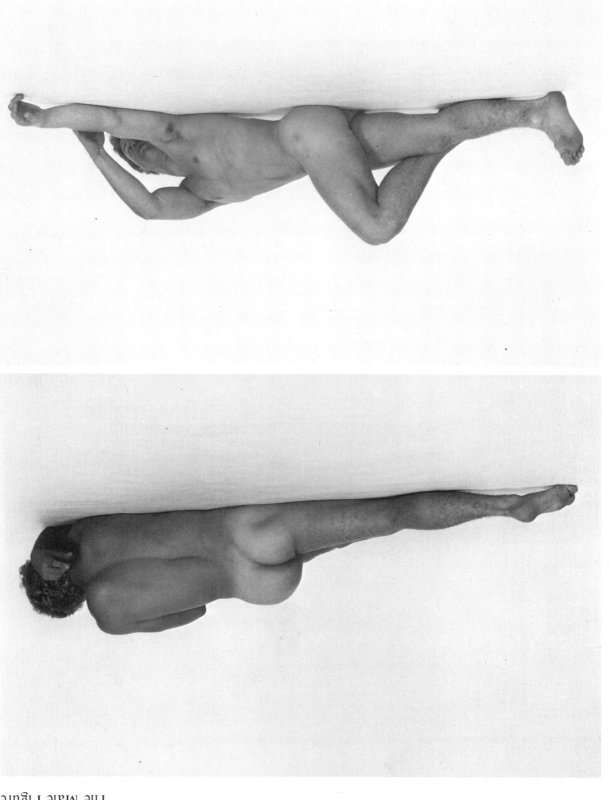

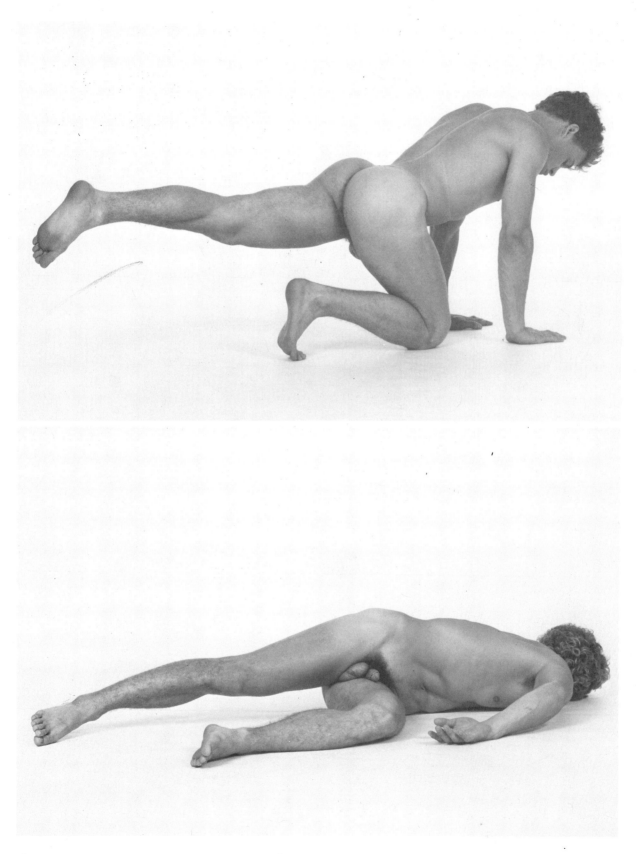

Foreshortened Views: Poses with Slight Foreshortening 283

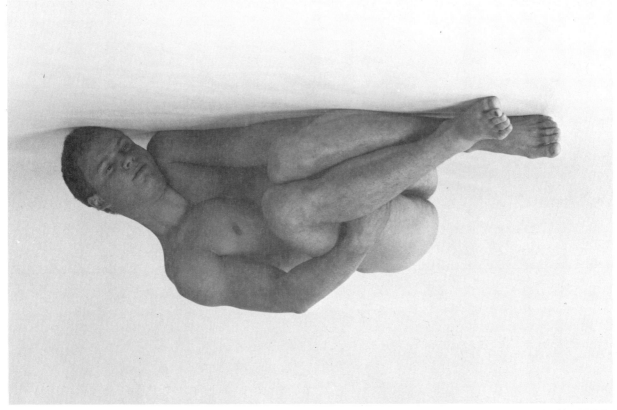

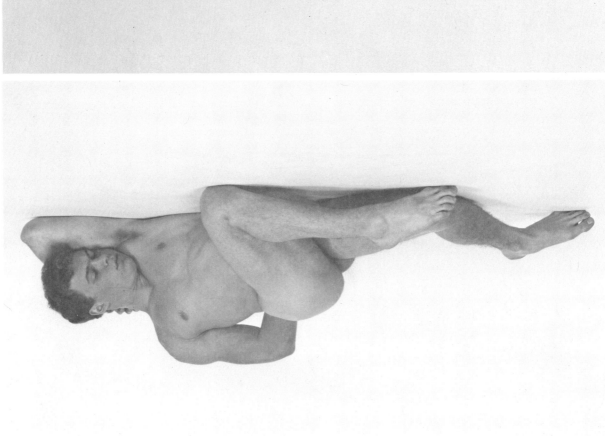

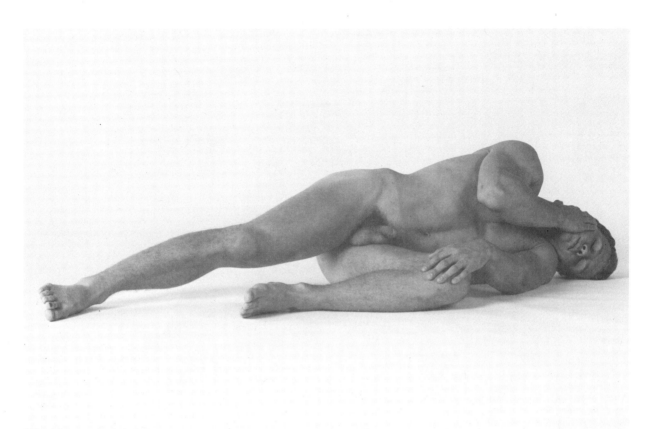

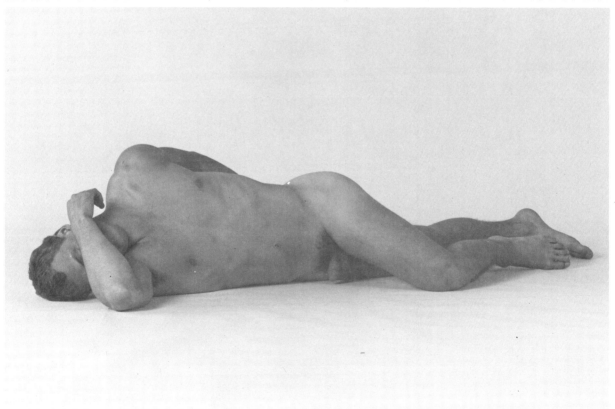

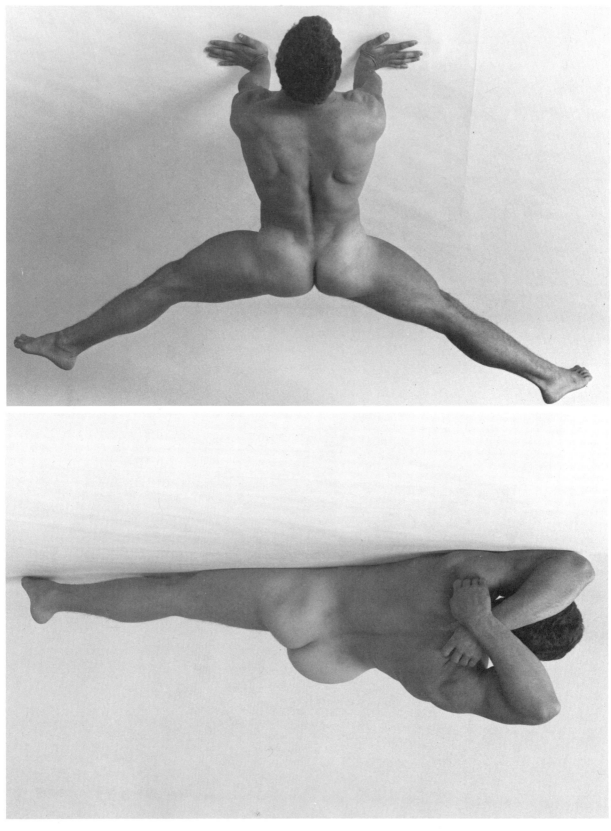

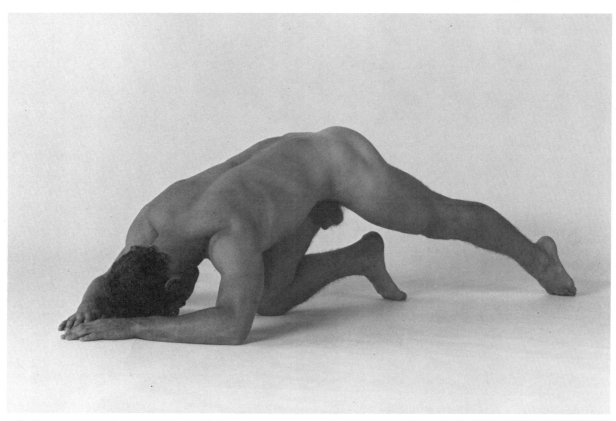

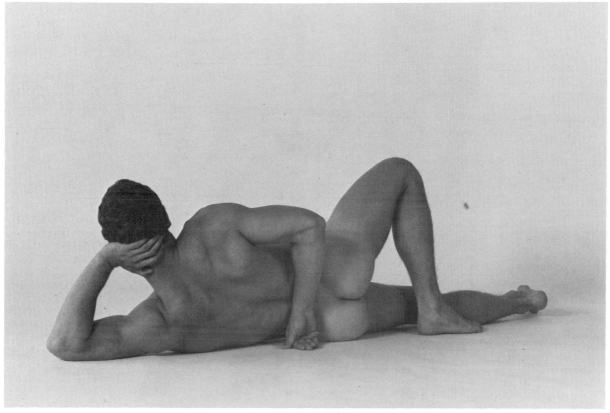

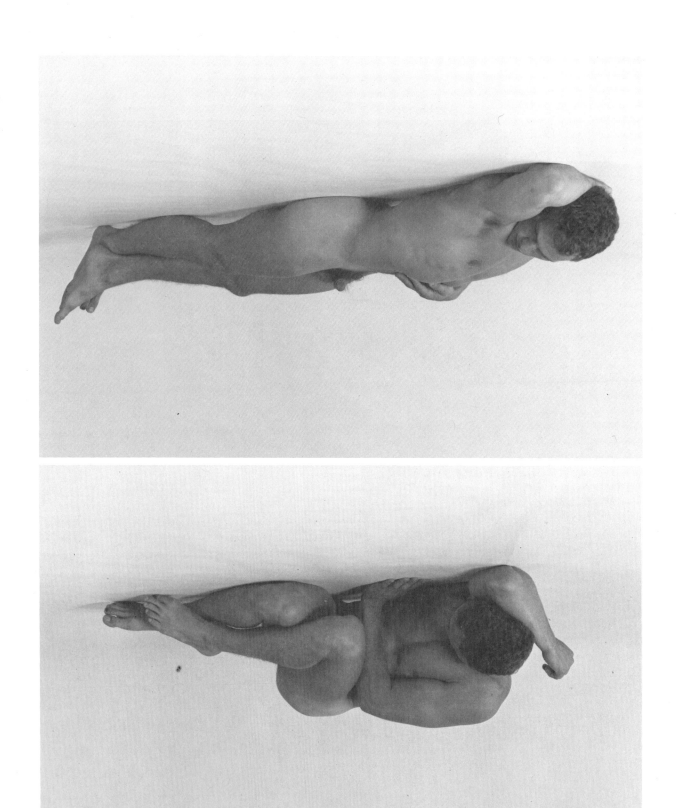

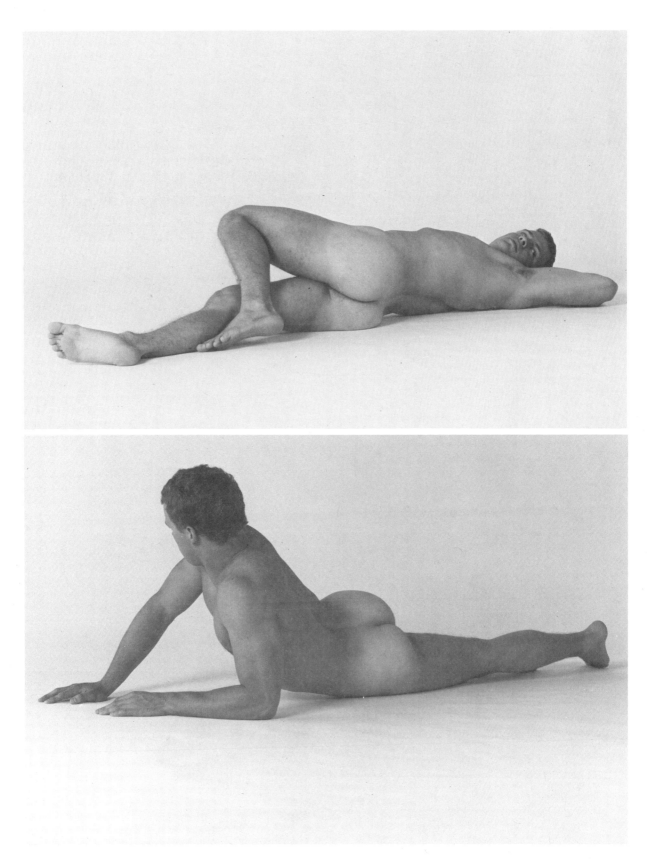

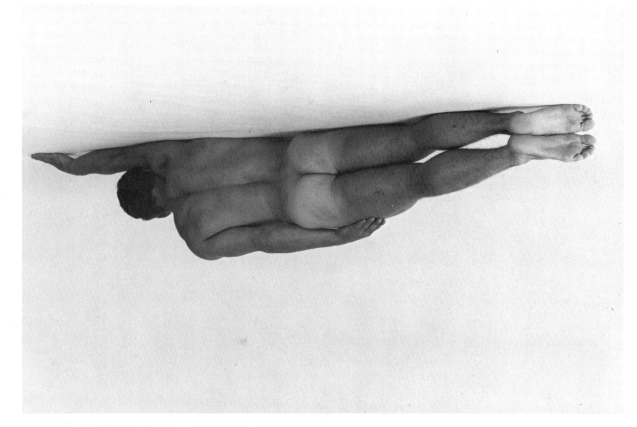